Chinese Blue & White Porcelain

Duncan Macintosh

Chinese Blue & White Porcelain

Charles E. Tuttle Company : Publishers
Rutland, Vermont

Published by the Charles E. Tuttle Company, Inc.
of Rutland, Vermont & Tokyo, Japan
with editorial offices at
Suido 1-chome, 2–6, Bunkyo-ku, Tokyo, Japan

Library of Congress Catalog Card No. 77-070845
International Standard Book No. 0-8048-1208-X

Printed in Great Britain

In Memoriam
J. B. M. and K. M. W. M.

Contents

List of Illustrations

Line drawings

Introduction

Chinese pottery and porcelain, venerated for many generations in China herself and elsewhere in the Far East, have also long stimulated keen aesthetic appreciation in Europe and North America. For many years there was little reliable information available for study in the West, and knowledge of the subject was therefore very limited, but the great Chinese Exhibition that was held in London in the winter of 1935-6 had a considerable impact on the study of oriental art and was subsequently to provide the main guidelines for students. Since that exhibition there has been a livelier appreciation of the nature of Chinese ceramic wares, greater discernment in identifying them and more knowledge and skill in attributing them to what we now have good reason to believe are their correct periods.

Contemporary with this growth in interest, understanding and research, we find the view, strongly held in the West at least, that the invention of the hard, white and translucent porcelain that first became popular in the fourteenth century represents the ultimate in the skill of the Chinese potter. It certainly also represents a complete break with earlier tradition, for until the end of the Sung dynasty (AD 960–1279) and the subsequent Mongol Yüan dynasty (AD 1279–1368) nearly all Chinese ceramic wares were of pottery, made from coarser clays and stoneware, and fired at comparatively low temperatures. When this newly invented porcelain was decorated with brilliant underglaze colours, either cobalt blue or copper red, the revolution in taste was complete.

Copper red decoration, often referred to as 'underglaze red', seldom proved satisfactory until after the foundation of the Ch'ing dynasty in the seventeenth century, but the underglaze blue, ie decoration painted in cobalt blue on to the body of a vessel, glazed and then fired at a high temperature, proved much more successful. This form of decoration, long known as 'blue and white', has never failed to please, and today can claim to be considered the most popular genre in Chinese ceramic decoration.

That it should excite as much interest as it does throughout the world today is scarcely surprising, for not only has it continuously been in the main stream of Chinese porcelain manufacture since at least the early fifteenth century, far longer than any other genre, but it has also had, as we shall see in Chapter 7, an immense effect on the manufacture of porcelain elsewhere. To many people, even today, in Europe and North America Chinese porcelain is synonymous with blue and white, and if one was to pursue the enquiry a stage further, it is more than likely a good many people would reply that the ubiquitous 'Willow Pattern' was the main, if not the only, decorative motif. The truth of the matter, of course, is that the history of blue and white over the last 600 years has far more to say and merits much more serious study.

Anyone who has been studying Chinese porcelain for a few years is bound to be asked sooner or later how one can tell a genuine piece of porcelain from a fake, or even to say all there is to be said about the subject briefly and in generalities. There are clearly few things that are less possible, for there can be no short cuts or instant expertise in the study. What we can do in the first instance, however, and this will be the aim of this book, is to explore the main thoroughfares of our history, to see how, when, where and why the blue and white genre originated, how it developed in later years and what factors enabled it to survive in the face of the rival attractions of other styles of decoration and art forms. In this study the reader is also bound to notice that there are a number of avenues opening off the main thoroughfares that invite an excursion. These I have signposted in the bibliography, and many of them may well reward detailed study later on.

Ceramic forms

Before going on to study the development of blue and white decoration, we should first consider the forms taken by the vessels that were frequently decorated in underglaze blue and the terms commonly used to describe their different parts. The forms and their shapes can, of course, vary very considerably, and so it would be impossible to describe all the variations here. Some of the most common, however, are illustrated in Figs 1, 2 and 3, and these we shall now discuss.

Fig 1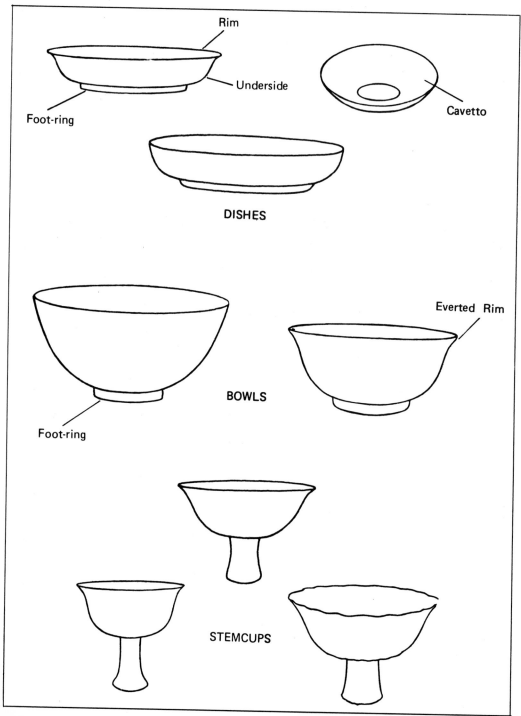

Dishes

Dishes are among the most common ceramic forms of all ages (Fig 1) They can be potted with an everted rim, with a straight one (common in the fourteenth and early fifteenth centuries), or else with a flattened edge of the type that is found on early examples (see Plate 7) and often in the latter half of the sixteenth century on Swatow and *kraaksporselein* dishes (see Plates 69 and 77). Dishes of not more than 8in diameter are frequently referred to as 'saucer dishes', but larger ones are seldom described in this way. It is very uncommon to find a dish without a foot-ring.

Bowls

Bowls are also very common ceramic vessels (Fig 1) and can be made in a variety of shapes. The example illustrated with a marked foot-ring is a *lien-tzŭ* or 'lotus bowl', which was particularly popular during the third Ming reign, that of the emperor Yung-lo, but was also made in later Ming periods. The other example, which is very much more common, was produced throughout the history of blue and white. Bowls were occasionally made without foot-rings during the fourteenth century, but they are very uncommon. Note that the exterior of a bowl, like that of a dish, can be referred to as the 'underside' and the interior sides as the 'wall'.

Stemcups

These are not so common a form as dishes or bowls, though they were derived from very early origins (Fig 1). They were potted in a number of shapes, and the three examples shown are the most common. The finely potted foliated stemcup was first produced during the Hsüan-tê reign early in the fifteenth century, but was also copied in later Ming periods (see Plate 31). During the Hsüan-tê period stemcups were mostly used for ritual purposes, but during the reign of his grandson, Ch'êng-hua, they were frequently used for wine.

Ewers

Ewers can also be made in a number of different shapes, but the example illustrated (Fig 2), which was modelled on a Middle Eastern prototype, is in a shape that was first produced in the early fifteenth century and was later extensively copied during the eighteenth century (see Plate 15 and Colour Plate IXA). Some early ewers, ie those made before the end of the fourteenth century, lack foot-rings.

Moon flasks

Perhaps the most common of a fairly wide variety of flasks made at the end of the fourteenth century and in the early years of the fifteenth, they were frequently copied during the eighteenth century. The moon flask was so called because the shape was thought to resemble the beautiful full moon of autumn, though sometimes, as in the example illustrated (Fig 2), when it is provided with two loop handles for carrying over a certain distance, it was also referred to as a pilgrim flask. It is doubtful, however, if a flask made from such fragile material as porcelain was ever used by pilgrims, and many other moon flasks do not have handles at all (see Plates 13 and 14). Early flasks and other large and heavily potted vessels were frequently made without foot-rings.

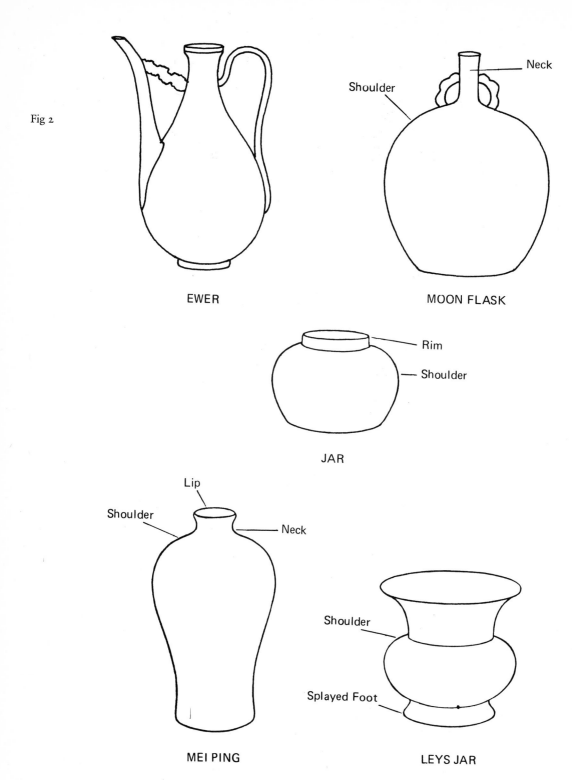

Fig 2

EWER

MOON FLASK

JAR

MEI PING

LEYS JAR

Jars

Jars are also among the most common of ceramic vessels (Fig 2), and were inevitably produced in a wide variety of shapes. Some, like the *cha-tou* or leys jar or *kuan* or storage jar, were made for specific purposes, but others, made in many different shapes, do not appear to have been intended for any particular purpose. As with such vessels as ewers and flasks, which are rounded in shape and clearly strongly potted, the main part of the jar is somewhat predictably referred to as the 'body'. Like similar flasks and ewers, early jars were often potted without a foot-ring.

Plum blossom vases

Mei-p'ing or 'plum blossom' vases (Fig 2) were first included in the Chinese potter's repertoire in the tenth century and have remained very popular ever since, though the shape, particularly around the neck and the tapering of the body, has varied very considerably over the years. They were originally intended, as the name implies, to contain sprigs of plum blossom around Chinese New Year and in early spring. It is fairly rare to find the early examples, ie those made before the beginning of the fifteenth century, potted with foot-rings.

Leys jars

Leys or *cha-tou* jars (Fig 2) first appeared in the early fifteenth century and have remained very popular ever since. This type of jar always has the same characteristics—a widely flaring lip and splayed foot—and is said to have been made in the shape of a grain measure but was in fact commonly used as a spittoon or waste jar.

Bottle vases

Bottle or *yu-hu-ch'un-p'ing* vases are made in the shape of a pear (Fig 3). This is a form that first appeared in Chinese ceramics in the T'ang dynasty and, with certain variations, has remained very popular ever since. Bottle vases are normally potted with foot-rings.

Double gourd flasks

'Double gourd' flasks or *hu lu p'ing* first appeared in the Sung dynasty and have been fairly popular ever since. The term is really a misnomer, for in fact these flasks are modelled on the shape of a perfectly normal gourd. Like the moon flask with loop handles illustrated in Fig 2, the double gourd flask is sometimes referred to as a pilgrim flask, but again it is scarcely likely to have been carried by real pilgrims. Although Sung double gourd flasks were normally potted without a foot-ring, in the form illustrated here (Fig 3), they usually have them.

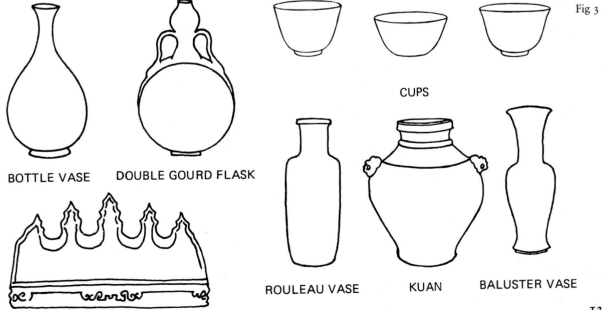

Fig 3

CUPS

BOTTLE VASE DOUBLE GOURD FLASK

ROULEAU VASE KUAN BALUSTER VASE

PEN REST

Cups

Cups are clearly also among the commonest of ceramic forms (Fig 3) and are found in all periods. Some of the earliest examples, ie those made during the fourteenth century, and also some rougher examples of provincial wares lack foot-rings, but the vast majority do have them, and in the eighteenth century they were very thin and finely potted.

Rouleau vases

Rouleau vases (Fig 3) were particularly popular during the K'ang-hsi reign in the seventeenth century and also during the nineteenth century, when a number of copies of K'ang-hsi wares were made. Some of these vases measure nearly as much as 3ft in height.

Baluster vases

Baluster or *yen-yen* vases (Fig 3) were also first made during the seventeenth century and continued to be popular throughout the Ch'ing dynasty. They are seldom as tall as many *rouleau* vases, but examples of nearly 2ft in height are not uncommon.

Pen rests

Pen rests (Fig 3) are not very frequently found among the wares of any period, but, when decorated in underglaze blue, are more commonly associated with the Moslem wares of the Chêng-tê period than with any other (see Plate 32). The rest is an ornamental stand for pens or brushes made in the form of five mountain peaks, possibly representing the Five Sacred Mountains of China, with the highest peak in the centre and the others diminishing in size on either side. Pen rests are not made with foot-rings.

Food storage jars

Kuans or food storage jars are another popular form, commonly made in all periods (Fig 3). They can vary in size quite considerably, some being quite small; the larger variety, often measuring as much as 18in in height, are more commonly found among fourteenth-century wares than those of any other period (see Colour Plate II and Plate 4).

Slip

The reader will find, particularly in the early chapters of this book, that many of the wares are described as showing 'slip' decoration or sometimes as being coated with 'slip'. This may be a term that he is not familiar with. As will be described in greater detail in Appendix A, slip is a thin coating of porcelain paste and water mixed to the consistency of cream. It was frequently used as a coating to conceal the blemishes in the body of an unfired piece of porcelain or else to cover the join where two sections of a jar or vase had been luted together. Sometimes, too, decoration was moulded in it (see Plate 1), for it was clearly very much softer than the paste of a vessel and so distinctly easier to work in.

A note on pronunciation

The pronunciation of Chinese words may at the outset appear to present some

1 Yüan dynasty stemcup decorated on the outside with a dragon, the same design moulded in slip in the interior, and the inside of the rim decorated with a freely drawn classic scroll. (Height: 12.7cm)

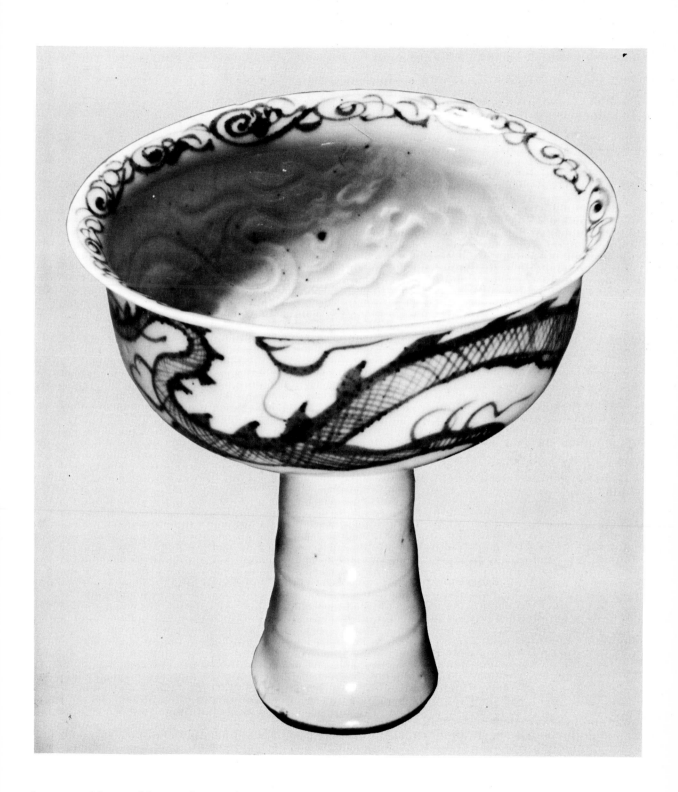

insuperable problems, for with Chinese we are dealing with a language system that is totally different from ours. While, however, we cannot pretend to offer anything resembling a comprehensive survey of the rules for pronunciation here, the following selection of approximate sound equivalents should help.

Initial consonants

ch (before i or u), as 'j', though without the voiced effect, in 'jam'.
ch (before a, e or o), as 'dr', though without the voiced effect, in 'draw'.
ch' (before i or u), as 'ch', though rather stronger, in 'cheese'.
ch' (before a, e or o), as 'tr', though rather stronger, in 'tree' (the tongue should be curled back and the lips retracted, but without lip action).
hs, as 'sh', but a sound made rather more to the front of the mouth, as in 'sheen'.
j, as 'r' in 'run' (the tongue should be curled back and the lips retracted, but without lip action).
k, as 'k' in 'sky' (American pronunciation).
k', as 'k', though rather stronger, in 'king'.
p, as 'p', though rather softer, in 'spray' (American pronunciation).
p', as 'p' in 'petal'.
t, as 't', though rather softer, in 'stem'.
t', as 't' in 'tea'.
ts (before a, e, o or u), as 'ds' in 'loads of'.
ts' (before a, e, o or u), as 'ts' in 'lots of'.
tz (before u), has the same value as *ts*.
tz' (before u), has the same value as *ts'*.

Vowels

a, as 'a' in 'father'.
ê, as 'u', though rather longer, in 'us'.
eh or *e*, as 'eah' in the slang word 'yeah'.
i, as the French 'i' in 'petit'.
ih, has the same quality as *j*, but is vocalised.
o, after the gutterals *k*, *k'* and *h* and as a separate syllable by itself is like *e*, but after other consonants it is like the diphthong *ou*.
u, as 'u' in 'rule'.
ü as the French 'u' in 'tu'.

Diphthongs

ai, as 'ai' in 'aisle'.
an, as 'arn' in the British pronunciation of 'barn'.
ang, as a nasalised 'an', but without the hard 'g' ending.
ao, as 'ow' in 'cow'.
ên, as 'en' in 'open'.
êng, as a nasalised 'en', but without the hard 'g' ending.
ien, as 'yen', the Japanese currency.
ou, as 'ou' in 'although'.
ua, as the French 'oi' in 'oie'.
uei, as 'way'.
un, as 'oon' in 'noon'.
ung, as a nasalised 'un', but without the hard 'g' ending.
yu, as 'yeo' in 'yeoman'.

1 Origins: the Fourteenth Century

The beginnings of blue and white are still shrouded in mystery, and no one can say with certainty when it was first produced. We do know, however, that it was fairly common by the middle of the fourteenth century, but how long before that it had been made is not at all clear. Chinese sources, moreover, can give us little help in this direction, for the two main histories of Chinese pottery and porcelain, the *T'ao shu* and the *T'ao lu*, which were published in the eighteenth century, are surprisingly silent on the subject. Rather more significantly, the *T'ao-chi-lueh*, published in 1322, does not mention it at all, though it is very likely that some blue and white had been produced by that time. We know that cobalt glazes had been used during the T'ang dynasty, but during the rule of the more conservative and inward-looking Sung dynasty Chinese taste favoured the muted glazes of jade-like depth of the superb monochrome wares that were produced during that period. The Sung, however, were defeated and replaced by the foreign Mongol or Yüan dynasty that Kublai Khan founded in 1279, and from then onwards for rather over a century the Chinese again had access to imported cobalt blue from Persia. It is therefore very likely that the Chinese potters, who we know copied some of the Middle Eastern ceramic forms, also turned to decorating their wares with cobalt blue. Marco Polo, however, who left China in 1292, does not refer to Chinese porcelain at all, though he was a keen observer and waxed enthusiastic over Chinese silks and embroideries. We may therefore assume that the first blue and white porcelain was produced either right at the end of the thirteenth or else very early in the fourteenth century.[1]

Whenever it first appeared, the production of blue and white represented a complete break-away from the Chinese taste of the Sung dynasty, and so we can well imagine that the transition came slowly and was by no means popular at first with the more conservatively minded of the Chinese. Some fourteenth-century writers refer to it as vulgar and garish. It should, moreover, be remembered that no new type of porcelain can appear suddenly; it must come by a process of evolution, and the very potters who produce a new type have probably been brought up in the tradition of the earlier wares. So we will briefly consider those precursors of blue and white.

The most prominent of these is the only porcelain ever to be made to imperial order during the Yüan dynasty. It was also made at Ching-te Chên, and is a bluish-white ware made for the palace and decorated in slip with the characters *shu-fu* (Privy Council—see Fig 13L, p. 139), by which name it is known. It sometimes had other moulded decoration. The relation between the two types of porcelain can clearly be seen in the stemcup illustrated in Plate 1 and the small bowl in Plate 2B. The stemcup is decorated on the exterior with a serpentine dragon painted in underglaze blue and another in the interior moulded in slip. The character 'precious' has also been moulded in slip on the base, and this, together with the moulded dragon, clearly indicates that it was modelled on an earlier *shu-fu* type. Though the small bowl bears none of the slip decoration that is characteristic of *shu-fu* ware, it is identical in shape to a fairly common type that is frequently decorated in the interior with a moulded dragon and sometimes with the *shu-fu* characters.

The obvious question now to ask is where the potters got the idea of decorating their wares with underglaze painting. The answer to this may in part be from the Persian potters who had been decorating their earthenware vessels with underglaze blue since the tenth century, but because the decoration is so wholly Chinese in character, it would be unwise to assume that this is the complete answer. The Sung, as we have noted, favoured the magnificent monochromes that were produced during that period, but the existence of some stoutly potted stoneware jars known as *tz'u chou* ware—decorated with freely drawn floral motifs in brown or black under a creamy glaze and made first in Hopei Province during the Northern Sung dynasty and later at Chi-chou in Kiangsi—suggests that even then new influences were at work. Much of the earliest blue and white is decorated with floral motifs very similar to those found on *tz'u chou* ware made in Chi-chou, which appears to suggest that these fairly primitive motifs, which had been known for over a century, were popular enough to be copied in the new genre.

A further example of the transitional stage can be seen in the bluish-white glaze of many of the earliest blue and white wares. This is known as *ch'ing pai* (bluish-white) or *ying ch'ing* (shadow

2 Yüan dynasty wares (*left to right*):
A Cuboid water jar decorated on the sides with sprays of blackberry lily, chrysanthemum and two varieties of peony, and on the gently sloping shoulders with freely drawn cloud scrolls. (Height: 7.6cm)
B Bowl of traditional *shu-fu* shape decorated with a freely drawn floral scroll on the outside and a classic scroll on the inside of the rim. (Diameter: 11.5cm)

C Jarlet with lotus-shaped lid, decorated with a blackberry lily scroll. (Height: 6.4cm)
Vessels of types A and C were frequently exported to Southeast Asia.

blue), though the latter is merely a modern term frequently used by dealers. Ch'ing pai wares had been produced in and around Ching-te Chên during the Sung dynasty, but were not greatly appreciated; they were also made fairly extensively during the Yüan and early Ming dynasties. It is not surprising, therefore, that the white of many of the early blue and white wares also shows the same characteristic bluish cast. We may therefore consider the new genre decorated under the glaze in the *tz'u chou* style and covered with the familiar *ch'ing pai* glaze as a further development of types that had been produced for several generations before.

Many of the earliest examples of blue and white take the form of small water pots (Plate 2A), which are fitted with small loops or 'ears' so that they could be hung from a scribe's belt. Such pieces have a non-Chinese connotation and resemble more the small water jars that were carried by the nomadic people of the Middle East. It is not surprising that this should be so, for the Mongol Yüan dynasty of China was closely related to the more westerly Mongols of central Asia and, as has already been noted, Chinese potters sometimes imitated the shapes of Middle Eastern wares, though they always decorated them in the Chinese taste. Not all these wares, however, are modelled on Middle Eastern shapes,

for there are also a number of small vessels made for everyday domestic use that are wholly Chinese in character. These frequently take the form of small storage jars or *kuans* fitted with characteristically Chinese lotus-leaf lids (Plate 2c) or else small ewers in the typically Chinese shape of the double gourd.

The clay used for making these early wares, like that frequently used in a number of provincial kilns later in the Ming period, often contained impurities that caused it to burn a reddish-brown where it was not wholly covered by the glaze when the porcelain was being fired. The manufacture of porcelain then, unlike that of earthenware and stoneware vessels, was still in its infancy, so that the techniques for purifying the paste were not yet fully developed. The cobalt blue used for decoration was not wholly satisfactory either, for it could behave in a variety of different ways when the porcelain was being fired; depending on the varying conditions in the kiln it could sometimes turn out a dullish grey or even almost black, and at other times a pure ultramarine blue (see Appendix A). By the middle of the century, however, the potters were able to produce more sophisticated wares and to control the behaviour of the blue to a much greater extent.

In 1351 two vases (Plate 3) that are now in the

19

3 One of the two 'David' vases made for presentation to a temple and inscribed to the effect that it was made in 1351. The main decoration is a four-clawed dragon pursuing a pearl (see Appendix B, Nos 7 and 36), and around the foot are auspicious symbols surmounted by a peony scroll. (Height: 63.3cm)

4 *Kuan*, Yüan dynasty, decorated in very dark blue with mandarin ducks swimming amid lotuses and waterweeds. (Height: 48cm)

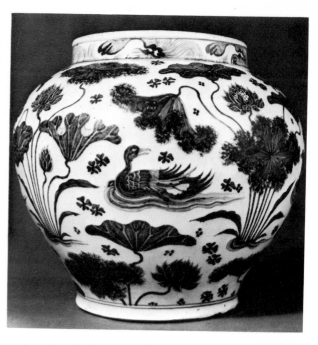

Another indication that the potter was now in full control of his materials is to be found in the stemmed bowl illustrated in Colour Plate I. This bowl, which is clearly of the same 'family' as the David vases and can therefore be attributed to a similar date, is very finely potted and the blue is rich and dark. It is decorated in the interior with a pair of mandrake ducks, the symbol of connubial bliss, swimming amid lotuses and other water plants. The exterior shows scrolling lotuses and spiky leaves, so characteristic of many wares of the period, and the rim carries the popular classic scroll that recurs on many other fourteenth- and fifteenth-century wares.

Percival David Foundation at London University were made for presentation to a temple. These are extremely important pieces, for they are the only fully documented wares of the fourteenth century extant, and so enable us to identify a number of similar pieces that were probably made about the same time. Tall, slender and well decorated, they represent a far higher degree of skill on the part of the potters than any of the other wares so far considered that are normally attributed to the first half of the fourteenth century. It is clear that by this time the potters were able to handle their new medium with considerable skill, so that the two vases can be considered the first true milestone in the history of blue and white.

While some Yüan potters chose to decorate their porcelain in underglaze blue, others experimented with decoration in underglaze copper oxide. At best this produced a bright cherry-red colour, but the copper proved to be far harder to control than the cobalt, and often came out of the kiln a more russet colour and sometimes even a rather ugly brown. The colour also had a distressing tendency to run, which, added to its other shortcomings, made it a much less satisfactory material to work with and so was soon discontinued. It was, however, sometimes used in conjunction with cobalt blue, and in the large *kuan* now in the Percival David Foundation (Colour Plate II) we have an excellent example of brilliant cobalt blue and the bright cherry-red of

the copper oxide. This jar is one of the three extant. (The second, which has a lid, is in China, while the third, which for many years served as an umbrella stand in a European household, is now in a Japanese collection.) It is particularly interesting, for the beading that surrounds the skilfully moulded floral panels is clearly based on similar beading that can be found on Middle Eastern metalwork. This jar can therefore be considered yet another example of an early blue and white ware based on an earlier Middle Eastern prototype. It also clearly indicates the rejection of the formal style of the delicately potted wares of the Sung dynasty and a groping towards the forcefulness and naturalism of the early Ming pieces.

This increasing forcefulness can again be seen in the massive *kuan* illustrated in Plate 4. Heavily potted, it was clearly intended for robust use and is typical of many such storage jars, which were exported to the Middle and Near East at this time. The dark blue is boldly applied and, as is typical of fourteenth- and fifteenth-century wares, shows signs of being 'heaped and piled'. This was but to be expected, for the potters had difficulty in grinding the imported cobalt, and so one frequently finds particles of unground cobalt at the end of each brush stroke. Where these particles appear to be heavily applied, they frequently burst through the glaze and formed minute rust spots on the body of the piece in question. The glaze, however, unlike the bluish-white of the earlier *ch'ing pai*, is milky white and of slightly uneven texture, forming what is frequently called an 'orange peel' effect. Examination under a powerful lens will reveal myriads of bubbles in the glaze, which cause this effect. The base of this jar, like all other vessels made in the fourteenth and early fifteenth centuries, is unglazed.

The Yüan dynasty, never loved by the native Chinese, showed signs of decline in power even immediately after the death of Kublai Khan at the end of the thirteenth century, and in 1325 the first of a series of insurrections broke out. It is not clear how far these were directed against the Mongols or how far the leaders were battling against each other, but by 1368 the might of the dynasty had been completely destroyed and all but one of the insurrectionists eliminated. The victor was one Chu Yuan-chang, who, though he had sprung from humble stock, was able to topple the last remaining remnants of the foreign dynasty. He then founded his own dynasty, the Ming, and ascended the throne as emperor, taking the name Hung-wu as his reign title. His task was to restore order throughout the empire, which he did with ruthless despotism, and to ensure that his dynasty was firmly established.

With the re-emergence of a native Chinese family as the ruling dynasty, the political failure of the Sung was well remembered and new influences were soon at work to ensure that their mistakes were not repeated. The empire during Sung times had been introvert and constantly on the defensive against barbarian incursions. The Ming, on the other hand, at least in their early years, were sure of themselves, for the foreign invaders had at last been defeated and ousted. Rather than reviving Sung traditions, therefore, they looked back for inspiration to the T'ang dynasty, which had also been confident and at the same time ready to learn from its neighbours. In these circumstances it is not surprising that the ceramic styles of the Yüan were allowed to survive and became increasingly popular. As has already been noted, some of the more conservatively-minded of the Chinese may still have had reservations about the more garish blue and white decoration, but in 1388 Ts'ao Chao, writing in the *Ko-ku-yao-lun*, was able to report: 'At the present time the best porcelain made in Ching-te Chên is white and brilliant. There are also cups decorated in blue-black or gold which are greatly admired.'[2] It is therefore clear that while the superb *t'o t'ai* or 'sweet white' wares that today are most frequently associated with the succeeding reign were the most popular, others decorated in 'blue-black' or blue and white had at last gained acceptance.

The vigour and naturalism that began to be found in late Yüan decoration continued unabated in the new reign, and new forms of porcelain were also made. These included not only the large *kuans* or storage jars, such as that illustrated in Plate 4, but also *mei-p'ing* or 'plum blossom' vases (Plate 9) and very large dishes, some of which had delicately foliated rims (Plates 5 and 7). The body of these wares was frequently coated with slip or an opaque glaze to cover any impurities that might be found in the paste, for it was still impossible to eliminate them, and the decoration was painted on to it before the vessel was

5 Large dish made for the Persian market, early Ming dynasty, decorated in the centre with a fish swimming in eel grass and other waterweeds, around the cavetto with a lotus scroll and on the flattened foliated rim with a diamond diaper border. (Diameter: 60.5cm)

glazed and fired at a very high temperature. The potters still had difficulty in controlling the behaviour of the blue cobalt decoration, so that it sometimes came out unsatisfactorily, but, in addition to the tones that have already been noted, we can now find vessels that are decorated in a rich and dark purplish blue.

The decoration is well and freely drawn on these wares and the motifs are teeming with flora and fauna, mythical animals and a variety of emblems—so much so that they often appear crowded and almost rigidly confined within their borders. But the general effect is vigorous and pleasing. Prominent in the motifs are strange and mythological animals known as *ch'ilins*, fish (Plate 5), ducks, aquatic plants, pheasants (Plate 6), phoenixes (Plate 7) and flowers and fruiting plants of a type that can also be seen in Plate 6.

6 Large dish, early Ming dynasty, decorated in the centre with a pair of pheasants amid flowers and grapes in a garden, a lotus scroll around the cavetto and a diamond diaper border on the flattened rim. (Diameter: 50.8cm)

The dishes shown in Plates 5 and 7 are both well and stoutly potted, as if for everyday use, and both are skilfully painted. They are alike in other ways, too, for both show the familiar fourteenth-century 'diamond diaper' design on the rim, and the cavettoes of both, like so many other four-teenth-century dishes, are decorated with lotus wreaths amid spiky leaves. The rim of the dish in Plate 7 is decorated with characteristic waves breaking to the left (those on fifteenth-century dishes always broke to the right), and they are so realistically drawn that it is almost impossible to see the spray that they throw up. This dish is of interest in other ways, too, for not only is the decoration extremely crowded but the 'white on blue' effect is typical of a number of middle and late fourteenth-century wares. This technique did not survive for long into the succeeding century,

7 Large dish, early Ming dynasty, with the decoration
reserved in white on a blue ground. The motif in the central
panel is of two phoenixes in flight amid cloud scrolls that
are surrounded by a circle of fourteen lotus panels framing
floral sprays and auspicious symbols, and an outer band of
camellia scroll; on the cavetto there are chrysanthemum
scrolls, and on the flattened foliated rim serpentine waves
breaking to the right. (Diameter: 46cm)

and so we may assume that the imported blue
cobalt that was needed in large quantities for this
form of decoration was no longer so plentiful.

As the century approached its close, there is
clear evidence, as we can see from the quotation
from the *Ko-ku-yao-lun* already referred to, that
blue and white was becoming more widely appre-
ciated. This is scarcely surprising, for while the
decoration of the wares produced at the turn of
the century might be less vigorous than that of
earlier ones, an increasing refinement is discern-
ible. The large square flask (Plate 8) in the
Victoria and Albert Museum is an excellent

example of this. A derivative of an earlier T'ang
type that showed Western influence, this flask is
very well potted and delightfully decorated with
a well drawn three-clawed dragon of ferocious
mien leaping from the waves. Such a large flask,
when filled with water, would be too heavy for a
man to carry slung from his belt, and so it is very
possible that both it and a number of similar
flasks from the Ardebil Shrine and now in the
Tehran Museum, were made for ornamental
purposes rather than practical use. Although it is
fitted with loops so as to be slung from a belt, the
excellent condition it is in clearly bears out the

9 *Mei-p'ing* vase, early Ming dynasty, decorated with a scene depicting an episode in a T'ang dynasty drama, a floral scroll on the shoulder and a band of lotus panels framing lotuses around the foot. (Height: 35.6cm)

8 Large flask, early Ming dynasty, decorated with a three-clawed dragon leaping from serpentine waves, the shoulders decorated with lappets, the neck with a classic scroll and the sides with lotus scrolls. (Height: 36.9cm). Similar flasks, which were probably made rather earlier, may be seen in the collections in Istanbul and Tehran.

view that it was never carried by a nomad, but rather used solely in the home.

A further example of this increasing refinement is to be found in the *mei-p'ing* already referred to (Plate 9). Very well potted, this vase is more delicately decorated than any of the other wares considered so far, with a touching scene from a dramatic incident set, to judge from the dress, in the T'ang period. It is, moreover, one of the finest fourteenth-century examples known to us, and so we may well assume that such delicate wares foreshadow the sophistication and refinement of those made in the following century.

2 The Classical Period: the Fifteenth Century

10 Two large dishes, early fifteenth century:
A The central design shows three melons on a vine, a floral scroll around the cavetto and waves breaking to the right on the flattened rim. (Diameter: 37cm)
B The central design shows grapes on a vine and a floral scroll around the cavetto, which is moulded to match a foliated rim decorated with a scroll of morning glory. (Diameter: 43.5cm)

When the ageing Emperor Hung-wu named his grandson his heir in 1392, his fourth son, the Prince of Yen, began actively plotting to usurp the throne. His opportunity came six years later when the old emperor died and was succeeded by a young and untried ruler. The Prince of Yen's march towards the imperial capital of Nanking was a triumphal one, and the city itself was taken and sacked in 1403. The young emperor was long thought to have perished in the devastation of his capital, but many years later, halfway through the century, a middle-aged man who had lived for many years in a monastery came out into the world and claimed to be the deposed emperor. Be that as it may, he had disappeared from history in 1403 when his uncle succeeded him and took the reign title of Yung-lo.

Despite the savagery surrounding his accession, the new emperor raised the Ming dynasty to the zenith of its power. Annam was reincorporated into the empire in 1407, Japan paid tribute, and naval expeditions sailed as far as Aden and the Somali coast. The emperor had no love for Nanking, and so moved the imperial capital to Peking, the power base of his earlier years, which he virtually rebuilt in 1421, completing the Forbidden City there a year later. During his reign, too, he introduced peace and good order; the eunuchs were kept under control and the ministers were loyal and efficient.

By the time, as has already been noted, of the manufacture of the David vases, blue and white had reached a stage in its development at which mastery of the materials had been attained and definite styles of painting established. There are no more great landmarks until the fine wares of the Hsüan-tê period came on the scene. It is not surprising, therefore, that there can be no very clear-cut distinction between the blue and white of the late fourteenth century and that of the early years of the fifteenth, though the Yung-lo period did see the development of a few new ceramic forms. The increasing refinement of the wares that we have noted in the previous chapter continued and grew apace. A. D. Brankston, a young scholar of the late 1930s who more than any other opened the eyes of the West to the wonder of the early Ming wares, wrote a few years before he died: 'In Yung-lo the lotus has budded, in Hsüan-tê the flower has opened in all its freshness, and by Ch'êng-hua the leaves begin to tremble in the breeze.'[1] It is, then, during this first reign of the new century that we can see the opening of the lotus, a foretaste of what is to come.

Among the most characteristic wares of the period are some large dishes decorated with floral and fruit motifs. They are very wide in diameter, frequently measuring as much as 43.5cm, and are heavily potted (Plate 10). Sometimes the rims are left plain and at other times delicately foliated. Like the dishes of the previous century, their bases are unglazed and they bear no reign mark. Another particularly popular motif for the central panel is a bouquet of lotus and other plants most sensitively painted and tied together with a ribbon

11 Detail of a large dish, early fifteenth century, decorated with a 'bunch of lotus' in the central panel, a floral scroll around the cavetto and a classic scroll around the rim. (Diameter: 34cm)

(Plate 11). Such dishes were frequently copied later in the century and in the following one, but the freshness and freedom of the painting was replaced by a stiffness and stylisation that betrays the results as the contrived efforts of a copyist.

These dishes, as with so many other wares of the period, vary in colour from a deep kingfisher blue to a fainter shade that sometimes gives the impression of drifting like smoke into the glaze. Typical though this is of a number of the Yung-lo wares, it would be a mistake to assume that all blue and white showing this rather smoky effect can be attributed to the period. Many of the much coarser wares made in provincial kilns much later in the century and in the one that followed also share it, and yet their decorative motifs clearly reveal that they belong to the later period. More characteristic of the blue decoration of the period, particularly on bowls and vases, is the appearance of what are commonly called 'tear drops' of cobalt and glaze that still remained molten after the rest of the glaze had solidified, and so began to run down the side of the vessel before the

opening of the hot kiln and the inrush of cold air. These 'tear drops' take the form of blackish streaks in the glaze that show where the cobalt had re-oxidised when exposed to the cold air from outside. The blue decoration also appears to show the 'heaped and piled' effect already noted in Chapter 1, for the potters still had considerable difficulty in grinding their cobalt smoothly.

A characteristic type of vessel that was also developed in the early years of the fifteenth century is the *lien-tzŭ* or 'lotus bowl', so called because it is shaped in the form of an opening lotus flower. These were mostly made in very finely potted plain white porcelain devoid of any decoration, save for delicately incised *an hua* or 'hidden' decoration. The increasing popularity of decoration in underglaze blue, however, is again evident in the delicately painted designs that are to be found on some of these bowls (Plate 12). Unlike the dishes of the period, but in common with the other bowls, the *lien-tzŭ* bowls show a well defined foot-ring that is high and cut square, and a base that has clearly been moulded by hand

12 Bowl of *lien-tzŭ* shape, also known as a 'lotus bowl', for its shape was thought to be symbolic of the opening of a lotus; early fifteenth century and characteristic of the Yung-lo period; decorated in the interior with a band of *ju-i* heads around the base, a floral scroll on the sides below a form of key fret border around the rim, and on the outside with a lotus scroll around the rim and lotuses alternating with auspicious symbols around the sides. (Diameter: 13cm)

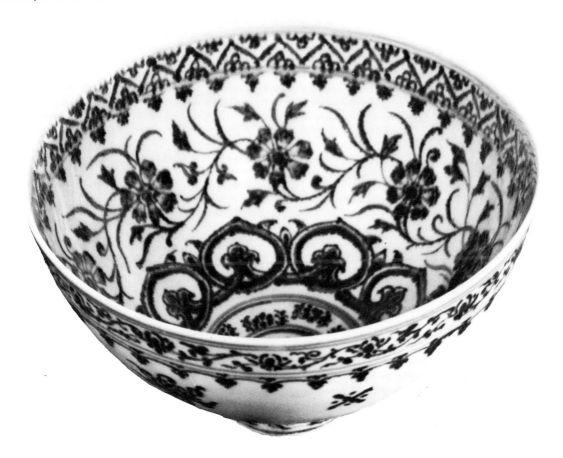

and is slightly convex when seen from underneath—one can see where the potter has pressed it down from inside with his fingers.

The early Ming, as we have already noted in the previous chapter, tended to look back beyond the failure of the Sung to the T'ang dynasty for inspiration, and were also ready to continue with the ceramic traditions of their Yüan predecessors. A late echo of an earlier T'ang type can be seen in the large 'moon flasks', so called for they were thought to resemble the full moon in shape. The example illustrated in Plate 13, which is clearly of imperial quality, is magnificently decorated with a freely drawn dragon rampant amidst lotus scrolls. Another such flask (Plate 14) in the National Palace Museum in Taiwan has bow-shaped handles attached to the narrow neck, and so could conveniently be carried over a certain distance with one's fingers coiled around the handles. This might well be a variation on a common type of flask found in the Middle East. It is attractively decorated with a landscape scene and five musicians and dancers, who appear, to

judge from their dress, to have come from north China.

Among the commonest of the Middle Eastern forms that were evidently very popular in the early years of the century is the ewer (Plate 15) with a moderately narrow neck and long spout connected to this neck by an additional support. This is also clearly a derivative of a type that was known in the Middle East as early as the ninth century. Though the shape of the vessel is wholly foreign, the decoration, as on other early wares, is entirely Chinese, as can be noted from the lotus scrolls and spiky leaves on the example illustrated. Moreover the key fret or 'thunder pattern', as it is sometimes called (see Appendix B, No. 45), which can be seen around the foot, is a motif frequently found on a number of early Chinese bronzes. Such wares, however, were unknown in China before the fourteenth century, and the author of the *Ko-ku-yao-lun* tells us 'the men of old . . . did not use ewers . . . these were first used by the Mongols. The men of China only began to use them in the Yüan dynasty.'[2]

13 Large moon flask, early fifteenth century, decorated with
a three-clawed dragon among lotus scrolls. (Height: 41.4cm)

14 Pilgrim flask, early fifteenth century, with the main
decoration depicting a group of strolling musicians, and also
decorated with stiff plantain leaves around the neck and
bands of lotus panels around the shoulders and foot.
(Height: 29.8cm)

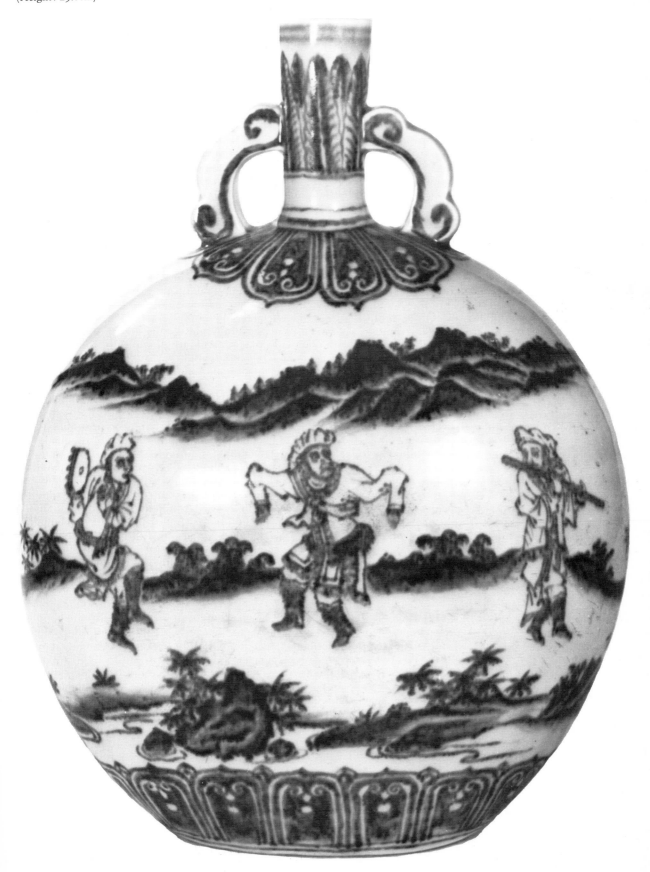

15 Ewer modelled on a Middle Eastern prototype, early fifteenth century, decorated with stiff plantain leaves around the neck, peony scrolls around the shoulders, body and spout and a band of 'thunder pattern' key fret around the foot. (Height: 50.8cm)

I Stemmed bowl, Yüan dynasty, decorated on the outside with a lotus scroll surmounting lotus panels around the base of the bowl, and a well drawn classic scroll around the rim; the interior decorated with a pair of mandrake ducks swimming amid waterweeds. (Height: 16.5cm)

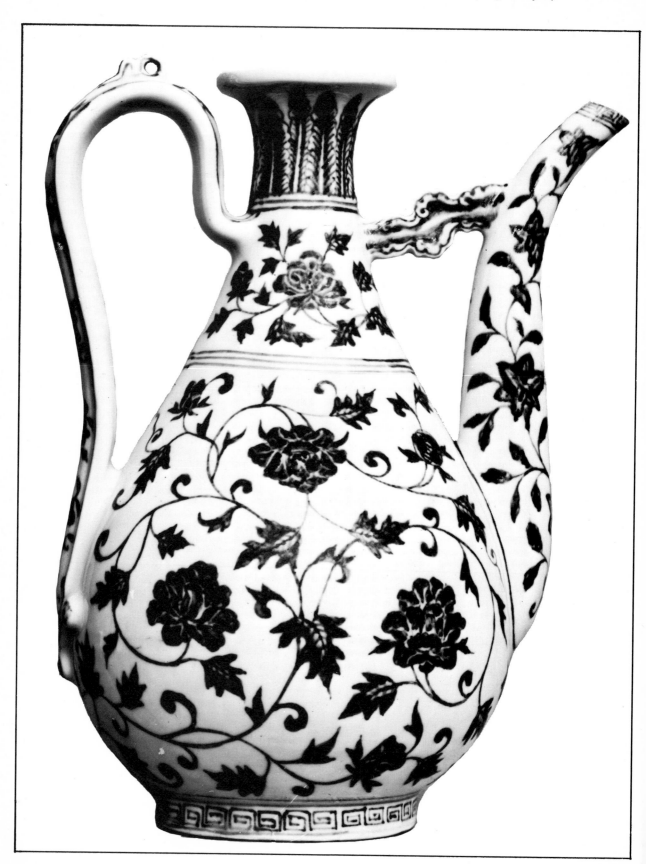

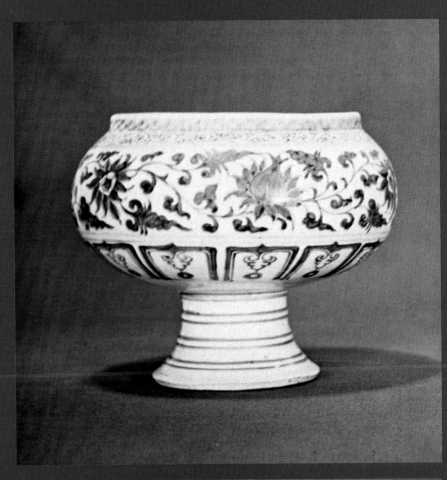

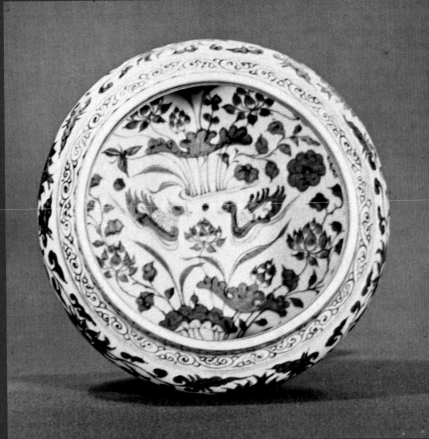

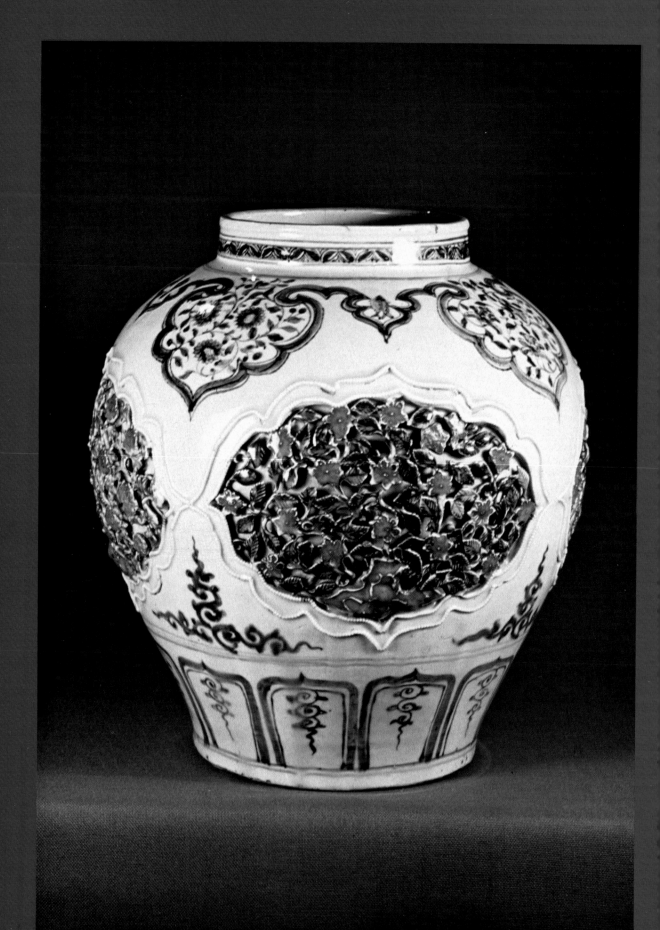

II Wine jar or *kuan*, Yüan dynasty, decorated with open-work panels framing flowers and leaves painted with underglaze cobalt and copper red, lotus panels around the foot and alternating large and small lappets on the shoulder. (Height: 83cm)

16 Stemcup, early fifteenth century, the exterior of the bowl decorated with two phoenixes flying amid lotus scrolls, which also continue as the decoration on the stem; the decoration in the centre of the interior is of two further phoenixes flying amid tight lotus scrolls. (Height: 10.5cm)

Yet another example of a loan from the Middle East can be seen in the superb pen box illustrated in Colour Plate III. The blue is as fine as any that can be found on any other early fifteenth-century ware, and the decoration, complete with panels framing sprays of chrysanthemum and a border of morning glory, is wholly Chinese in character. The shape of the box, however, is entirely foreign, and is clearly based on a similar metal pen box that had long been familiar to Persian scribes.

The stemcup (a cup or bowl set on a high foot) is one of the oldest ceramic forms in the world. It was found in ancient times in Mesopotamia and the Aegean region, and in the early Christian church was the prototype of the familiar European chalice. It had been known, too, in China for many centuries, but the example in Plate 16 is noticeably different from the one in Plate 1 that we have already considered. Here again we can see the introduction of a foreign form that has clearly been decorated in the Chinese taste. This new shape, which is frequently to be found in the delicately potted white wares of the period and again and again in the stemcups of the years that followed, is typical of what we have come to recognise as the characteristic form for the Ming stemcup. Why, we may well ask, this change in shape? The answer almost certainly lies in the fact that the design shows all the signs of being a derivative of an earlier Mediterranean and Near Eastern type that had gained acceptance in China during the Yüan dynasty, when the Middle Eastern influence was so powerful. Once again the dynamic Ming potters had looked beyond Chinese tradition for designs, but then had endowed the wares they made with a Chinese flavour by decorating them in the native tradition.

The Yung-lo reign saw not only the consolidation of the Ming dynasty and a clear recognition of China's supremacy once again in the Far East, but also the firm establishment of new ceramic forms. A more sophisticated taste in ceramics was in vogue, and the potters, supported now by increasing imperial patronage, were given the opportunity to use their new medium with all the skill that experience had taught them. Most of the blue and white porcelain usually attributed to the period bears no reign mark, and so is often merely referred to as 'early fifteenth century'. Some of it may, indeed, have been made during the following reign, that of Hsüan-tê (1426–35),

for clearly the same craftsmen were at work both before the end of one reign and after the beginning of the next. What is clear, however, is that by the time of Hsüan-tê's accession blue and white had gained true recognition and wide appreciation not only at the imperial court, but also among the scholars of the period. Generations of later potters have contrived to copy the wares of the period, and ever since they have excited the admiration and, indeed, the wonder of Chinese and Western connoisseurs alike. 'Only the mark of Hsüan-tê is excellent', wrote the author of the *Wu-tse-tsu* late in the sixteenth century; '. . . ever since that time, one hundred and fifty years ago, the price of such porcelain has been equal to that of Sung wares . . . Hsüan-tê wares are supreme not only for their fine shape and mark, but also for their colour, glaze and unrivalled drawing.' The author of the *Tsun-sheng-pa-chien* a few years later went even further in his praises: '. . . during the Hsüan-tê period potters were inspired by Heaven to produce works of subtle meaning and supreme artistry'.[3]

It is, then, for porcelain decorated with supreme artistry that we should look in the wares of the Hsüan-tê period. The dragon had long been a principal motif in Chinese art when Hsüan-tê succeeded to the throne, but it was during his reign that the skill of the potters became most apparent in depicting it, and never since have any of their successors equalled them. Of ferocious mien, the dragons appear to leap from the porcelain they are painted on, as can be seen from the brilliantly painted example on the saucer dish in Plate 17. This dish, which is exceptionally finely potted and clearly of imperial quality, also shows

17 Saucer dish, Hsüan-tê mark and period, decorated with a dragon among waves, and around the cavetto with two dragons in *an hua* slip decoration; the underside is decorated with two more dragons among waves and rocks. (Diameter: 17.8cm)

18 Fish bowl, Hsüan-tê mark and period, decorated with two scaly fish-dragons swimming through waves and beneath clouds and classic scrolls that show some deterioration from the finer styles of the fourteenth century; the six-character *nien hao* of Hsüan-tê is clearly visible on the rim. (Diameter: 56.6cm)

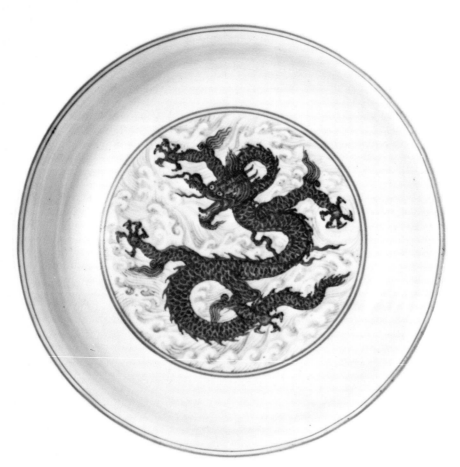

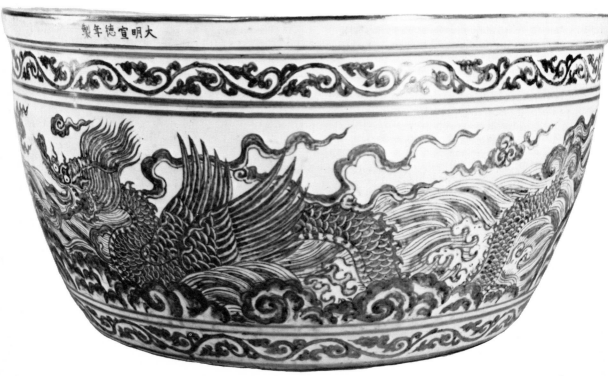

19 Saucer dish, Hsüan-tê mark and period, decorated with twin fish (see Appendix B, No 9) swimming amid lotus, eel grass and other waterweeds in the style of the fourteenth century, and serpentine waves breaking to the right on the rim. (Diameter: 20.3cm)

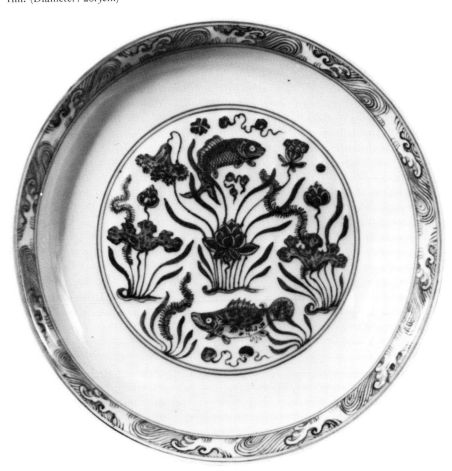

a survival of the *an hua* decoration of the Yung-lo period, for around the sides two additional dragons are incised in slip decoration. Another fine example of a Hsüan-tê dragon is the rather less common, scaly fish-dragon depicted on the sides of the bowl illustrated in Plate 18, which appears to progress through the waves with the momentum and assurance that one would expect of such a formidable beast. Very much more heavily potted than the saucer dish, the bowl in question was clearly made for robust domestic use, and the reign mark or *nien hao* of the period can be seen painted just below the lip.

Though Hsüan-tê potters showed more skill in their drawing, and the colour they used was more controlled than in the earlier wares, it would be a mistake to assume that their motifs show a complete break with those of the fourteenth century. The potter's craft was handed down from father to son, and it is more than likely that some of the Hsüan-tê potters had been at work during the later years of the Hung-wu period. It is not surprising, therefore, that we should find some

survivals from the earlier period, and such fourteenth-century motifs as scrolling lotus and aquatic scenes reappearing. The dish illustrated in Plate 19 is one such example of this return to the earlier style of decoration. As has already been noted, however, the waves on the rim of this fifteenth-century piece break to the right rather than to the left and are in general much less realistically drawn than the earlier type.

As has also been noted, it is impossible to draw a hard and fast line between the wares made at the end of the Yung-lo period and those produced in the following reign. Many dishes with plain and foliated rims of the type illustrated in Plate 10 were also made in the later period, as were *mei-p'ing* vases of the type considered in the previous chapter. These, however, are more elegant in shape and have a finely moulded neck in the place of the conical shape found in the previous century (Colour Plate V).

The earlier Ming tradition of looking outside the empire for inspiration also continued into the new reign, though it is very possible that the

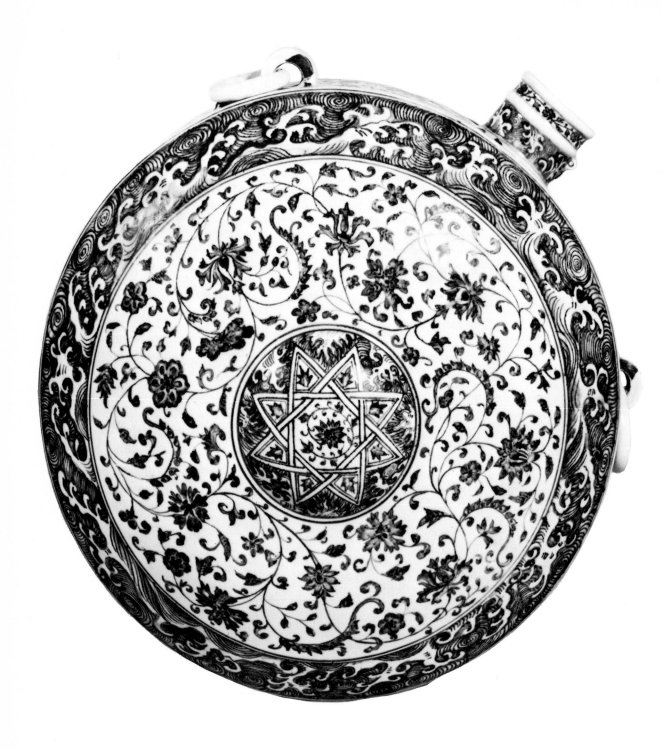

20 Pilgrim flask modelled on an earlier prototype, Hsüan-tê
period, decorated with scrolling lotus and chrysanthemum
around a geometric device framing a lotus scroll, and
serpentine waves around the perimeter and neck. (Diameter:
42cm)

21 Tankard, Hsüan-tê mark and period, modelled on a Middle Eastern prototype and decorated with feathery-petalled flowers growing on a meandering stem below a key fret design around the shoulders and arched facets, surmounted by a *fleur de lys* motif on the neck. (Height: 14cm)

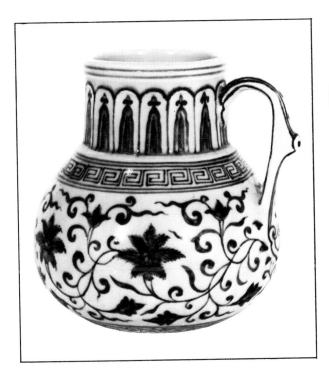

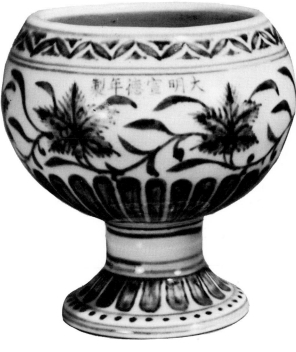

22 Stemcup, Hsüan-tê mark and period, decorated with a chevron design around the rim, floral scrolls around the bowl and petal forms that are repeated with dots around the foot; the six-character *nien hao* of Hsüan-tê is clearly visible on the bowl. (Height: 20cm)

Hsüan-tê wares that reveal Middle Eastern influence in their form are the work of a particular factory. The Freer Gallery of Art, Washington, DC, has a superb and massive flattened flask (Plate 20) and its thirteenth-century prototype.[4] The Chinese flask is magnificently decorated in the Chinese style with chrysanthemum and lotus scrolls and a geometric device that is slightly raised in the centre. Many similar flasks are decorated with the *yin-yang* (see Appendix B, No 38) device in the centre. It is very likely that this particular raised pattern replaced the hole in the prototype through which a leather peg could be fitted to attach it to a horse's saddle. It is clear, too, that the two rings on the Chinese flask and the loops on the prototype have distinctly non-Chinese nomadic connotations, and yet survived thus far into the fifteenth century, when the foreign nomadic tradition had long since been forgotten.

A further indication of the continuing foreign influence in design throughout the period can be found in the number of 'tankards' (Plate 21) that were produced. The term 'tankard' in this connection is wholly Western and somewhat misleading, for it is very likely that these vessels were in reality used for watering plants. Their shape,

23 Brush-washer, Hsüan-tê mark and period, decorated with the 'Three Friends of Winter'—pine, bamboo and prunus (see Appendix B, No 27)—above a foot-ring decorated with serpentine waves; the six-character *nien hao* of Hsüan-tê can be seen just below the rim. (Diameter: 26.5cm)

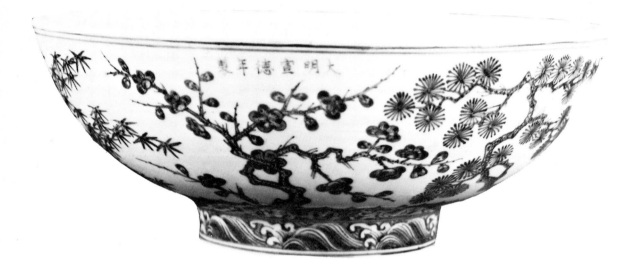

however, is based on an eighth-century Middle Eastern prototype, and is seldom found after the middle of the fifteenth century.

The unusually shaped stemcup illustrated in Plate 22 is also almost certainly the work of a particular factory, for it is wholly different from the shape (already noted in Plate 16) that is normally associated with the Ming dynasty and afterwards. Stemcups, particularly those decorated with the Eight Buddhist Emblems, were used in temples as altar utensils. They are often scratched or worn on the inside either because water was left in them and accretions of the mineral deposit remained or because ash from incense sticks fell into the bowl and was left until it could be removed only with a knife. Most stemcups in the Hsüan-tê period were used for ritual purposes, but a few others, which were normally made in the more common form already noted, were used for the much more mundane purpose of holding wine, and these were frequently decorated with mythical monsters or human figures.

Another form that is frequently seen amongst Hsüan-tê wares is that of the brush-washer (Plate 23), often decorated, as in the example illustrated, with the 'three friends'—the prunus, pine and bamboo. These are all the emblems of longevity and winter, and are also symbolic of the qualities of a gentleman and of the three religions of China, Taoism, Buddhism and Confucianism (see Appendix B, No 27). They were a particularly popular motif in the fifteenth century and were frequently depicted on saucer dishes. Though not entirely

unknown, they were but rarely seen on the wares of the centuries that followed.

It is clear that the Emperor Hsüan-tê took an active interest in the manufacture of porcelain and that his personal taste is reflected in many of the forms and decorative motifs of the period. Alongside the naturalism and vigour of the examples that we have considered so far, therefore, an immense increase in refinement is also discernible. This is nowhere better exemplified than in the superb moon flask illustrated in Colour Plate IV. It may clearly be compared to the earlier flask in Plate 13, and is not a type frequently made in the subsequent reigns of the Ming dynasty. In the eighteenth century, however, when Ch'ing potters endeavoured to copy fifteenth-century styles of painting, this motif of a bird perched on a branch was also popular (see Plate 54).

It may be that this flask can be attributed to the early years of the period, for, like earlier wares, it has no foot-ring and shows no reign mark. The fact that some Hsüan-tê wares, however, have foot-rings and others not, and that some show the six-character reign mark within a double circle on the base, while others, like the bowls illustrated in Plates 18 and 23, display it in a straight line just below the lip, and others not at all, is probably attributable to the fact that they were all made at different factories in the Ching-te Chên area. It is clear that there were a number of different factories in operation during the period, and probably only one or two of these made porcelain for presentation to the court. It is

very likely that there were others, as has already been noted, that concentrated on the production of wares modelled after Middle Eastern proto-types, and others again that turned out wares made in a variety of different ways and decorated with many different motifs.

Rather later in the reign a number of very finely potted and well decorated smaller wares that were made were intended for the scholar's table and the delectation of dilettanti. The small *mei-p'ing* that we have already noted in Colour Plate V is an example of this type of ware, and although it is decorated in the rather earlier style with floral scrolls, it bears the six-character *nien hao* of Hsüan-tê on the base and belongs either to the closing years of the reign or to the period immediately after the emperor's death.

The blue decoration of this vase, like so many other Hsüan-tê wares, clearly shows the familiar 'heaped and piled' effect already noted in the previous chapter. The earlier cobalt blue im-ported from the Middle East had been exhausted by the beginning of the fifteenth century, but tribute in the form of *su-ma-li* or *su-ni-po* cobalt was paid by Sumatra and Zanzibar during the reign, and this also produced the familiar and attractive 'Mohammedan Blue'. As with the earlier imported variety, however, the potters were still unable to prevent dark splodges of blue appearing on the decoration when their brushes were too heavily loaded with the poorly ground pigment. These were, of course, imperfections, but so characteristic of the highly esteemed Hsüan-tê wares did they become that the eigh-teenth-century potters, in their attempts to imitate fifteenth-century wares, contrived to copy them. In general their efforts are fairly easy to detect, for it is clear that the false 'heaped and piled' effect was deliberately applied, and they could not reproduce the effects of re-oxidisation of the cobalt that often took place on fifteenth-century wares (see Appendix A).

Despite its imperfections, the blue of Hsüan-tê wares is rich, brilliant and dark in tone and has always been greatly admired. It also gives the impression of being suspended in the glaze and does not cling closely to the body; the potters used to apply a primary coat of thin slip to the body to prepare the surface for the decoration, so that the blue is enclosed between two coats of glaze and has a pleasing lustrous quality.

The glaze itself is thick and rich and, when examined under a powerful lens, shows minute bubbles of the type already noted in fourteenth-century wares. These cause the rather uneven surface that has been compared to orange peel. Eighteenth-century potters had considerably more success in their attempts to simulate this effect than to imitate fifteenth-century blue deco-ration, and so collectors should be on their guard against assuming that wares with a slightly dimpled surface can confidently be attributed to the period.

After the death of Hsüan-tê in 1435 the court and government of his son, Cheng T'ung, was dominated by the eunuch Wang Chen, who led his emperor into a disastrous military campaign against the Western Mongols, and they ambushed and captured the emperor in 1449. For the next eight years his brother, Ching T'ai, reigned as interim emperor, but when Ching T'ai died in 1457, Cheng T'ung was restored, and continued to reign with the title T'ien-shun until he died in 1464. It is not surprising, therefore, that during this period of decline and confusion, known in ceramic history as the 'Interregnum', the produc-tion of porcelain of imperial quality also suffered severely. Indeed, it has been suggested that the imperial kilns stopped production altogether, and we know of no porcelain bearing the imperial *nien hao* produced during this period. However, as there is a good deal of very fine cloisonné ware that can be attributed to the middle of the century, it is clear that artistic work had by no means fallen completely into abeyance. Moreover, as there is substantially more porcelain bearing the Hsüan-tê reign mark than one would imagine would normally be produced in a brief reign of nine years, it has been suggested that some of this was in fact produced during the Interregnum that followed.

While some authorities have disputed this,[5] it is not at all surprising that some of the porcelain produced in private kilns during this period should bear the Hsüan-tê mark. It is a mark, as has already been noted, that has always been very highly regarded, and the decoration of the period has always been treated with considerable awe. Moreover it is also very possible that many of the potters during the fifteenth century were illiterate, and so would copy a mark of particularly fine calligraphy along with the main decorative motif

24 Covered jar with knobbed lid, Ch'êng-hua mark and period, the jar decorated all over with chrysanthemum and other plants, and the lid with floral sprays and a petal pattern around the knob. (Height: 14cm)

25 'Palace' bowl, Ch'êng-hua mark and period, decorated inside and out with lily scrolls. (Diameter: 14.9cm)

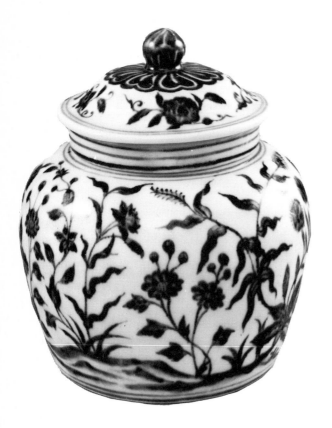

without really appreciating its full implication. We know, indeed, that the mark and style of the Hsüan-tê period were frequently copied by later generations of potters, and so far from branding this as a deliberate attempt to deceive, it should be considered more as a mark of respect for wares that have always been awarded pride of place.

Order was restored to the empire with the accession in 1465 of T'ien-shun's son, Ch'êng-hua, and it appears that shortly afterwards the imperial kilns started production again. The young emperor was infatuated with his consort, Wan Kuei-fei, and died shortly after her in 1487 of a broken heart. Like his grandfather, he placed his trust in his ministers, but with less happy results. They and the imperial eunuchs dominated the administration of the empire, and the emperor was content to leave it in their hands.

The porcelain of the period, however, is exceptionally fine, and has always been considered the main rival to that of Hsüan-tê. No blue and white was decorated with greater finesse or more

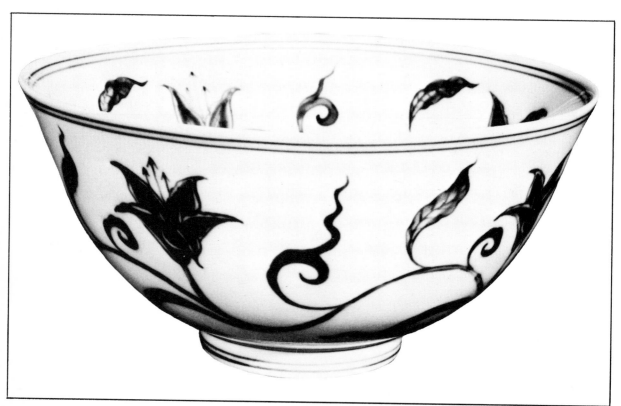

delicacy during the whole of the Ming dynasty. 'Never before was the hand of the Ming potter more controlled or that of the Ming painter more sure', Dr John Pope, for many years Director of the Freer Gallery of Art in Washington, DC, has written. 'It was a point in the history of the potter's art where there was nowhere to go but down.'[6] It may be that the Ch'êng-hua wares lack the strength and vitality of those of the Hsüan-tê period, but what they lack in this respect they make up for in even greater refinement and delicacy.

This growth in refinement probably reflected the taste of the dilettante emperor, and so the wares of the period frequently appear to be play-things made for his and his consort's amusement rather than for ritual use. The small jar illustrated in Plate 24, which is clearly of imperial quality, exemplifies a vast increase in refinement after the unhappy years of the Interregnum, and the floral decoration with which it is painted is indicative of the sensitivity of the period. Another form that was frequently used in and around the court can be seen in the 'palace bowls' of the period, which were often decorated with lily scrolls (Plate 25). This motif had not been seen before, but other palace bowls were decorated in an earlier style with fruiting melons (Plate 26) and lotus scrolls. Very much rarer are the stemcups of the period, which are decorated with wholly non-Buddhist motifs and were intended for wine rather than ritual purposes. All these vessels are thinly potted from a clay that is seldom dead white but more the creamy white of ivory in tone. This is particularly noticeable near the foot-ring, where the glaze is thinner. When correctly fired, this glaze is in general very much thinner than that of Hsüan–tê wares, and is perfectly smooth and lustrous.

Although the refinement and delicate potting of the three examples illustrated so far are typical of the period, the nature of the cobalt blue is somewhat atypical of what is normally considered characteristic of the Ch'êng-hua reign. The reason is that they can almost certainly be attributed to the early years of the period, and, as we have already seen, it would be a mistake to draw an absolute distinction between the porcelain of any one period and the following one. The blue cobalt that we have come to identify with the Ch'êng-hua period is noticeably different from

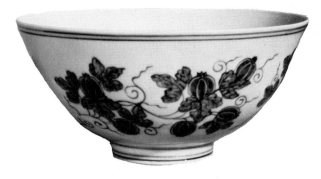

26 'Palace' bowl, Ch'êng-hua mark and period, decorated with large sprays of fruiting melon on a vine. (Diameter: 15.3cm)

27 Saucer dish, Ch'êng-hua mark and period, decorated with the 'Three Friends of Winter'—pine, bamboo and prunus (see Appendix B, No 27)—*ling-chih* fungus at the foot of the pine and a curiously shaped rock. (Diameter: 18cm)

that of the previous reigns, for the supplies of *su-ni-po* cobalt that had last been imported in 1434 were virtually exhausted by the beginning of the period. The Chinese were therefore compelled to rely on local cobalt, and though this was in many ways far less satisfactory than the imported variety, it is clear that the potters found it very much easier to grind and prepare. The result is that the 'heaped and piled' effect that can be seen on all the earlier wares has been replaced by a much paler tone of blue. It is clear, too, that with this more finely ground cobalt the potters were able first to outline their decoration and then fill it in with a paler wash. Though this meant that the free bold strokes of the earlier potters had gone for ever, the more delicate 'outline and wash' technique was entirely in keeping with the thinner potting, lighter glaze and more delicate form of decoration that is typical of the period. The potters of the eighteenth century found this more effeminate style of decoration far easier to imitate than the 'heaped and piled' effect, and so they copied it extensively.

A superb example of the new technique can be seen in the saucer dish illustrated in Plate 27, which is in the British Museum. The central motif in this dish is again of the Three Friends, though now there is a new feature—a stylised rock that was absent in the bowl illustrated in Plate 23 and in earlier representations of the motif. It was to remain thenceforward, but when it is found in nineteenth-century portrayals, it is so changed that it makes the scene reminiscent of a Victorian grotto.

Another example of the new 'outline and wash' technique is to be seen in the saucer dish illustrated in Plate 28, which is decorated with the Eight Buddhist Emblems (see Appendix B, No 31). The effect of the technique is particularly apparent in the painting of the Wheel or *Chakra* set amid scrolling lotus, though it appears that the potters had difficulty in painting the remaining seven of the emblems around the cavetto, for even the finely ground pigment had to be firmly applied if it was not to run down.

The blue of the reign mark, like that of the main decoration, is watery and thinly applied, and though the calligraphy is not excellent, the characters are well applied and written with confidence. As is usual with the *nien hao* of other periods, the characters are normally surrounded by a double circle, though occasionally this is replaced by a double rectangle. With a few exceptions, all the marks of the period appear to have been executed by the same hand. This is not surprising when we consider the comparatively few marked pieces of blue and white that are known to exist.

It was during the Ch'eng-hua reign that underglaze blue decoration was first used as an outline for enamels, showing that the potters of the period fully appreciated the uses the finely ground cobalt could be put to. After the outlines had been finely etched in blue on the body of the wares, they were glazed and fired at a high temperature. *Tou-t'sai*—'contrasting' or 'opposing' coloured enamels—were then applied over the glaze before the porcelain was fired a second time at a much lower temperature. The enamels, which are in a very wide range of colours and tones, almost always tend to obscure the underglaze outlines, although the general effect is very pleasing.

The Emperor Ch'eng-hua died in 1487, mourning for his consort, and was succeeded by his son, a youth of no more than seventeen, who took the reign title of Hung-chih. His reign was undistinguished, and though it is true to say that underglaze blue-decorated porcelain continued in the traditions of the previous reign, yellow glazed wares were more in favour and received a greater share of the imperial patronage.

The most important example of Hung-chih blue and white porcelain is a large temple vase now in the Percival David Foundation at London University (Plate 29). This bears an inscription on the rim to the effect that it was donated to the Kuan-wang Temple in Peking, and was 'Made on a lucky day in the fifth month of the ninth year of the Hung-chih period [1496] by the disciple Ch'eng Ts'un-erh'.[7] The blue decoration of this particular vase is singularly dark, but many similar vases and other wares of the period show a distinctly greyish tinge in the blue. This was due to the rather poor quality of the local cobalt used, to the conditions in the kiln during the firing and to the thickness of the glaze. On many Hung-chih wares the glaze was particularly thick, and has the appearance of a layer of treacle on the body. Except where it has managed to ooze through accidental holes in this glaze, the blue decoration appears to be distinctly greyish, and in these spots it is frequently the bright blue that was

28 Saucer dish, Ch'êng-hua mark and period, decorated
with the Eight Buddhist Emblems (see Appendix B, No. 31)
among formalised lotus scrolls, with the *chakra* in the
central field and the remaining seven emblems around the
cavetto. (Diameter: 19.2cm)

29 Temple vase, Hung-chih period, decorated around the body with lotus scrolls and a wave pattern with rocks and bamboos around the foot, rather crowded lappets around the shoulders and stiff plantain leaves around the neck; a dedicatory inscription just below the rim includes a date that corresponds with 20 June 1496. (Height: 62.1cm)

30 Dish, Hung-chih mark and period, decorated in attempted imitation of the Hsüan-tê style, with a five-clawed dragon amid lotus scrolls in the central field and eight floral medallions around the cavetto; the underside shows two dragons amid arabesques of passion flowers. (Diameter: 26.2cm)

31 Stemcup, Hung-chih period, decorated in the Hsüan-tê style and showing the six-character Hsüan-tê reign mark on the base, decorated around the exterior of the cup with ten fruiting sprays that each correspond with the ten moulded lobes of the cup, and ten corresponding lotus panels at the base of the cup where it meets the stem. (Diameter: 16.6cm)

intended. We may therefore assume that the excessively thick glaze had the effect of smothering the blue decoration to such an extent that it prevented the reduction of the cobalt oxide to the bright blue of cobalt silicate.

We should not assume, however, that a greyish tinge to the blue is necessarily characteristic of all Hung-chih wares, for at other times the potters were able to use a purer cobalt and to ensure that the glaze was not excessively thick. One such example of a far better shade of blue can be seen in the saucer dish illustrated in Plate 30, which is decorated with a dragon among lotus scrolls. The dragon itself deserves mention, for it is indicative of the loss of mastery in drawing of the period, and, unlike the dragons of the Hsüan-tê period already noted, appears almost ludicrously out of its element. This decoration in general, like so much of that found on Hung-chih wares, shows all the signs of having been hastily executed, and lacks the subtlety of the previous reigns. The potting of the dish, however, also like so many of the wares of the period, is delicate and the porcelain translucent and resonant.

Many of the finest Hung-chih wares are unmarked and presumably, therefore, were made in private kilns. Though clearly not intended for use at court, they are often of a very fine standard and must be considered not far short of what is generally considered imperial quality. There was also a tendency to look back to the Hsüan-tê period for inspiration, and though the potters attempted to imitate the earlier style, they seldom had the skill to match their predecessors. The dragon on the dish illustrated is clearly based on a Hsüan-tê prototype, but falls far short in achievement. The stemcup in Plate 31, however, is of a quite different order. Extremely delicately potted with a gently flaring rim, ten lobes around the bowl and a fluted stem, it is obviously a late echo of a similar bowl of the Hsüan-tê period now in the National Palace Museum in Taiwan. As if to complete the imitation, the *nien hao* of Hsüan-tê is to be found in the interior of the bowl. One should not assume, as we have already noted, that this is a deliberate 'fake'; this late use of a venerated mark should be considered rather as a tribute to the potters of the earlier period.

3 Late Ming Wares:
the Sixteenth Century

32 Pen rest in the form of five mountain peaks, Chêng-tê mark and period, decorated with 'Mohammedan scrolls' and Persian inscriptions within rectangular panels on both sides of the highest peak that together read 'pen rest'. (Height: 22.5cm)

When Hung-chih died in 1505, he was succeeded by his son, then a boy of fourteen, who took the reign title of Chêng-tê. The young emperor soon showed himself to be an adventure-loving carouser dominated throughout his reign by Moslem eunuchs, who encouraged him in a life of vice while they helped themselves to porcelain from the imperial factory. The seeds of decay were already planted in the Ming dynasty, and Chêng-tê and his cousin who succeeded him are considered the two most worthless of the Ming emperors. Both cruelly humiliated and punished the officials who attempted to remonstrate with them.

It was during Chêng-tê's reign, however, that, through the good offices of the governor of Yunnan, supplies of 'Mohammedan Blue' again became available from Central Asia. Of still greater significance was the discovery of the best indigenous cobalt available (known as *fo t'ou ch'ing* or 'Buddha Head Blue') just south of Ching-te Chên.[1] Though the potters were not able to feel the full benefit of these new supplies until the next reign, the best of Chêng-tê blue and white is described in the *T'ao shu* as being 'antique and splendid', possibly because it rivalled that later Mohammedan Blue, the *su-ni-po* of the Hsüan-tê wares. For a good deal of the reign, however, the greyish tinge that we have already noted in a number of the Hung-chih wares was again very much in evidence. In the decorative motifs of the period, however, we can see a form of transition between the classical styles of the fifteenth century and the new styles and mass production of the Chia-ching and Wan-li periods later in the century.

The most interesting and conspicuous examples of blue and white of the period, however, are the so-called 'Mohammedan wares' that the Moslem eunuchs who so dominated the emperor had made for themselves in the imperial kilns. Most of these, which bear the imperial *nien hao*, are utensils for the writing table, such as brush rests, ink slabs, boxes and vases, though a few mandarin spherical hatstands, bowls and dishes were also made. These articles are usually inscribed with such mottoes in Arabic as 'Strive for excellence in penmanship, for it is one of the keys of livelihood', which is to be found on a brush rest, though another in the Percival David Foundation is more simply inscribed with the characters meaning 'pen rest' (Plate 32).

One of the most important examples of the Mohammedan wares is the table screen illustrated in Plate 33. This is decorated with the 'Mohammedan scrolls' or arabesques that became fairly common during this period, around a central panel in which there is a text from the Koran in

33 Table screen, Chêng-tê mark and period, decorated with 'Mohammedan scrolls' around a central panel containing a passage from the *Koran*; the six-character *nien hao* of Chêng-tê is clearly visible at the foot of the screen. (Height: 45.8cm)

III Pen box of Islamic form, early fifteenth century, the exterior decorated with panels of lotus and chrysanthemum reserved on a diaper ground of interlocking circles and florettes; the interior consisting of three compartments and decorated with chrysanthemum, crapemyrtle and blackberry lily scrolls (the lid that would normally have fitted the box is missing). (Length: 32cm)

IV Moon flask, Hsüan-tê period, decorated on one side with a bird perched on a branch of peach with bamboo, and on the other side with another bird on a prunus branch, also with bamboo; around the shoulders and foot are bands of detached scrolls, and around the neck a spray of bamboo. (Height: 30.8cm)

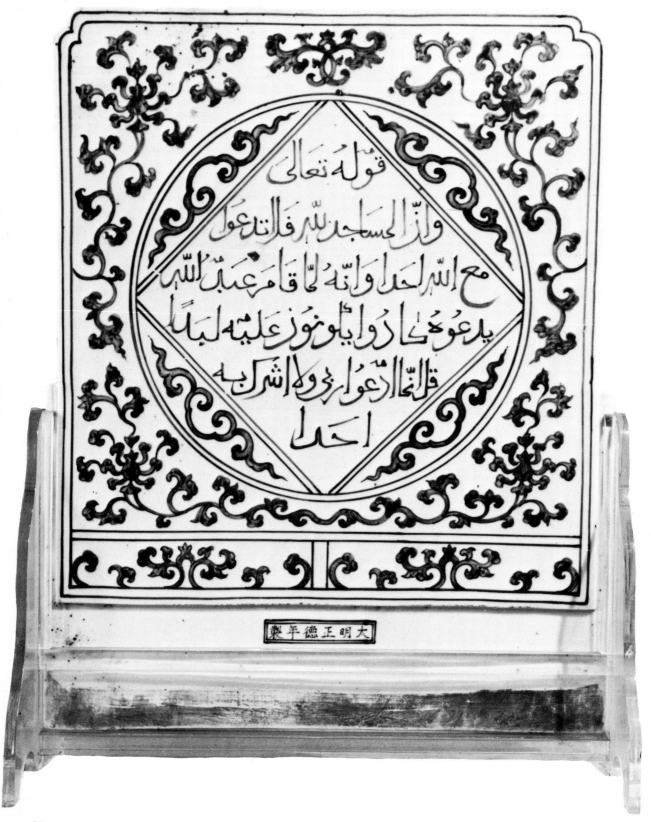

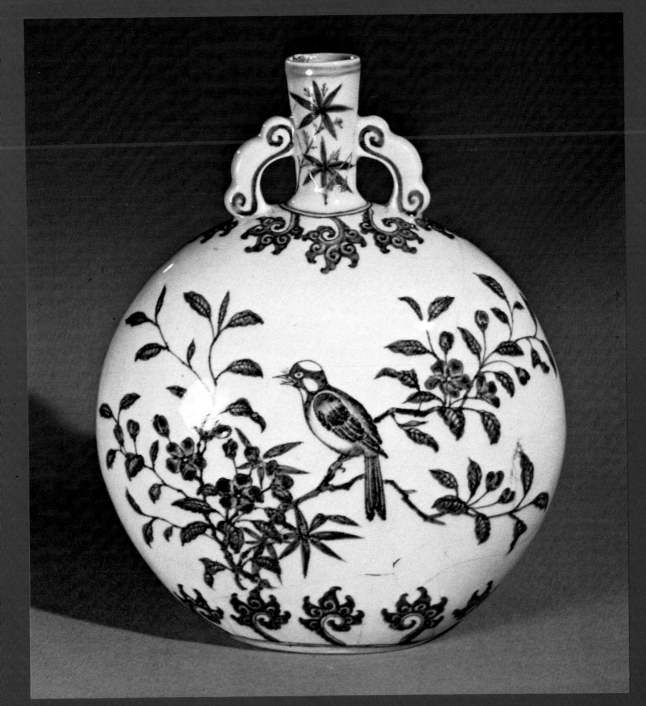

V Vase of rather squat *mei-p'ing* form with a knobbed cover, Hsüan-tê period or slightly later, decorated with a lotus scroll and lotus panels around the shoulders and foot; the lid decorated with a poorly drawn classic scroll around the sides and a petal pattern on the top; Hsüan-tê *nien hao* on the base. (Height: 12.5cm)

34 Box for writing accessories, Chêng-tê mark and period, decorated with arabesque foliage motifs alternated with medallions containing Arabic inscriptions that read, on the lid, 'A fool finds no contentment', and on the sides, 'The reins are of no use to a blind man'. (Length: 20.4cm)

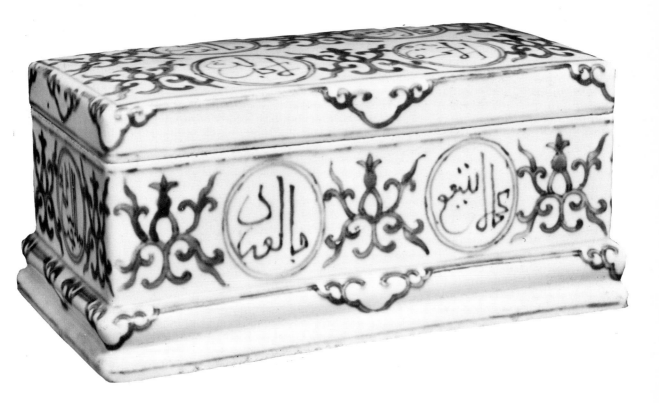

Arabic.² Another example of the Mohammedan wares, the pen box illustrated in Plate 34, is of interest in as much as while it is decorated wholly in a Mohammedan style with arabesques and Arabic inscriptions, its shape is entirely Chinese and functional. It is in striking contrast with the pen box made about a century earlier and illustrated in Colour Plate III, for the latter is Middle Eastern in form, but wholly Chinese in decoration. It therefore seems that whereas the earlier potters had consciously looked outside the empire for inspiration in their forms, they now no longer felt the need to do so, but were at the same time prepared to accept alien decorative motifs when the occasion demanded. As we shall see in Chapter 7, these same potters were also ready to decorate other wares intended for export to Portugal with national emblems and Jesuit motifs.

By no means all the wares of the period were Moslem in character, and it is among the non-Moslem ones that we can observe the transitional aspects of Chêng-tê blue and white. These wares, consisting mainly of bowls, ewers and vases, are finely potted and well decorated in the traditional fifteenth-century style, even though this often appears to be rather overcrowded. They nor-

mally bear the reign mark in four characters, for the prefix *Ta Ming* is omitted. The blue decoration, as has already been noted with a number of Hung-chih wares, is rather greyish in hue, and the thick glaze often causes a rather pleasant misty effect. This is particularly clearly seen in the vase illustrated in Plate 35, an interesting piece in which we can see a combination of the traditional fifteenth-century motifs with styles that are now recognised as more Mohammedan in character. The lotus scrolls, plantain leaves and key fret at the base of the neck look purely fifteenth-century, but at the same time the lotuses are set against an arabesque motif that is more suggestive of the Mohammedan wares. These same arabesques, however, were to survive into the subsequent Chia-ching period, which in all other respects was to be wholly non-Moslem.

A small group of jars that are not of imperial quality also bear the four-character reign mark of the period. These, which were almost certainly made in the Ching-te Chên area, are occasionally round or square, and can at other times be hexagonal or octagonal. Decorated with religious emblems, phoenixes, children at play or sometimes with older motifs, they foreshadow develop-

35 Large vase, Chêng-tê mark and period, decorated with lotus scrolls and arabesques above stiff plantain leaves on the bowl of the vase, a formalised scroll around the foot, a band of 'thunder pattern' key fret around the base of the neck surmounted by a flame motif, a classic scroll rather higher up the neck, and four compartments, each containing *ling-chih* fungus, just below the rim; the four-character mark of Chêng-tê is clearly visible in a rectangular panel on the neck. (Height: 45cm)

36 Hexagonal jar, Chêng-tê mark and period, decorated on each of the six sides with lotus growing in water, lotus panels around the foot, *ju-i* heads on the shoulders and a 'thunder pattern' key fret around the neck; four-character Chêng-tê mark on the base. (Height: 9.6cm)

ments in the following reign, when hexagonal or octagonal jars were fairly common. The example shown in Plate 36 is clearly decorated in the older style, for the lotus and other water plants that it shows are reminiscent of a fourteenth-century motif. Such jars frequently bear commendation marks in the place of the reign mark, and one in the British Museum carries the inscription *Wan fu yu t'ung*, 'May infinite happiness embrace all your affairs'. The existence of these jars made in private factories clearly suggests that there were forces at work determined to keep alive the traditional styles of decoration at a time when the imperial factories were so dominated by the Moslem eunuchs.

Chêng-tê died, leaving no direct male heir, in 1521, and so was succeeded by his cousin, who took the reign title of Chia-ching. The new emperor was a devout Taoist, who soon ousted the Moslem retinue of his predecessor and showed himself intolerant of all other religions. He was wont to surround himself with Taoist alchemists, and for one period of twenty years withdrew altogether from governmental affairs, leaving all in the hands of the unpopular grand secretary, Yen Sung. For a brief period he flirted with Buddhism, but soon reverted to Taoism, and eventually died from the effects of a drug administered to obtain the elixir of immortality. His reign

37 Saucer dish, Chia-ching mark and period, decorated in white reserved on a dark purplish blue ground, with a peach tree twisted into a conventionalisation of the character *shou* ('long life') and *ling-chih* fungus growing around the base. (Diameter: 15.7cm)

was an unhappy one for the empire, for it saw the end of the peace that it had enjoyed for almost 100 years. There were at least four mutinies in the imperial army, and the Tartar Oirats, a constant threat from the north from 1542 onwards, raided the suburbs of Peking itself in 1550. Moreover the Japanese, who had been more or less submissive since the beginning of the previous century, grew dissatisfied with the trading agreements they had previously had to accept, and in the 1550s constantly looted the Ningpo–Shanghai region. The Europeans, too, had begun to make themselves increasingly felt in the Far East, and in 1557 the Portuguese were awarded the peninsula of Macau in return for their assistance against pirates in the South China Sea.

Despite the misfortunes of the period, however, and the lack of good government, Chia-ching blue and white has always been very highly regarded. This is almost certainly due to the high quality of the cobalt blue, which the Chinese have often considered superior to that of the Ch'êng-hua period. The supplies of finer cobalt from Kiangsi that had been discovered earlier were now available and great care was taken in preparing them. Teams of three were regularly employed for three days at a time in grinding up and preparing the finest quality, and prizes were awarded for the best work. But the period was also one of mass production, and regular orders were received from the court. In 1544 it placed an enormous order for 1,340 table services, comprising over 35,000 pieces, and ten years later the court's requirements amounted to over 100,000 pieces. As can be expected, therefore, there was a tremendous variety in the quality of the blue decoration, and only the very finest wares, decorated in the characteristic dark violet blue of the period, were reserved for the palace. Other inferior pieces, which are often indistinguishable from Wan-li wares, were made for general commercial purposes and for export.

With the emperor himself a devout Taoist, it is not surprising that Taoist motifs predominate in Chia-ching wares. The most popular of these is a peach tree twisted into the form of a conventionalised *shou*, the longevity character (Plate 37); and the peach itself and the *ling-chih* fungus seen growing around the tree in the example illustrated are also symbolic of long life. This motif was to recur in later periods, but was never so

popular as it was during the Chia-ching reign. As can be seen, the decoration of this particular saucer dish is reserved in white on a dark purplish blue ground that has clearly been applied with superbly free strokes of the brush. That the potters were able to use this technique is evidence that the precious cobalt blue was once again in abundant supply. It will be recalled that it had previously been used in this style in the fourteenth century, when supplies of imported cobalt from Persia were also plentiful, and now, after a period of scarcity, it was once again so freely available that it no longer had to be carefully measured out as if it was gold. So plentiful, indeed, was it, and the allocations so little controlled, that there were many instances of pilfering from the imperial factories. We may well assume that the supplies thus stolen found their way to the numerous private kilns that proliferated throughout the period.

Since its first appearance in the fourteenth century, the production of blue and white, like other porcelain wares, had depended on the skill and artistry of the potters who had worked for generations at the kilns. Skilled though they undoubtedly were at potting and well capable of decorating their wares with superb decorative motifs, they were inevitably less sophisticated and less original in their approach than the trained artists who, there is good reason to believe, now appeared on the scene and worked alongside the

38 Ewer, Chia-ching mark and period, decorated with
heart-shaped panels framing *wa-wa* or children at play,
classic scrolls on the handle and spout and chevron pattern
borders on the lip and the base of the cover. (Height: 29.2cm)

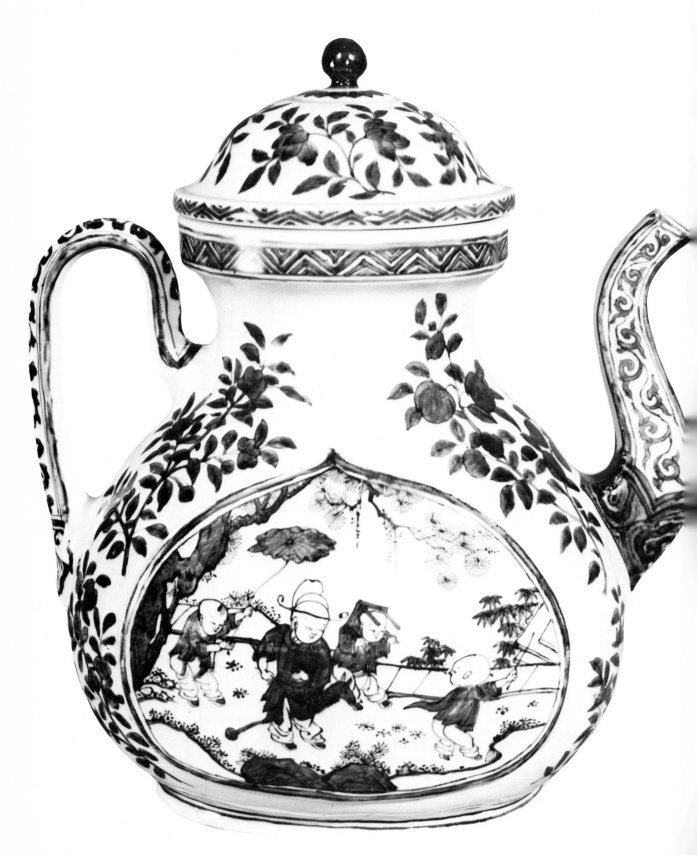

39 Bowl, Chia-ching period, decorated in a rather perfunctory manner with phoenixes flying among floral scrolls; on the base are four cyclical characters, *kuei-ch'ou nien-ts'ao* ('made in the *kuei-ch'ou* year'), which indicate that the bowl was made in 1553. (Diameter: 11.8cm)

potters in the imperial factories. One of their motifs that was particularly popular during the Chia-ching period was that of the *wa-wa* or 'hundred children' at play. Some sixteen of them can be seen in the panels painted on the sides of the magnificent *kai-kuan* or covered jar illustrated in Colour Plate VI. The *wa-wa* are, of course, an innovation of these artists, but, even so, the rest of the decoration seen on this jar and also on the ewer illustrated in Plate 38 is very much more traditional. The remaining decoration on the jar is of lotus scrolls very much in the tradition of the fourteenth and early fifteenth centuries, while the Taoist element in decoration can be seen in fruiting sprays of peach on the ewer. The *wa-wa* in the central medallion, however, appear to be playing beneath the shade of a pine tree, symbolic of Buddhism, which may well suggest that this particular piece was produced during the emperor's Buddhist period.

It can therefore be seen that while these artists were groping towards a greater naturalism in their decoration, which was to find fulfilment in the following century, older and more traditional influences still survived. They were to continue to do so until the demise of the dynasty, but in the brief transitional period between the fall of the Ming and the firm establishment of the Ch'ing the cultural descendants of the artists were given full rein. We may well regret the passing of traditional standards and decorative motifs, for at their finest they represent the acme of the potter's art, but by the Chia-ching period the hold of the Ming over the empire was less sure and the traditional skills of the Ming potter were beginning to show signs of decadence.

As has already been noted, the Chia-ching period was one of mass production, and a great deal of the porcelain was well below what is generally accepted as imperial quality both in potting and decoration. An example of this rather inferior ware can be seen in the bowl illustrated in Plate 39, which is decorated in a most perfunctory style with three phoenixes amid floral scrolls, and is clearly of commercial quality only. It is, however, of interest in as much as it bears a cyclical date mark on the base that indicates it was made in 1553. Dated pieces of porcelain are comparatively rare, but some, like the large temple vases illustrated in Plates 3 and 29, clearly show inscriptions that indicate the year of manufacture and

sometimes even the month in question. Others, however, like the bowl under consideration, are inscribed with what is known as a cyclical date mark, and these are frequently harder to date.

The Chinese cycle consisted of sixty years, which, for the period that we are concerned with, started in approximately the year 1324, and then was renewed in 1384, 1444 and so on. Each year within the cycle is known by a particular name, indicated by two characters, and this enables us to date it. Some of these cyclical marks are incorporated into the *nien hao*, and so wares bearing them are easy to date, but more often this is not the case. In these circumstances the dating of a piece must also take into consideration the nature of the potting and the decorative motif. The four characters on the bowl that we have been considering read *kuei-ch'ou-nien-ts'ao*, 'made in the *kuei-ch'ou* year'; and as the potting and decoration are clearly sixteenth century, this piece must have been made in 1553 rather than 1493 or 1613.[3] (See Appendix B.)

When Chia-ching died, he was succeeded by his son, Lung-ch'ing, who survived him by only a few years. The porcelain of his reign is similar to that of the earlier period, but marked pieces are very rare. He was himself succeeded by his son, who took the reign title of Wan-li, in 1572. The first part of this new reign was dominated by the most outstanding grand secretary of the Ming dynasty, Chang Chu-cheng, while the imperial

40 Dish, Wan-li mark and period, but decorated in the
Chia-ching style with *wa-wa* or children playing on a terrace,
and cranes, ducks, lotus and waterweed on the cavetto.
(Diameter: 31.4cm)

army under competent generals maintained effec-
tive defences. A Japanese attempt to invade
Korea in the 1590s petered out with the Japanese
emperor's death, but it made heavy demands on
China's resources and eventually precipitated her
military decline. Moreover, after Chang Chu-
cheng's death, the government of China was torn
by strife among the mandarins, while the emperor,

ruling now only in name, abandoned more and
more of his responsibilities to the eunuchs.

It was during the Wan-li period that considera-
tions of quality finally gave way to those of
quantity in order to meet the insatiable demands
for porcelain from the court. Moreover the beds
of fine clay at Ma-ts'ang, which had shown signs
of exhaustion during the Chia-ching period, were

41 Pair of bowls, Wan-li mark and period, potted with areas of openwork in the sides, including the four characters *fu shou k'ang ning* ('Happiness, long life and tranquillity'), and decorated with four medallions, each framing a phoenix, with floral scrolls around the foot and just below the rim. (Diameter: 8.8cm)

now virtually used up, so that the Wan-li potters had to go further afield to find their supplies. They were also cruelly oppressed by the eunuchs, who exploited their position and influence at court to order vast quantities of porcelain for themselves. There is a story that the potters were once severely punished for their inability to make large fish bowls to the eunuchs' specifications, and one of them, a potter called T'ung, took the responsibility upon himself and sacrificed his life by flinging himself into the midst of the kiln's furnace, whereupon the bowls came out perfect. His fellow potters then built a temple to him and worshipped him as the 'Genius of Fire and Blast'.[4]

It is not very surprising in view of the difficulties that the potters had to face that many of the blue and white wares of the period, which were frequently decorated very much in the same style as those of the Chia-ching reign, tend to be of rather indifferent quality. Some, however, were very finely potted and decorated with a good deal of skill. For example, the dish illustrated in Plate 40 is clearly decorated in the style of the earlier period with *wa-wa* playing on a terrace, and the cranes depicted around the cavetto show that the Taoist tradition in decoration was very much alive during this period. The blue of this piece, however, though dark and well applied, lacks something of the brilliance and vitality of the best of Chia-ching wares.

To some extent, too, the period was one of innovation that taxed the potter to the uttermost. The two bowls in Plate 41, which are clearly of imperial quality, are delicately potted with areas of openwork in the sides, and these in turn include the characters *Fu shou k'ang-ning*, 'Happiness, long life and tranquillity'. Commendation inscriptions of this kind, as has already been noted, are known on the earlier wares of the century, and also appear to have been particularly popular during the Wan-li period. That bowls as intricately potted as these should have come out of the kiln as perfect as they have is in itself most surprising, and also indicative of the most skilful workmanship.

This same spirit of innovation sometimes led the potters in private kilns to produce wares that showed a good deal of humour, representing a complete break with tradition and the dictates of the imperial court. The water dropper moulded in the form of a woman in her bath, shown in Plate 42, is unlike anything made previously or, indeed, at all frequently in later years. It has nothing in common with the delicacy or charm of the objects made for the scholar's table in the fifteenth century, and yet it is clear that the man who made it and the one who subsequently used it at his desk show a spark of humour that was previously lacking.

The Ming dynasty was dying, and the decline

42 Water dropper, moulded in the form of a woman reclining in a bath and holding a fan, Wan-li period, decorated with floral scrolls on either side. (Length: 11.6cm)

43 Saucer dish, Wan-li period, decorated in the central field with a riverside scene including two men in a boat, a pagoda and distant hills, and with key fret pattern around the rim; the six-character mark of Hsüan-tê showing on the base. (Diameter: 12.5cm)

in the quality of imperial porcelain, particularly towards the end of the reign, was marked. As if, however, to compensate for this decline, a good deal of porcelain was produced in private factories, and that was superior to many of the wares made for the court. It is true that some of the produce of private kilns was made solely for export and lacks something in delicacy, but the best of the wares made for the domestic market are finely potted, and decorated in a pale shade of silvery blue that appears to foreshadow the lighter styles of decoration of the K'ang-hsi and Yung-chêng periods. Such wares usually carry the Hsüan-tê and Ch'êng-hua reign marks, and are frequently decorated with landscape scenes in a far less formal style than previously seen, showing some of the characteristics of ink painting in their freedom and spontaneity (Plate 43). The use of carefully graded washes of blue in the portrayal of rocks and mountains foreshadows the techniques used during the K'ang-hsi period in the next century, and also suggests that the artist-decorators were now working more for private patrons than to imperial order.

4 New Developments: the Seventeenth Century

44 Censer, decorated with a scene from the 'Romance of the Three Kingdoms' and inscribed on the base to the effect that it was made in the fifth year of T'ien-ch'i (1625). (Diameter: 22cm)

45 Tall slender vase, Transition period, decorated with a landscape scene, water in the foreground and distant mountains, and bearing an inscription that has been translated as follows: 'Ten thousand springs open and clear, the trees lush with the smoke of the five mountain ranges.' (Height: 39.3cm)

Well before the end of the Wan-li period the empire was showing signs of disintegrating, and this process accelerated in the years following the emperor's death in 1620. He was succeeded by his son, who survived him by only a few months and was then succeeded by his own son. This young prince, who took the reign title of T'ien-ch'i, was a mere boy of fifteen at the time of his accession. It was a difficult time for a boy, and now, unlike in the early years of his grandfather's reign, there was no powerful and able grand secretary to support him. The young emperor made things worse by neglecting his state papers to idle away his time in carving ivory, and left the affairs of state to the brutal and most powerful eunuch in all Chinese history, Wei Ching-hsien, who quickly crushed the young reformist party and filled the court with his own sycophants. The emperor himself died in 1627 and was succeeded by his brother, Ch'ung-chêng.

The new emperor, who tried to revitalise the rapidly deteriorating Ming government, had arrived too late upon the scene. The Manchus, who had been quietly occupying far-off Manchuria since the beginning of the Ming period, now posed a new threat. In 1616 their leader, Nurhachi, had proclaimed a new dynasty, and a few years later won such overwhelming victories over the imperial armies that he was able to seize control of the whole northeastern segment of the empire. In the years that followed Ch'ung-chêng's accession, the Manchus repeatedly broke through the Great Wall and even threatened Peking itself. Taxes and conscription became more and more oppressive on the Chinese population as banditry and rebellions spread throughout the empire and the Ming government became increasingly demoralised. Finally a domestic rebel captured Peking, and the defeated emperor committed suicide. A Ming army commander there-

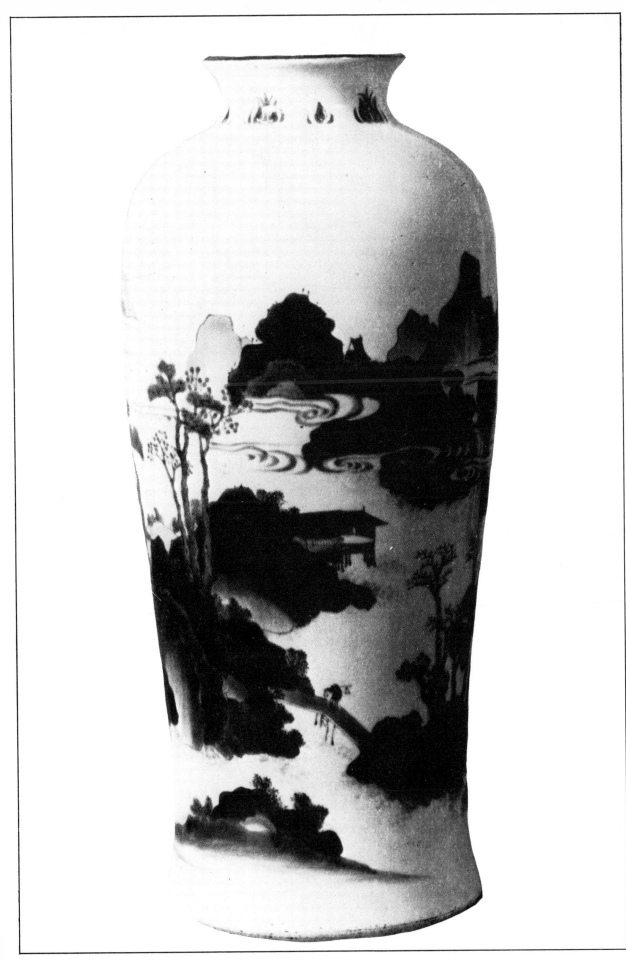

upon accepted Manchu aid to restore the dynasty, only to find them seizing the throne for themselves. Sporadic resistance from Ming loyalists continued for a generation, but the great Ming dynasty was gone for ever.

It is scarcely surprising in view of the chaotic state of the empire at the end of the dynasty that little or no porcelain was produced in the imperial factories. A good deal of very fine porcelain, however, was produced in private kilns in the difficult years that marked the decline and fall of one dynasty and the rise of another. Examples of this, which were long disregarded in the West when collectors were hunting for the later and highly prized K'ang-hsi porcelain, are known as 'Transition wares'. They are difficult to date exactly, for they bear no seventeenth-century reign marks, though occasionally pieces can be found with a misleading Chia-ching *nien hao* or with cyclical marks. Often of very fine quality and well decorated, they seem to be the work of the artist-potters who had begun to foresake the imperial factories before the end of the Wan-li period and were now firmly committed to various private patrons. It is not surprising, therefore, that many of the decorative styles that had prevailed in non-imperial porcelain at the end of the previous century and had first been seen during the Chia-ching period survived and became increasingly popular in the new century. The decline of the dynasty was bound to mean a far looser imperial control over ceramic decoration, and so the moment that the artist-potters had long been waiting for had at last arrived, and they were given free rein in producing new motifs. An early example of the kind of decoration they were capable of can be seen in the censer illustrated in Plate 44, which bears an inscription to the effect that it was made in 1625. The scene depicted is one from the 'Romance of the Three Kingdoms' and is painted much in the style of many privately produced wares of the later sixteenth century. More akin to the styles of the earlier period though this piece is, it also foreshadows developments that were to dominate the next fifty years or so.

While it is certainly true that this censer belongs to the Transition period, it cannot be said to be truly typical of the wares of that period. These, which were strongly made as if for export in a sadly disordered period of Chinese history, are of a far better material and have a clear white glaze that is thickly but very evenly applied. The blue of the decoration is of a bright violet hue, which, under the bubbly glaze, has often been compared to 'violets in milk'. The decorative motifs have frequently repeated characteristics, indicating the use of a set of stock patterns. This is not particularly surprising, for there is good reason to believe that the artist-potters of the time drew a good deal of inspiration from woodblock illustrations that had appeared in novels anything up to 100 years previously. The scenes they painted, therefore, consist of landscapes, precipitous mountains and waterfalls surrounded by swirling pools and sensitively drawn plants. As in the vase illustrated in Colour Plate VII, the underglaze decoration is also often supplemented by lightly incised patterns. Delicately decorated with a mandarin beneath a willow tree and a deer, lakeside scene and distant mountains on the other side, this vase is a particularly fine example of Transition blue and white of about 1640.

As can be seen, therefore, the decorative motifs now show a distinct break with traditional styles of decoration, and, though something of a late echo of the non-imperial wares of the Wan-li period, are much less formal than many of those of the earlier sixteenth century. In general they show a new appreciation of natural beauty, and coincide with a period that saw a revival of landscape painting. This is particularly apparent in the magnificent vase illustrated in Plate 45. As if in tune with the sensitive quality of its decoration, it also bears an inscription that has been translated 'Ten thousand springs open and clear, the trees lush with the smoke of the five mountain ranges'.

There are, it is true, a few pieces of porcelain that bear the *nien hao* of the first Ch'ing emperor, Shun-chih (1644–61), but in general the Transition styles continue far beyond the demise of the Ming dynasty and well into the K'ang-hsi period. The brush pot illustrated in Plate 46, which bears a cyclical mark that can be equated with 1660, is of particular interest for a number of reasons. Firstly, it is finely decorated in a pencil-drawing style that is unusual among Transition wares but is fairly common in the early K'ang-hsi period, and secondly, like many earlier Transition wares, it depicts a scene from literature. We may therefore assume that it was probably copied from one

46 Brush pot, later Transition period, decorated with a group of men and boys outside a house that is largely overshadowed by a plum tree, and inscribed on the other side with a verse that could have been composed by the man for whom the pot was made. The base shows the cyclical date mark *kuei-tzu nien chih* ('made in the *kuei-tzu* year', ie 1660). The rim is coated with a brown wash, which may have been applied to prevent chipping. (Height: 9.1cm)

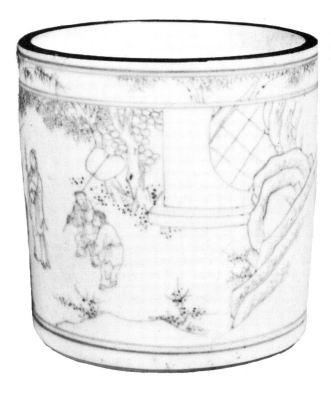

of the illustrations in a book published some time in the sixteenth century. The side of the pot not shown carries part of a poem of the Wei dynasty of the Six Dynasties period that can be translated as follows:

> I pick a spray of plum blossom and give it to
> the courier
> Who will carry it to you at Lung-t'ou,
> There is nothing of interest in Kiang-nan,
> So I send you a single twig of spring.[1]

The scene shows a group of men and boys outside a house overshadowed by a plum tree, and on the extreme left stands a single man, presumably the courier or the writer of the poem, holding a spray of plum blossom. On the side not shown there are also other men, and ponies which, we may assume, are waiting to take the courier on his mission.

While Transition wares were being produced, a good deal of blue and white that has never been especially highly regarded in the West, but which is greatly prized in Japan, was being made specifically for export to that country. The earliest of these wares, which the Japanese call *ko-sometsuke* or 'old blue and white', were originally made for the domestic market, but they were quickly

adapted by the Japanese tea-masters for their own ends and subsequently made to suit the Japanese taste. They were very roughly made, but the very clumsiness of their appearance has endeared them to generations of Japanese, who have nicknamed them *ranzoheu*—'things made at haphazard'.

They appear to have been made at speed, and sand often adheres to their bases. Much of the decoration, too, was only half completed on many of the dishes before they were exported (Plate 47). These blemishes, however, have only added to their appeal in Japan, and a recent connoisseur from that country has written: 'Among Chinese porcelain the T'ien-ch'i stands out like a flower in the field.'[2] While few Westerners would share this view, another Japanese authority has said rather more pointedly: 'T'ien-ch'i *ko-sometsuke* was made in the declining years of the Ming, when the life of the people was uncertain, and they reflect the feeling of danger, self-denial and eternal loneliness.'[3] This is something we can understand far more easily, and it is clearly the feeling represented by the two lonely sages seen disputing on a hillside in the dish illustrated in Plate 48. We may well conclude, therefore, that just as the finely potted and decorated Transition wares were made for the mandarinate and later for export to the West, so *ko-sometsuke* porcelain reflects the spirit of the time more truly and was originally made for the ordinary people.

Ko-sometsuke wares have always been considered the precursors of the more sophisticated *shonsui* porcelain, which was made to the specific order of the Japanese tea-masters. Rather later than most *ko-sometsuke*, this was made in the latter part of the Ch'ung-chêng period and during that of Shun-chih. Many of the wares carry the inscription *Gorodaiyu wu shonsui* on the base, though the jar shown in Plate 49 does not do so. It is not clear what the inscription stands for, but perhaps the easiest explanation is that Gorodaiyu was a Japanese who ordered tea from a Chinese merchant, Wu Shonsui (Wu Hsiang-jui), and it combines both their names. In striking contrast to the roughly made *ko-sometsuke* wares, *shonsui* porcelain is frequently very finely potted, and the vessels, which are made with a great deal of skill and attention to detail (Plate 49), are decorated in a deep and pure violet blue. The rims of the vessels, most particularly of dishes and saucers,

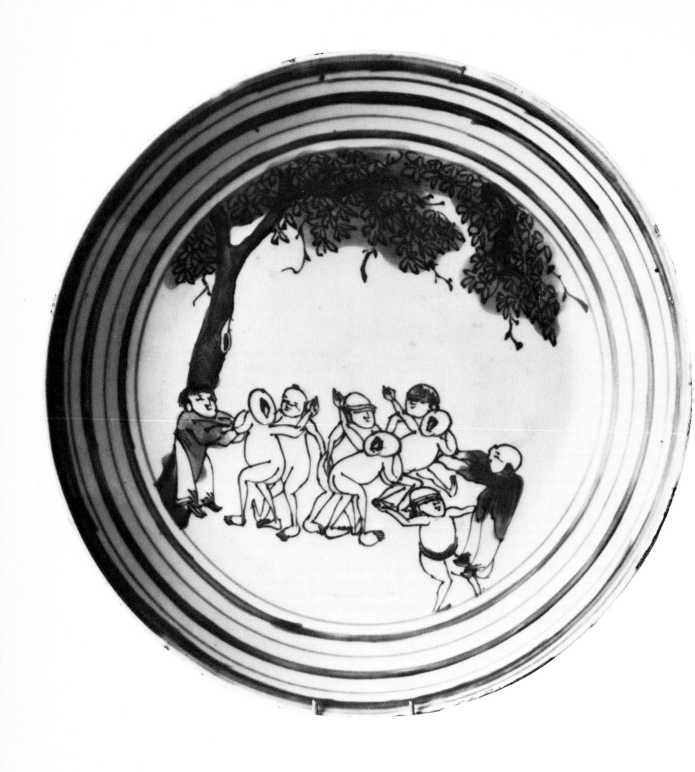

47 Saucer dish, *ko-sometsuke*, early seventeenth century,
decorated in cartoon style and intended for the Japanese
market. (Diameter: 20.3cm)

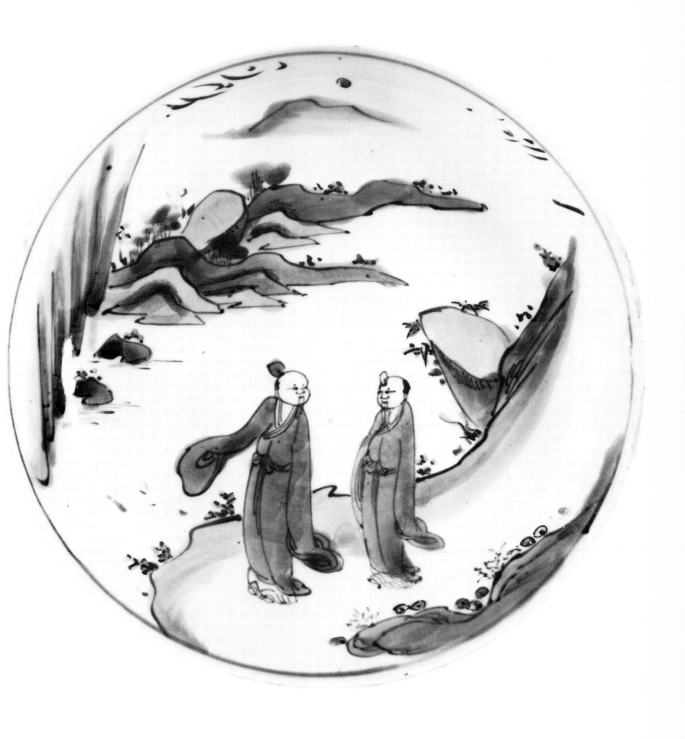

48 Saucer dish, *ko-sometsuke*, T'ien-ch'i period, decorated with a scene depicting two sages disputing on a mountainside. (Diameter: 20.8cm)

49 Jar and cover, *shonsui*, Ch'ung-chêng period, decorated around the body with a landscape of bamboos, peonies and other plants, and rocks, and the design interspersed with birds and various insects, including butterflies and dragonflies, and around the mouth with a broad band of lappets; the cover is decorated with a landscape around the knob and a diamond diaper border around the rim. (Height: 17.4cm)

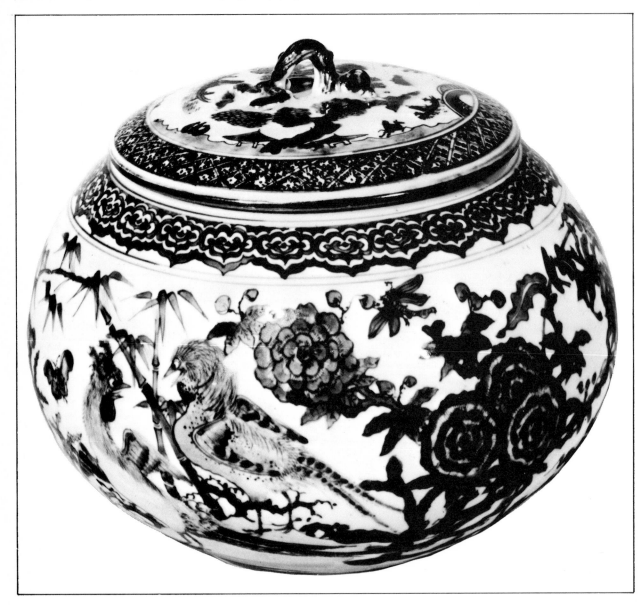

are quite commonly coated with a brown substance, and it is very possible that this was intended to prevent chipping. It is unusual to find this coating on earlier wares, but it did become increasingly common during the K'ang-hsi reign and is frequently found on later copies of the porcelain of that period. It may well therefore be that this treatment was required by importers to ensure that the wares shipped to them were not damaged in transit.

Shonsui porcelain, which was made specifically for the Japanese tea ceremony and therefore specifically for use at table, consists of such obvious tablewares as tea bowls, water jars, cups

for hot water, bowls for hors d'oeuvres, plates and sake bottles and cups. Unlike the *ko-sometsuke* wares, which are basically Chinese in character, their decorative motifs are wholly Japanese. So much is this the case that a Japanese authority has recently written: 'To those who are used to true Chinese porcelain, they produce an unnatural feeling . . . *Shonsui* pieces smell of Japan. They are full of the taste of the *machikata* [the Japanese merchant class] like a heavily made-up woman; so we slap our thighs and say they must be valuable.'[4]

As we have already seen, the great Ming dynasty fell with the suicide of the last emperor in

1644. The Manchu were quick to take advantage of the situation, and seized the throne for themselves, thus establishing the Ch'ing, the last imperial dynasty to rule China. The first emperor of the new dynasty, who took the reign title of Shun-chih, followed a wise policy of continuing to employ Ming officials who were prepared to serve under him and giving ranks in the nobility to the Ming military commanders who surrendered. Even so, though most of the populace was pacified, Ming loyalists continued military resistance for nearly forty years, and many of the Chinese secret societies of today can trace their origins to the time when they were anti-Ch'ing groups operating underground in favour of the deposed Ming.

The first Ch'ing emperor died in 1661 before his task of pacification was completed, and was succeeded by his son, then a boy of only seven, who took the reign title of K'ang-hsi. His reign, which was to last for over sixty years, is the longest in Chinese history and one of the most glorious. The first six years were dominated by four regents, but thereafter, when the emperor began to rule for himself, it was to see the conquest of southwest China and Formosa, which remained loyal to the Ming until 1683, the pacification of the Mongols in the northwest, and the signing of the first treaty with an occidental power, Russia, in 1689. The emperor himself was tolerant of all religions and friendly towards Christian missionaries, employing a number of Jesuit priests very usefully in and around the court. Though Manchu by birth, he was thoroughly Chinese in his love of learning and patronage of the arts.

'Western collectors', wrote R. L. Hobson, for many years Keeper of Far Eastern Antiquities at the British Museum, in 1915, 'have agreed to give the place of honour to K'ang-hsi blue and white.'[5] He was thus expressing the views of connoisseurs of the late nineteenth century and the early years of the twentieth. Tastes alter, and the years since he wrote have seen a good deal of research into and greater appreciation of the Ming wares. Nevertheless the best of K'ang-hsi blue and white is without peer, and for generations it has graced the sideboards of many English country houses.

From the point of view of ceramic history, the K'ang-hsi reign can be divided into three distinct periods, the first of which dates from his accession until 1683. Much of this time covers a period when the emperor was still a boy, and the whole of it when the Ch'ing had still to establish their supremacy over the empire. It should therefore be considered a continuation of the Transition period, for imperial control had not yet been adequately imposed over the porcelain factories, and it is impossible to distinguish between many of the blue and white wares made for the court and those for private patrons. Though heavily potted, a number of vessels of good quality were made during this period, and some also show copper red decoration under the glaze in addition to the blue. Some of them, again, carry a boldly drawn K'ang-hsi reign mark, and others the *nien hao* of Ch'êng-hua or Chia-ching, an artemisia leaf mark where one normally expects to find the reign mark, or no mark at all. The continuation of Transition styles of decoration on early wares of the period can be seen in the dish illustrated in Plate 50. This shows in delightfully informal style two court ladies out riding with a rather portly gentleman and two grooms in attendance. It bears no reign or other mark, and can be compared in style to the earlier Transition wares.

This first part of the reign was turbulent, and in 1675 pro-Ming rebels threw the province of Kiangsi into turmoil, pillaging and burning the imperial factories at Ching-te Chên. Two years later a magistrate of Fou-liang was appointed as superintendent of the factories and charged with responsibility for restoring them. He was fairly successful, for he persuaded the government to allow him to divert the land tax from Fou-liang, which had previously been sent to Peking, for the rebuilding of the factories. Perhaps it was the damage the rebels had done and the fear they might return that caused him to issue a proclamation forbidding the use of the imperial *nien hao* on porcelain, for he wished to ensure that no piece bearing it was broken or trodden underfoot. It is not known for certain how long this regulation was in force, or whether it was ever properly implemented, but it did give rise to the use of such 'shop marks' on porcelain as the artemisia leaf already mentioned, and also the hare, double fish and incense burner in place of the reign mark. Other K'ang-hsi wares just show an empty double circle of the type that was normally drawn around the *nien hao*. This, however, and the four-character K'ang-hsi reign mark (omitting the

50 Dish, early K'ang-hsi period, decorated in the central
field with two fashionable ladies out riding with a gentleman
and two grooms in attendance, and around the cavetto and
flattened rim with floral sprays and lotus panels framing
maidens. (Diameter: 35.6cm)

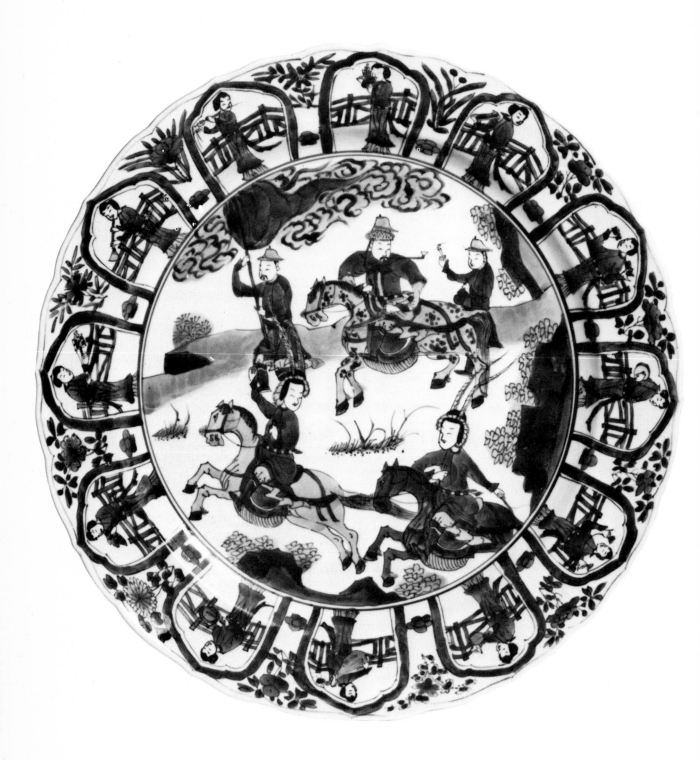

51 Covered jar, middle K'ang-hsi period, decorated with prunus blossom reserved in white against a deep blue ground of 'cracked ice'. The base shows an empty double circle as mark. (Height: 25.4cm)

normal first two characters, *Ta Ch'ing*) have been so frequently applied to later copies of K'ang-hsi porcelain that collectors should be very much on their guard against assuming that the presence of either mark indicates that the pieces in question can be attributed to the period with certainty.

Scarcely had the imperial factories been restored than their future was again jeopardised, but this time by the emperor himself. He had already set up plans for the manufacture of metal-work, glass, enamels and lacquerware in the palace precincts, and now, presumably appre-

hensive of the depredations of the rebels, he wanted to have the porcelain kilns there as well. A Jesuit priest, Père d'Entrecolles, who lived in Ching-te Chên in the early years of the eighteenth century, tells us that the emperor brought in workmen with all the necessary equipment to set up kilns in Peking, 'yet all their labour was wasted. It is possible that interested motives may have contributed to their want of success, however that may be, it is King-te-tching alone that has the honour of furnishing porcelain for all parts of the world'.[6]

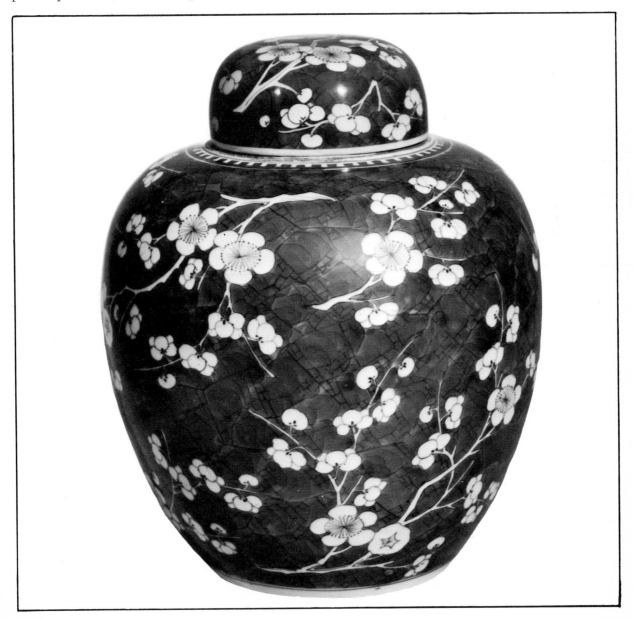

52 Tall vase of *rouleau* form, K'ang-hsi period, decorated with a series of pictures depicting different scenes. (Height: 91.5cm)

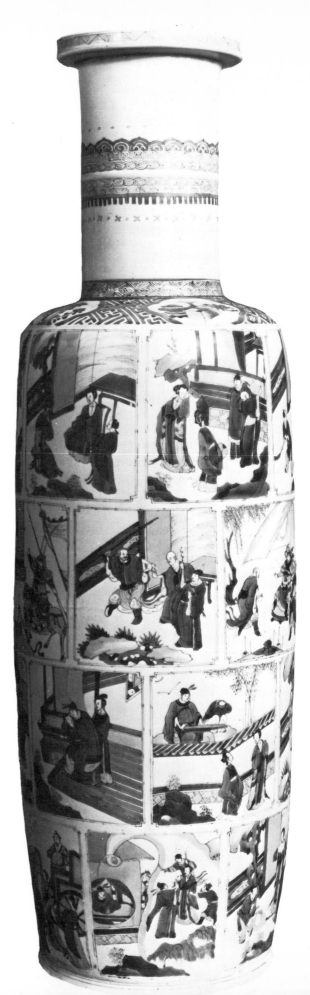

We may well believe that there were 'interested motives' that opposed the removal of the factories, for at that time they had been established at Ching-te Chên for over 200 years, and all the raw materials that the potters needed were near at hand. Happily the emperor was persuaded out of his folly, and by the ninth month of the same year (1680) an imperial decree was issued ordering porcelain from the factories.

The uncertain fortunes of the first part of the reign can now be considered as ushering in the second period, which began auspiciously in 1683 with the appointment of Ts'ang Ying-hsuan, who may himself have been a master potter, as director of the imperial factories. It is therefore clear that the emperor had altogether given up his schemes for moving the factories, and under his firm patronage they could now settle down to producing the characteristic wares for which his reign is known. Perhaps the best known of these are the 'prunus blossom' jars, which are beautifully decorated with sprigs of plum blossom against a blue ground painted in such a way that it can be said to resemble the cracking of ice on frozen rivers at the end of a hard winter (Plate 51). These jars, which were copied and vulgarised time out of mind in the centuries that followed, were used for gifts of ginger and other suitable sweetmeats at the Chinese New Year. The prunus blossom design, also popularly known as the 'hawthorn' design, is symbolic, as we have already seen on saucer dishes decorated with the 'Three Friends', of the passing of winter and the approach of spring. It has been copied on to almost every conceivable ceramic form, notably the bottle vases of the period and also, in the eighteenth century and later, on the border of dishes and plates.

Just as well known as charactesistic of the K'ang-hsi reign are the massive vases in *rouleau* form (Plate 52), which were to achieve immense popularity at the end of the last century and prompt Oscar Wilde to say: 'I find it impossible to live up to all this blue and white.' Of huge dimensions, often standing as much as 36in high, they had to be made in two or three sections before being luted together and fired as one piece (see Appendix A). As can be seen from the example illustrated, they are often skilfully decorated with a number of comparatively small panels, each showing a scene from a story.

53 Pair of vases, K'ang-hsi period and made of 'soft paste', one decorated with a scene depicting a man carrying a child on his pony and a servant struggling behind (A), and the other inscribed with a verse from a poem (B). (Diameter: 7.2cm)

Among the other decorative motifs that can often be seen on the later wares of the reign are landscapes derived from Sung and Ming paintings, historical or legendary characters, and poetic verses. The figure on horseback on the cup illustrated in Plate 53A is Ho Chih-chang, who was active in the middle of the tenth century as a statesman and poet. The scene depicts an incident when, being both a very bad rider and very drunk, he mounted a horse from which he was soon thrown down a well shaft. There he was later found sleeping peacefully. A poetic inscription on the other side of the cup, which commemorates the event, can be translated as follows:

For Chih-chang riding a horse was like
 sailing a boat,
He just closed his eyes and fell into a well to
 sleep.[7]

The pair to this cup (Plate 53B) is also inscribed with a poem that can be translated as

Set out three cups and pass them round to
 the sages,
Tossing off your cup, you bare your head
 before kings and princes,
And carelessly write on paper as misty as
 clouds.[8]

The other side of this cup bears a scene in illustration of the verse, showing three sages and an attendant engaged in literary pursuits.

The underglaze decoration of K'ang-hsi blue and white is painted in a pure sapphire blue that the reign has always been famous for. The outlines are often so faint as scarcely to be visible, and the decoration as a whole shows delicately graded washes of blue that give a most pleasing effect. This is not surprising, for the greatest possible care was taken in the preparation of the cobalt blue, and the ideal medium for painting designs was still considered to be blue and white. The demand for it both at home and abroad was enormous, and so the paste for making the vessels was also prepared from carefully selected clays freed from all impurities. Great care was taken over the potting, and before any vessel was glazed, it was brushed over with a feather duster so as to remove any impurities that had escaped notice before. The glaze itself, which is thin and lustrous, has an attractive suspicion of bluish-green about it instead of being the dead white that so often betrays the finest nineteenth-century attempts to copy the wares of the period. Occasionally, however, it is slightly marred by minute brown specks known as 'pinholing', and these are particularly noticeable on the base of the wares. This is of little account, however, for many of the finest wares were made for display rather than everyday functional use, and have a foot-ring that is often grooved or beaded as though the piece was intended to be placed on a wooden stand.

54 Pair of saucer dishes, late K'ang-hsi period, decorated with cranes and peach trees. (Diameter: 15.8cm)

Such was the demand for blue and white porcelain throughout the middle part of the reign that methods of mass production were introduced, and a single piece might pass through as many as seventy pairs of hands before it reached the kiln. One man would give the vessel its basic shape on the wheel, another would add handles and spouts as necessary and a series of others would be responsible for the various stages of underglaze decoration. No one man, therefore, could claim the finished product as his own, though there is no indication that the decoration was ever as perfunctorily applied as in other periods when an enormous demand resulted in mass production. The allegation, moreover, that decoration towards the end of the century was mechanical is surely refuted by the pair of saucer dishes sensitively decorated with cranes and peach trees that are illustrated in Plate 54.

In the K'ang-hsi period we can also notice two completely new developments in the production and decoration of blue and white porcelain. The first of these concerns the use of what is commonly called 'soft paste'. This is a modern term that is totally misleading, and is more often used to describe the completely different kind of wares that were produced in Chelsea and Sèvres in the eighteenth century. It should rather be referred to by its Chinese name, *hua-shih*, and so far from

being soft, it has an intensely hard body, though the glaze that is applied to it gives a rather softer effect than is normally seen. *Hua-shih*, which was used extensively towards the end of the following century, was considered very rare during the K'ang-hsi period, and was certainly far more expensive than ordinary porcelain. The paste has a far finer grain than is usual, and Père d'Entrecolles likened painting on it in contrast to ordinary porcelain as writing on vellum in contrast to paper. It is also very much more fragile and lighter than porcelain and so was predictably used for making small objects for the table and scholar's desk. The vases illustrated in Plate 53 are clearly made in *hua-shih*, and 53B shows the characteristically irregular crackle that the glaze develops later if it does not appear as soon as the wares are taken from the kiln.

The spirit of innovation was clearly abroad, and the second development of the potters, who were not content to keep to traditional techniques in underglaze blue decoration, was to invent a new one. Glaze had long been blown on to the body of a vessel through a bamboo pipe, but now the potters tried first blowing a background field of cobalt blue on to the body of the wares and then glazing them. That they were able to do so suggests that once again they had a plentiful supply of the blue pigment, and this is

but to be expected, for, as we have already noted, the Chinese had now discovered reliable methods of refining their own previously unsatisfactory local cobalt. The consequent effect, known as 'blown' or 'powder' blue, has a somewhat speckled appearance, clearly caused by the splatter of the minutely ground cobalt as it came into contact with the vessel. During the K'ang-hsi period porcelain painted in this way also shows white panels decorated with underglaze motifs of the type seen on the two vases illustrated in Colour Plate VIII, and very pleasing is the general effect. It was, however, also an innovation that we may well conclude presaged a major break with the traditional blue and white techniques, for, even before the close of the K'ang-hsi period, and even more frequently during the eighteenth century, the panels that the 'blown' blue surrounded were decorated not with underglaze blue but with enamelled motifs. In addition, the potters later developed a tendency to 'improve' on the 'blown' blue by adorning it with scrolls in gilt.

The final ceramic period of the K'ang-hsi reign, which began in 1710, is characterised by a stricter control than ever over the imperial factories and also by the increasing popularity of *famille verte* enamel wares. A number of special plates to commemorate the emperor's birthday were made during this period, and they were also decorated with overglaze enamels. A variety of delightful small jars and vases with a 'peach bloom' glaze can also be attributed to the closing years of the reign. While it is true that blue and white wares were certainly still made in this final period of the reign, there is therefore some reason to believe that they had begun to give ground to the enamelled porcelain and monochrome glazes that were to become increasingly popular in the rest of the eighteenth century.

5 Later Blue and White: the Eighteenth and Nineteenth Centuries

By the time K'ang-hsi died in 1722 the Ch'ing dynasty was firmly established in power and the empire it ruled stronger than ever. The reign of his son, Yung-chêng, was to be a period when the greatest emphasis was laid on the production of new glazes and the simulation of the classical wares of the Sung and Ming dynasties. According to the *T'ao lu*, it was from this period that the copies of older pieces stem. T'ang Ying, one of the most influential men ever to be appointed superintendent of the imperial factories, compiled a list of the wares required by the court, and this, though not as comprehensive as we might wish, gives us a good impression of the variety of porcelain produced during the reign. Of the sixty types that he refers to, only three—copies of Hsüan-tê, Ch'êng-hua and Chia-ching wares—are described as being decorated in underglaze blue. We may therefore conclude that although blue and white was still popular, its production must now clearly be seen in the context of the growing popularity of enamelled wares and the different types of monochrome glazes produced in imitation of Sung wares.

In attempting to copy Hsüan-tê blue and white the potters contrived to imitate the 'heaped and piled' effect and the 'orange peel' texture of the glaze that we have already observed in the authentic wares of the fifteenth century. As a rule these attempts are not good enough to deceive, though there are a few examples that frequently require close scrutiny before they can be correctly identified. The pilgrim flask illustrated in Plate 55 is clearly very closely modelled on the flask of the Hsüan-tê period illustrated in Colour Plate IV. Although the later flask is undoubtedly decorated with very considerable delicacy and skill, a careful examination of the two flasks will reveal that it is no more than an extremely competent copy of the earlier piece. The refinement, sensitivity and skill in potting are all there, but in the Yung-chêng flask there are indications that betray the painstaking yet skilful efforts of the imitator.

Other simulations of Hsüan-tê wares are easier to detect, for the 'heaped and piled' effect has obviously been deliberately applied. On the flask illustrated in Plate 56 we can see an example of this contrived effect, for the dots along its floral spray are too regularly placed to be the accidental result of painting with a too heavily loaded brush. As if to remove any lingering doubt that may have remained, this vase is correctly marked with the *nien hao* of the period. That many Yung-chêng are so marked only confirms that here was no deliberate attempt to deceive, but rather an act of tribute to the superb wares of the fifteenth century. Such was their popularity that great care was taken to imitate them in every particular. Père d'Entrecolles tells us of how rather earlier in the century the imitations were cooked in a broth of chicken and other meats after they had been fired, and then left in the muddiest sewers for a month in order to counterfeit an antique appearance.[1]

Attempts to copy Ch'êng-hua and Chia-ching wares were rather more successful. The delicate and even feminine style of decoration popular during the Yung-chêng period was more akin to that of Ch'êng-hua wares, and the thin and translucent glazes that we associate with the earlier wares could easily be copied by eighteenth-century potters. Using, as they did, a well ground and purified cobalt, they were also able to copy the styles of the Chia-ching potters, though the shapes of the wares belong more to the eighteenth century than to the sixteenth. The teapot illustrated in Plate 57, like the ewer in Plate 38, is decorated with *wa-wa* or children at play, but while the earlier piece could equally well have been used to contain water or wine, there is no mistaking that the eighteenth-century vessel is intended purely for tea.

Despite what appears to be described in T'ang Ying's list, the K'ang-hsi styles of blue and white decoration continued into the later reign alongside copies of earlier wares. As with many of the copies of Ch'êng-hua and Chia-ching pieces, the blue of these is lavender in tone or occasionally slightly darker where it has been thickly applied, and the body appears as silvery white under a smooth and even glaze. The *mei-p'ing* vase in Plate 58 is a superb example of the fine potting of these wares. It is markedly different from earlier vases of this type, showing a gently rounded body tapering down to a slender base and a meticulously finished shallow foot-ring that has been moulded to fit on to a wooden stand.

When the emperor died in 1735, he was succeeded by his son, Ch'ien-lung. His reign lasted until 1796, when he abdicated out of respect for his grandfather, K'ang-hsi, for he did not want to reign longer than him. His reign was

55 Flask, Yung-chêng period, decorated in the fifteenth-century style (cf Colour Plate IV) with birds perching on prunus and bamboo, tendril spray borders around the foot and upper body and bamboo sprays around the neck. (Height: 29.8cm)

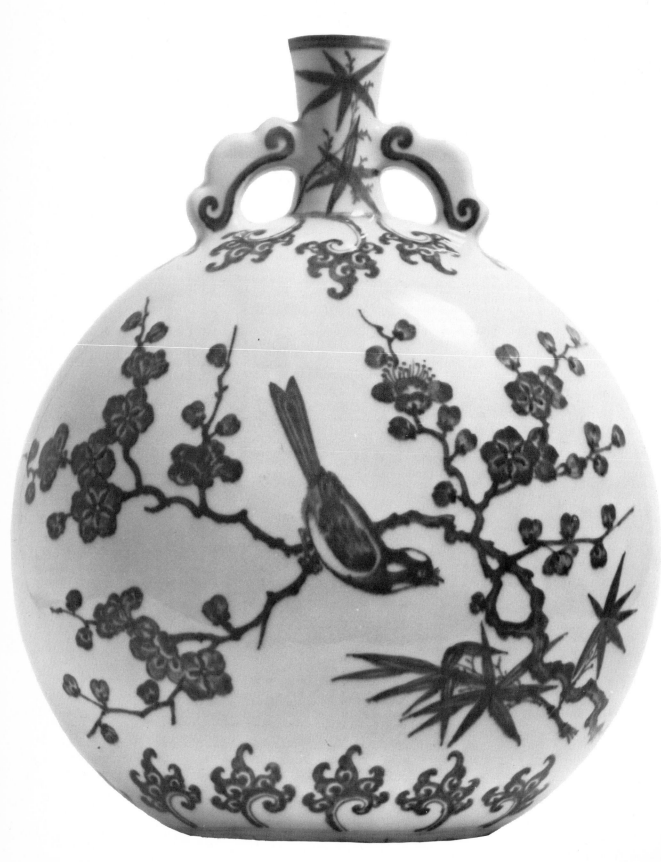

56 Flask, Yung-chêng mark and period, decorated in the fifteenth-century style with a composite floral scroll including peony and chrysanthemum, lotus panels around the foot, *fleur de lys* around the shoulder and a classic scroll at the rim. (Height: 22.8cm)

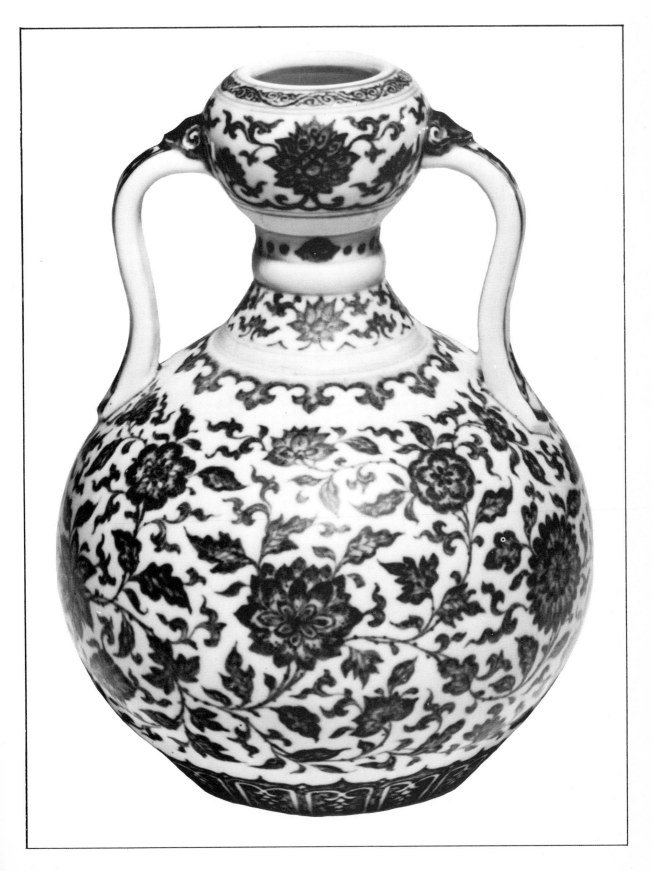

57 Teapot, Yung-chêng period, decorated in the Chia-ching style with *wa-wa* playing in a garden. The base shows the six-character reign mark of K'ang-hsi. (Height: 14cm)

58 Vase of unusual *mei-p'ing* form, Yung-chêng mark and period, decorated with a pattern of dense scrolling foliage whose thin curving stems sprout feathery serrated leaves. (Height: 23.5cm)

to see the zenith of Ch'ing power, but also the beginnings of its decline. The first four decades showed all the evidence of vigour, integrity and wisdom in the use of an autocratic power less restrained than in any other period of Chinese history. The population increased, the arts flourished and trade expanded. Europeans in the imperial service expressed admiration for all they saw, and this gave rise to a vogue for Chinese styles in Europe that ranged from landscape painting to the wearing of pigtails. The emperor himself was an enthusiastic patron of the arts and a connoisseur of porcelain, and it was during his reign that all the wares in the imperial collection were carefully catalogued. This long period of prosperity and success, however, gave rise to vanity in the emperor in his later years, and in 1780 he entrusted the government of the empire to his unscrupulous minister Ho-shen, who knew

well how to satisfy that vanity while he helped himself to all manner of perquisites. It is not surprising, therefore, that rampant corruption in the government service resulted, while the morale of the mandarinate sadly deteriorated.

In the early years of the reign T'ang Ying, who had been superintendent of the imperial factories since 1729, was able to ensure that fine porcelain was produced for the court; but after his retirement some twenty years later there was a marked decline in the quality of blue and white, though the fine quality of the enamelled porcelain of the period confirms that the potters were as skilful as ever. There is also some reason to believe that blue and white went somewhat out of fashion towards the end of the century, and a great deal of what was made was destined for export to the West rather than the home market.

Yung-chêng traditions continued, however,

59 Pilgrim flask, Ch'ien-lung mark and period, decorated in the fifteenth-century style with eight lotus panels framing the Eight Buddhist Emblems, a motif of eight *ju-i* heads on the central boss, a key fret pattern around the outer perimeter and central boss and *ling-chih* fungus around the neck and foot. (Height: 49.2cm)

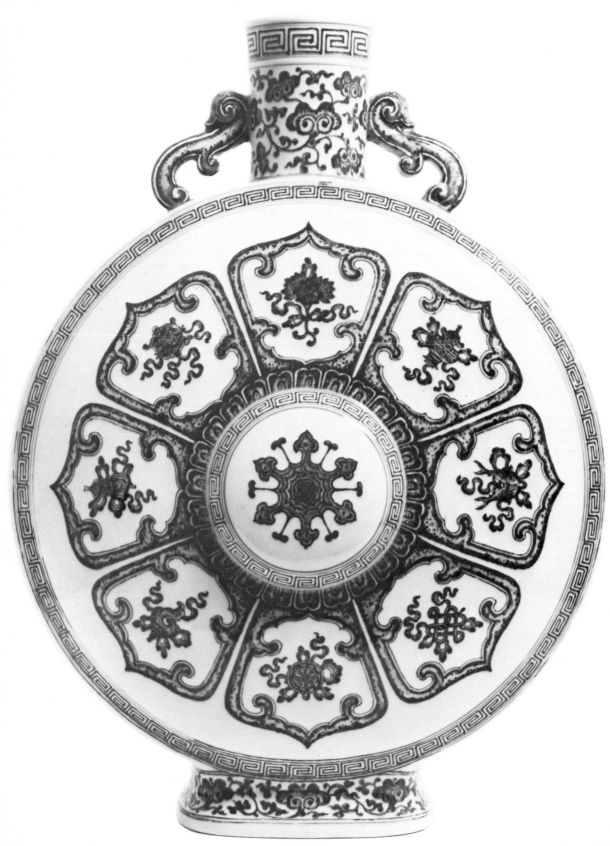

60 Vase, Ch'ien-lung mark and period, decorated in shaded tones of blue with four medallions of two butterflies each, surrounded by a fruiting gourd with leaves and tendrils; five further butterflies forming a design above a band of *ju-i* heads around the foot; the neck decorated with another fruiting gourd and further butterflies. (Height: 41.2cm)

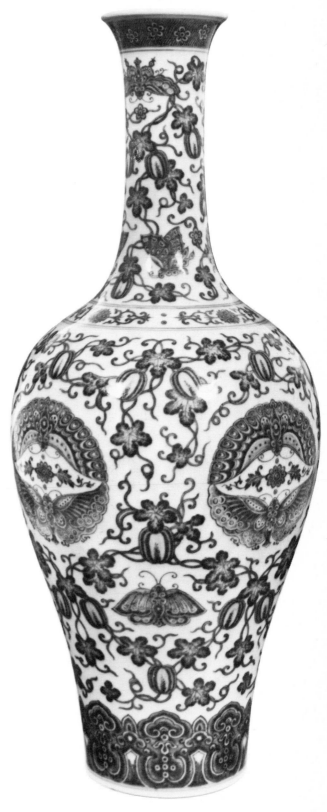

when the reign was still young, and copies of Hsüan-tê wares were still made. Though some of these early examples are very fine, it is true to say that those of the Ch'ien-lung period are rather inferior to those of the earlier reign, and very much easier to detect. The *mei-p'ing* vase and ewer in Colour Plate IX are decorated in a very fine blue, but in the following years the blue of similar wares often appeared almost blackish against a dead white ground. The ewer illustrated is clearly a late echo of the type that has already been noted in Plate 15, and the *mei-p'ing* is no less obviously based on a very common early fifteenth-century prototype. The deteriorating attempts at imitation are evident from the large pilgrim flask illustrated in Plate 59. Though this is a well potted piece and handsomely decorated with the Eight Buddhist Emblems that we have already considered in Plate 28, the attempt to simulate a 'heaped and piled' effect in obviously contrived dots of darker blue is feeble and very easy to detect. There was, however, no attempt to deceive, for this flask, like the *mei-p'ing* and ewer, bears the seal mark of Ch'ien-lung.

The finest of Ch'ien-lung wares were frequently not those made in attempted imitation of fifteenth-century pieces but those decorated in an altogether new style. In the best of these the potter was able to show that he had complete mastery of his materials and could still produce porcelain that was finely potted and delicately and sensitively decorated. Unhappily this skill was not to survive into the latter part of the reign, but the vase illustrated in Plate 60 reveals that, in the early years of the period at least, the Ch'ien-lung potter was the equal of his K'ang-hsi ancestor. This vase, which is clearly of imperial quality and bears the seal mark of the period, is well potted and superbly decorated in a clear lavender blue with butterflies amid the branches of a fruiting gourd. The four butterfly medallions, which are meticulously painted in delicately shaded tones, again emphasise the skill and mastery that the finest of the potters could show.

The technique of potting in 'soft paste' or *hua-shih* that had started, as we have already seen, during the K'ang-hsi period was particularly popular during the Ch'ien-lung reign for the manufacture of very small pieces. The small box shown in Plate 61, which was used for containing the red paste used in Chinese chop marks, is

61 Box and cover, Ch'ien-lung period, made from 'soft paste' and decorated with a scene depicting an episode from the Dragon Boat Festival. (Diameter: 12.6cm)

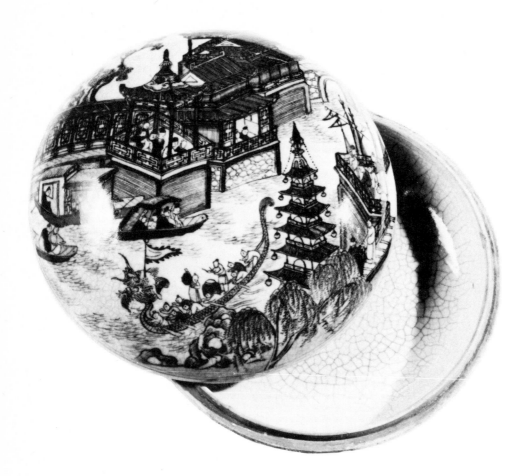

typical of the 'soft paste' wares made at the end of the century. The lid, decorated rather in the K'ang-hsi style, depicts a scene from the Dragon Boat Festival, and the rather dull glaze of the interior reveals the characteristic brown crackle that we have noted before.

When the old emperor abdicated, he was succeeded by his fifteenth son, who took the reign title of Ch'ia-ching. The empire that he succeeded to had already been planted with the seeds of decay; the imperial government was thoroughly corrupt and demoralised and the populace discontented. A more able man might have been able to stem the tide, but the new emperor surrounded himself with time-serving courtiers and brutally reprimanded those honest officials who had the temerity to remonstrate with him. Even after the dismissal of the notorious Ho-shen in 1799, the empire was troubled by revolts of various sects in the north and piracy in the southern seas that called for years of continuous warfare and sadly depleted the imperial treasury.

It is scarcely surprising in these circumstances that the quality of porcelain continued to decline. The best examples of blue and white porcelain are probably to be found in the interior of the so-called 'Peking bowls', which were decorated on the outside with *famille rose* enamels. While there was a general decline in quality, the traditions of the previous reign continued, and the best of Ch'ia-ching wares can compare very favourably with those made in the closing years of the old century. The decoration on the saucer dish illustrated in Colour Plate X is formalised in the extreme, but the gently shaded tones it shows and the delicacy of the potting are more suggestive of the wares of the mid-eighteenth century. This dish, which is clearly of imperial quality and is exceptionally finely finished, confirms that there were still potters at work who were capable of producing fine wares of almost feminine delicacy.

There was an attempted renaissance during the reign of Ch'ia-ching's successor, Tao-kuang (1821–50), but it was destined to be short-lived. His reign is better known for the complete dis-

62 Pair of covered vases, Tao-kuang period, decorated in the K'ang-hsi style with nesting and flying cranes and deer amid rocks and pine trees. (Height: 47cm)

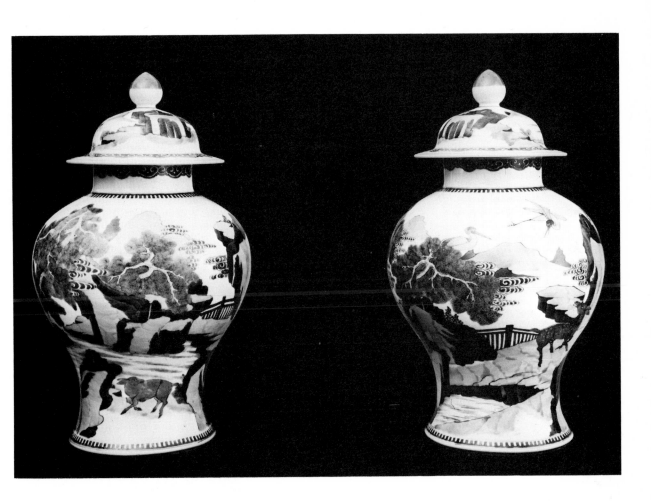

appearance of the last vestiges of imperial authority; it was to see the loss of Hong Kong to Britain, the establishment of extra-territorial rights for foreigners, the increasing influence of foreign missionaries and rapacious traders, and the cession of the 'Treaty Ports'. Throughout the period there was continual dissension, which was to explode a few years after its close in the disastrous Tai P'ing Rebellion.

It is surprising, therefore, that anything in the nature of a renaissance was possible at all when the dynasty was so clearly doomed. Much of the blue and white porcelain decorated with *tou t'sai* enamels, however, was better than anything that had been seen for almost forty years. A number of copies of K'ang-hsi blue and white wares were also made during the reign with a good deal of skill (Plate 62), and the best of these can be distinguished from their originals only by the dead chalky white of the body.

Some of the potters also continued to make copies of fifteenth-century wares, though these normally carry the seal mark of the period and make no pretence of being as skilfully potted as the earlier eighteenth-century copies. The bowl in Plate 63, which has been copied with a great deal of skill and artistry, is of particular interest, for it has clearly been modelled on a bowl in the National Palace Museum in Taipei that was made in the Ch'êng-hua period and has been decorated with *tou t'sai* enamels over the blue decoration.[2] It is very possible that the later bowl was originally intended to be decorated in this way, too, but for some reason the enamels were never added.

The Emperor Hsien-fêng, who succeeded to the rapidly disintegrating empire in 1850, was a man of little culture and so showed very little patronage to the potters. Even if he had been a very different ruler, there is no real reason to believe that he could have given the potters much support, for the Tai P'ing Rebellion broke out just after his accession and continued until almost the end of the reign. The rebels, who only just failed to topple the dynasty, succeeded in devas-

85

63 Bowl, Tao-kuang mark and period, decorated on the exterior with mandarin ducks swimming amid lotus and other water plants beneath five-clawed dragons contending for the flaming pearl around the rim; the interior of the rim decorated with Tibetan Sanskrit characters. (Diameter: 16.5cm)

64 Leys jar, T'ung-chih period, decorated with a floral scroll and lappets, alternating wth a leaf motif, suspended from a continuous scroll at the rim, a key fret motif and a band of *ju-i* heads around the shoulders and a band of lotus panels around the foot. (Height: 14cm)

tating the whole of central China. Ching-te Chên itself was destroyed, and those potters who had not fled were massacred. As if the rebellion did not present problems enough, the Second Opium War broke out in 1856 and Peking itself was looted by the invaders. It is scarcely surprising, therefore, that very little porcelain with the imperial seal mark was produced, and the little that was made is of distinctly inferior quality. The middle of the century is known, however, for the production of a number of massive vases that sometimes measure nearly as much as 5ft in height, and are frequently quite attractively decorated; since they are too tall to be placed on any piece of furniture, they are today known as 'floor vases'.

With the return of something like order to the empire at the beginning of the following reign, the new emperor, T'ung-Chih (1862–74), caused the imperial factories to be rebuilt. Again there was an attempted renaissance, but yet again it eventually came to nothing. There is good reason to believe that the spirit and at least the potential skill of the potters was as great as ever, but the doomed fortunes of the dynasty, bureaucratic confusion and corruption and Moslem rebellions in the western provinces combined to make any real imperial patronage or the production of quality porcelain impossible. Even so, the refine-

ment of the delicately potted and decorated leys jar illustrated in Plate 64 is evidence that the factories had recovered from the sack of Ching-te Chên a few years earlier, and were once again able to produce fine wares if only the opportunity arose.

That opportunity was not to arise in the few remaining years left to the Ch'ing. The next emperor, Kuang-hsü, who succeeded his half-brother in 1875, left no impression on Chinese history, even though his reign continued until 1908. Like his predecessor, he was dominated by the redoubtable figure of the Empress Dowager, Tz'u Hsi, widow of the Emperor Hsien-fêng. For almost half a century this former concubine ruled the imperial household and Chinese empire, and yet when she eventually died at an advanced age, it was without having contributed anything of value to the welfare either of the dynasty or the Chinese people. Rapacious in the extreme herself, her greed also gave rise to corruption on an unprecedented scale. She also thwarted the nascent reformist movement at the end of the century and subsequently connived in the anti-foreign Boxer uprising, which eventually gave rise to yet another foreign occupation of Peking in the early years of this century.

The empire was tottering to its final collapse,

65 Saucer dish, Kuang-hsü mark and period, decorated with a scroll of Indian lotus in the central field and lotuses and leaf motifs around the rim. (Diameter: 15.7cm)

66 Dish with inverted rim, early twentieth century, decorated in the Ch'ien-lung style with two five-clawed dragons contending for the flaming pearl amid cloud scrolls and flames. (Diameter: 26.5cm)

and, in the absence of any real imperial patronage, the quality of porcelain suffered acutely. R. L. Hobson has said that the chief interest of collectors of Chinese porcelain is to avoid the period. The potters of the time, however, strove to imitate Ch'ien-lung wares that the Empress Dowager had sent to them to copy. Their efforts were of little avail, for the decoration is at once weak and highly formalised, and their materials were inferior to those used earlier. The saucer dish illustrated in Plate 65 is typical of many of the wares made for the court, and illustrates the decline in quality that had been continuing since the middle of the nineteenth century. Blue and white had fallen from imperial favour, and was used only on the anniversaries of deaths in the family.[3]

As so often has happened, however, when it was clear that the court was either unable or unwilling to provide the patronage the potters needed, they found support from a number of

private patrons, and the wares produced in private kilns are often finer than those that came from the imperial factories. Most typical of these are large vases and dishes like the one illustrated in Plate 66, which are decorated in the styles of the seventeenth and eighteenth centuries with fearsome and well drawn dragons. Well potted though these wares are, they can almost always be distinguished from earlier pieces by the scales of the dragons, which appear to have been pricked out with a pin or sharp drawing instrument, so that the dragons themselves give the impression of being pitted all over with minute indentations.

The reign of the last Chinese emperor, Hsüant'ung, who reigned for three brief years before the final collapse of the dynasty and ended his days in the service of the People's Republic in 1967, is quite without significance in ceramic history. The history of blue and white, however, has continued since his abdication, and the 1920s and 1930s saw the production of some very fine copies of Ming and early Ch'ing wares that are fakes in the true sense of the word and often hard to detect. The Cultural Revolution inevitably put a stop for a while to the production of fine porcelain, but in recent years some intricately decorated wares made from porcelain of the finest quality have appeared. While the decoration of some of these is unhappily transfer-printed rather than hand-painted, there is also evidence that once again there are a number of very skilled potters at work.

6 Provincial Ming Wares
and Exports to Southeast Asia

67 Provincial wares, late fifteenth or early sixteenth century:
A and C, dishes, decorated respectively with a *ch'ilin* and a
peacock, each 30.5cm in diameter; B, a storage jar or *kuan*
with decoration in white reserved on a blue ground of three
sea-dragons contending for the flaming pearl amid cloud
scrolls, a band of lotus panels around the foot, phoenixes on
the sloping shoulders and a continuous scroll around the
rim. (Height: 29.8cm)

With very few exceptions, Chinese writers have
paid no attention to those porcelain wares that
were not made under imperial supervision for use
in the palace and at court. Even the fine white
wares of Tê-hua that we know as *blanc de chine*
are described very vaguely in the *T'ao lu* as having
been first produced 'sometime in the Ming
dynasty'. Many of these simple and stoutly potted
wares, however, are often very attractively deco-
rated, and show a far greater freedom and spon-
taneity than many of the later Ming imperial
wares. Study of them depends almost entirely on
the types of porcelain themselves and on the few
accounts that we have, very largely from South-
east Asia, of the uses that were made of them in
the countries to which they were exported.

Very many such wares are found in Southeast
Asia today, for they have been allowed to survive
there very much longer than in China. Not very
surprisingly, the peoples of the region prized them
very highly, and many of the wares were buried
with the dead or else carefully treasured and
handed down from one generation to the next. In
China, on the other hand, like so many other
simple domestic wares throughout the world,
they have been broken over the years. Coming as
they now do from Indonesia, Malaysia, the
Philippines and Thailand, they are frequently
referred to as 'export ware', but it is very likely
that many such wares are really identical to the
simple domestic vessels that were used in count-
less households throughout China. Many of them

can be compared in shape and form to the well
documented wares of finer quality that can easily
be attributed to a particular period, though they
are more roughly potted and freely decorated
(Plate 67). There are other types, however, that
can be considered genuine 'export ware', for
these were clearly made to suit the particular
requirements of the peoples of Southeast Asia.
We may well imagine that the crews of Chinese
junks trading in the region discovered first that
the porcelain they had taken along with them was
popular with the islanders, and then realised its
potential as an export commodity. By the end of
the sixteenth century, and very probably long
before, China had discovered that it was well
worth her while to barter for the goods she
needed with porcelain, for, as a Dutch trader
recorded in 1598, 'those [merchants] of China
trafficke with these islands and bring thither al
sortes of commodities out of their country, as al
silkes, cottons, porseleynes . . . and al curious
things that may be found'.[1]

The export of rare and precious articles was
usually forbidden by the Chinese authorities,
though gifts of porcelain of almost imperial
quality were occasionally presented to distin-
guished princes and others who had offered
tribute to the emperor. Until the end of the four-
teenth century celadon wares were the staple
export to Southeast Asia, though some shards of
Yüan blue and white have also been discovered at
Kota Batu, the site of the original capital of the

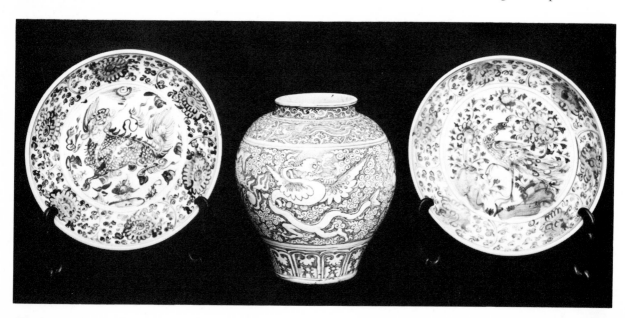

Fig 4

CHINA AND THE SOUTHEAST ASIAN TRADE ROUTES

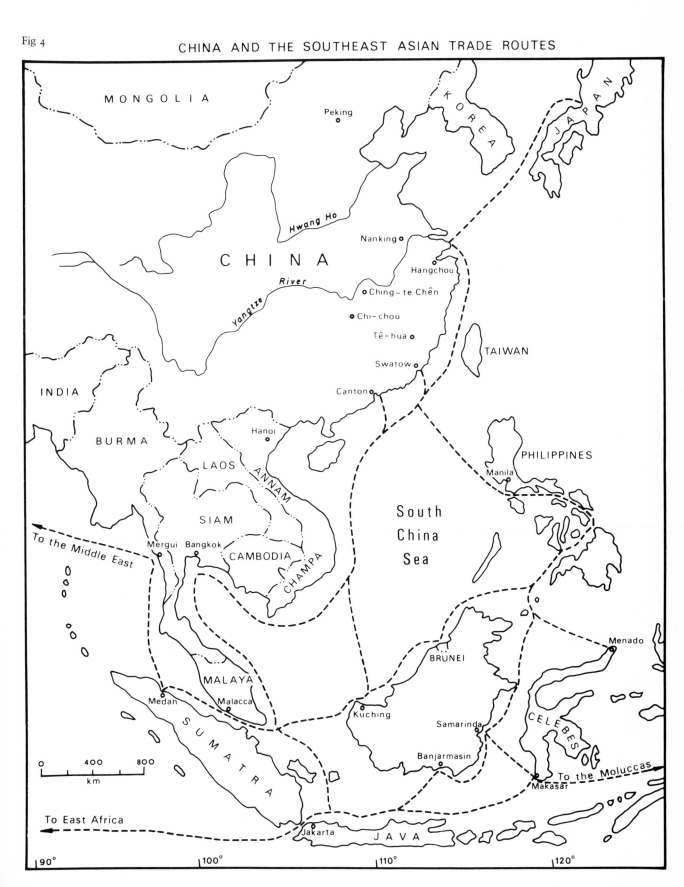

68 Export wares for Southeast Asia. A, water dropper modelled in the form of a chicken, early sixteenth century. (Height: 8.8cm). B, 'hole-bottom' saucer dish, late fifteenth or early sixteenth century. (Diameter: 9.7cm). C, *kendi*, 'Swatow' ware, early seventeenth century, set with Indonesian metal mounts, finely fluted around the bowl and spout and decorated with peonies. (Height: 20.9cm)

VI Jar with knobbed cover, Chia-ching mark and period, decorated with children playing in a garden, lotus scroll around the foot and shoulders and a border of interlocking cloud collars around the short neck; the lid decorated with scrolling lotus around the perimeter, florettes formed of circles and a circle of demi *ju-i* heads and petals around the central knob. (Height: 38.2cm)

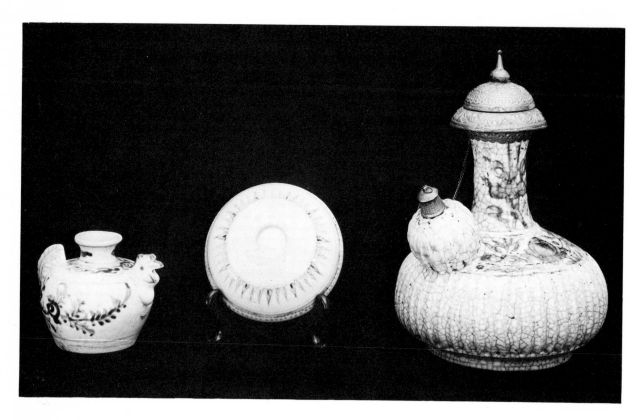

Brunei sultanate. Gifts to Middle Eastern potentates, however, were another matter, and blue and white porcelain was exported throughout the Yüan and Ming dynasties to the Persian court, where it was presented to the Ardebil Shrine by Shah Abbas at the turn of the sixteenth century, and to the Ottoman emperor. Coarser wares, often destined for the Southeast Asian market, could also often be picked up by merchants in most southern Chinese ports.

Just as the interest in and the demand for Chinese porcelain grew in Southeast Asia, so were the Chinese merchants ready to meet that demand with the supply of the coarser blue and white wares that we have just considered, and also with porcelain made especially to suit Southeast Asian tastes. Here, then, we have the genuine 'export porcelain' as opposed to the ordinary household wares that happened to be exported. Some of these wares are basically Chinese, but inscribed with Arabic characters to suit the Moslem communities of the region, very much in the same way that a good number of Chêng-tê wares were so inscribed to please the Moslem eunuchs at court. More typical of true 'export wares' were *kendis*, which were vessels for con-

taining water and associated with Buddhist ritual (Plate 68c); and small jars and water droppers made in the form of such birds as mandrake ducks (symbolic of marital bliss) and chickens (Plate 68A), or in the form of animals and reptiles like tortoises and frogs. These are clearly copies of earlier native earthenware vessels.

Other familiar export types include 'dragon' jars used for storing foodstuffs, which were particularly popular in north Borneo and extensively copied in Cantonese stoneware in the eighteenth century, and the peculiar 'hole-bottom' saucer dishes that seem to have been exported mainly to the Philippines and, to a rather lesser extent, to Indonesia in the late fifteenth and early sixteenth centuries. These show a recessed circular base (Plate 68B) and frequently have a raised orange-brown coloured fish at the centre. It is possible that the recessed base was so moulded to permit the dish to be fitted to the top of a bamboo and hold some form of oil lamp, very much in the same way that aluminium containers are used in Southeast Asia today. For some as yet inexplicable reason it appears that excavated children's graves in the Philippines have yielded twice the quantity of 'hole-bottom' saucer dishes as adult

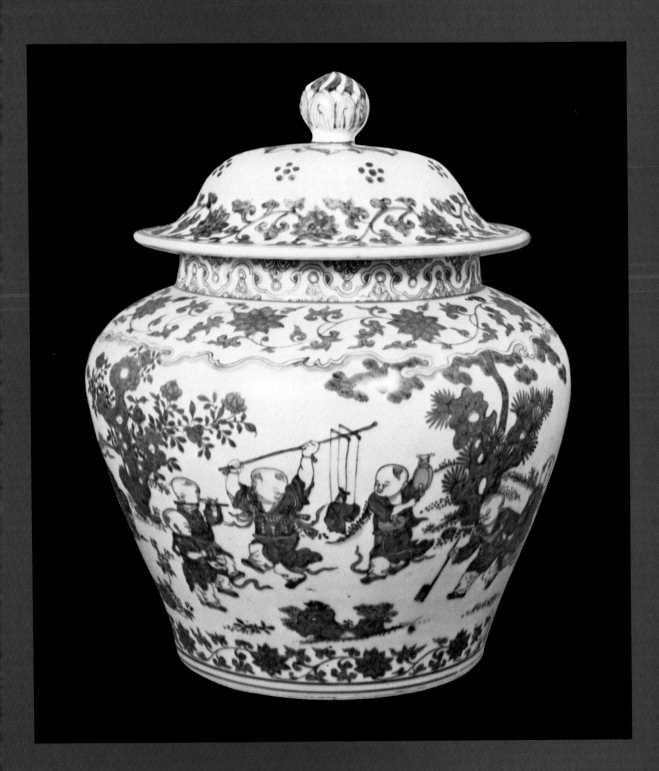

previous pages

VII Covered vase, Transition period, decorated around the sides with a mandarin beneath a willow tree, an attendant figure, a deer, a lakeside scene and distant mountains, and on the lid with a dilettante figure. (Height: 18.5 cm)

VIII Pair of covered vases of *rouleau* form, K'ang-hsi period, decorated with human figures, birds and flowers in medallions reserved on a background of 'blown' or 'powder' blue

69 (*below*) Dish, Tê-hua ware, late sixteenth century, decorated with a scene depicting an old man seated in a garden beneath the shade of a willow tree. (Diameter: 25.9cm)

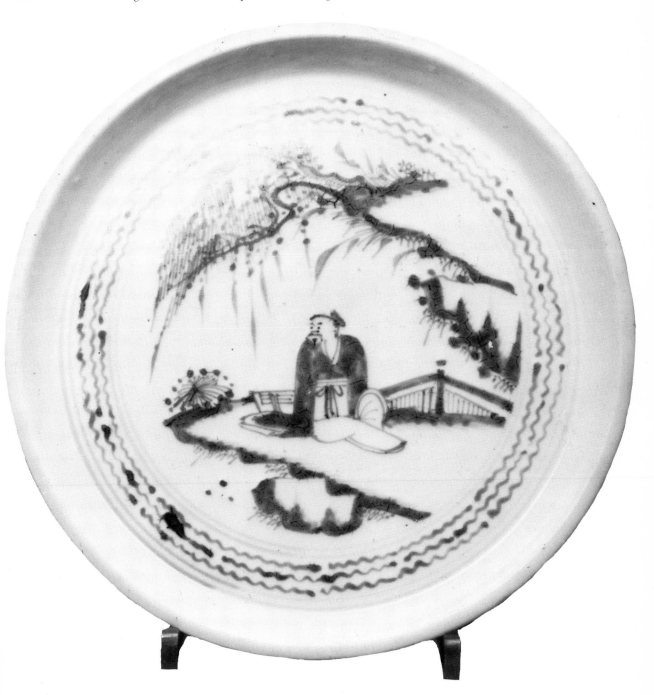

opposite

IX A Ewer, Ch'ien-lung mark and period, decorated in the fifteenth-century style with barbed quatrefoil panels on either side, one framing a fruiting peach branch and the other a bunch of lychees, surrounded by a chrysanthemum scroll; a band of lotus panels around the lower part of the bowl and a continuous scroll around the foot; the sloping shoulders are decorated with a stylised lotus scroll surmounted by stiff plantain leaves around the neck, the spout with floral scrolls and the handle with *ling-chih* fungus. (Height: 25.8cm)

B Vase of *mei-p'ing* form, Ch'ien-lung mark and period, decorated in the fifteenth-century style with flowering branches above boughs of peaches, lychees and pomegranates, each rising from sprigs of *ling-chih* fungus, stiff plantain leaves around the foot and a band of lotus panels around the shoulders. (Height: 32.5cm)

X Saucer dish, Ch'ia-ching mark and period, decorated in the central field with a three-pointed device having peonies on each of the three points and three stylised 'longevity' characters. (Diameter: 15cm)

70 'Swatow' ware, late sixteenth century. A, dish, decorated with a scene depicting a phoenix, chrysanthemum and bamboo beneath the moon in the central field and concentric waves interspersed with floral motifs around the flattened edge. (Diameter: 27cm.) B, dish, decorated with three daisy-like flowers in the central field and a roughly drawn continuous scroll around the narrow flattened edge. (Diameter: 22cm)

graves.[2] Is it therefore possible that they were some form of child's plaything?

Though most of the wares destined for export are distinctly more roughly made than those considered in the previous chapters, many of them were probably produced in a number of private factories in and around Ching-te Chên, and not considered fine enough for presentation to court. Others were almost certainly made at a number of sites in Fukien and other southern Chinese provinces. The best known of these are the so-called 'Swatow wares' of the late sixteenth century, which probably take their name from the port they were considered, quite erroneously, to have been exported from. The nineteenth-century port of Swatow, however, was an obscure little fishing village during Ming times and quite incapable of accommodating the ocean-going junks that were used to carry these wares to their export destinations in India, Southeast Asia and Japan.

With a few exceptions, 'Swatow wares' are all large plates and dishes of irregular shape made from inferior clay and lacking in finish. Instead of being carefully brushed over with glaze, as is the case both with the finer wares and also the simpler and more stoutly potted household wares, their bases give the impression of having been casually splashed with glaze, and sand or grit adheres to the foot-ring. They are, however, freely and boldly decorated with enamels or, much more commonly, with underglaze blue motifs. Two main types of decoration are known. On the one hand, some pieces are decorated with fairly intricate designs and show elaborate borders, and, on the other, there are a number very much more casually decorated in what is known as the 'finger-drawing' style, for it looks almost as if the potter has dipped his fingers in the cobalt and painted with them. Examples of the two types can be seen in Plate 70. The dish A is heavily potted, but the decoration is crowded and

stylised, clearly in imitation of far superior wares, but the dish B is unashamedly peasant ware and the crudely drawn flowers are painted in a distinctly greyish tone of blue.

Considerably more attractive and rather rarer are the sixteenth-century Tê-hua wares that, as has already been noted, are best known for the famous *blanc de chine*. Tê-hua blue and white is gently, almost timorously, decorated in a style that is suggestive of the *ko-sometsuke* wares of the seventeenth century. The sage sitting under a willow tree portrayed in the dish in Plate 69 has something of a pathetic air about him and seems rather apprehensive of the dangers that surround him.

Closely related to Chinese provincial blue and white, though not themselves strictly Chinese, are the Annamese wares that were produced in that part of Indo-China that is now North Vietnam. For about 1,000 years until 939 Annam had been a southern province of the Chinese empire. It then gained a proudly proclaimed, though tenuously maintained, independence for a few hundred years before being reoccupied by the Chinese in 1407 as a result of Yung-lo's expansionist fervour. It regained a form of independence in 1428, though the very name 'Annam' is Chinese for 'pacified south', and retained it until the coming of the French in the nineteenth century. During the periods of independence Hanoi was the capital of the Annamese kingdom. As the Hanoi area possesses an abundant supply of kaolin, one of the two main constituents of porcelain, it is not surprising that it also had three main kiln sites, which supplied wares for the court, for general domestic use and for export. The oldest of these sites is at Huong-canh, where a large number of domestic wares were made for local consumption, and the other two, Tho-ha and Bat-trang, started production about 1465 and during the first third of the sixteenth century respectively.

With a very few exceptions, it is much harder to date Annamese wares than Chinese, for they bear no reign marks; but it is generally supposed that the majority were produced between the fourteenth and seventeenth centuries, and possibly continued to be made until very much more recently. The later wares, which are more sophisticated and consist very largely of large and well potted baluster vases decorated in the earlier Ming style, can be attributed to the most recent of

the kilns at Bat-trang. The earliest examples of Annamese blue and white, however, which can be dated from the period before the Chinese occupation in 1407, show decoration that appears to have been very hastily applied in purely linear drawing of floral motifs. It is clear from the slightly later examples that the Chinese occupation had a profound effect on Annamese wares, and there is also some reason to believe that some Chinese potters, who may have fallen foul of the authorities or who wished to migrate south for some other reason, made their appearance in Annam during this period and elected to stay on there after it ended. Be that as it may, very many of the Annamese wares that are normally attributed to the middle of the fifteenth century resemble Chinese blue and white wares of the fourteenth and early fifteenth centuries very closely. We may therefore assume that there was a time lag of anything up to 100 years between the first appearance of the motifs on early Chinese blue and white and their gaining popularity in Annam.

The one dated example of Annamese blue and white is a bottle vase (Plate 71), which can be seen in the Topkapi Saray Museum in Istanbul. Its shape is not one that is commonly found among Chinese wares, but the decoration around the body is clearly based on motifs that were popular in China during the late fourteenth and early fifteenth centuries. We can see the familiar classic scroll around the rim and base of the neck, and the chrysanthemum spray amid a leaf scroll on the bulbous bowl of the bottle, although more delicately shaded than in earlier pieces; this motif can be seen again and again in earlier wares. This particular bottle also bears the inscription 'Potted for pleasure by Chuang a workman from Nan Ts'e-chou in the 8th year of Ta Ho'. As Ta Ho ruled in Annam from 1443 to 1454, this bottle can clearly be attributed to the year 1450. It is also very possible that Chuang was one of those potters who had decided to settle in Annam.

It would be a mistake to assume that all Annamese wares are slavish imitations of earlier Chinese blue and white. In fact, the best of them show a virility and freshness that rival the best of Chinese wares, and there is some reason to believe that they achieved their 'golden age' during the fifteenth-century 'Interregnum', when few wares of imperial quality were produced in

71 Annamese bottle vase, dated 1450, decorated around the
bowl with a chrysanthemum scroll, bands of lotus panels
around the shoulders and foot, a classic scroll and a band of
ju-i heads at the rim and repeated at the base of the neck,
and a band of lotus scrolls halfway up the neck. (Height:
54.8cm)

72 Annamese ewer, probably middle of the fifteenth century, modelled in the form of a dragon, its mouth forming the spout and a small circular opening in the raised tail. (Height: 21.6cm)

73 Annamese wares, fifteenth century. A, bowl, showing the unglazed lip, decorated in the centre of the interior with a floral motif and classic scroll at the rim, which is repeated on the exterior. (Diameter: 16.8cm.) B, jarlet, decorated with floral scroll that is typical of many simple Annamese wares above a band of lotus panels around the foot and a classic scroll around the rim. (Height: 8.9cm)

China. The ewer illustrated in Plate 72, which has been modelled in the form of a dragon and can be dated from this period, is indicative of the finest Annamese wares made in the forms of animals, birds and fish.

We have so far considered the better Annamese wares only, but in addition to these an enormous quantity of much more roughly potted household utensils were made for everyday Annamese use and for export to Southeast Asia. Many of these are large pieces, particularly dishes, vases and bottles, though a number of smaller wares were also made. Their decorative motifs were often hastily drawn, and take the form of leaf or flower patterns that have connotations with fourteenth-century Chinese wares (Plate 73). The blue of these humbler wares is often an almost inky hue, in striking contrast with the bright sky blue of many of the finer pieces. There is, indeed, good reason to believe that the more attractive colour was reserved for the most fastidious customers, if not just for the court itself.

The paste of many Annamese wares is normally inferior to that of most Chinese porcelain, and appears to be a greyish-white proto-porcelain

that is not translucent. The glaze and slip applied to the body did not marry so well with this inferior paste, and often tended to flake off in the manner shown in the small vase illustrated in Plate 73B. The glaze itself varies from a light brown in some wares to white in others, and may show signs of crackling. The surface may be either high gloss or matt. The rims of most Annamese wares were usually left unglazed and often appear almost chalky, and the bases are normally covered with a chocolate- or straw-coloured wash. When this is not the case, they have the colour of putty.

As we have already noted, a good deal of Chinese provincial porcelain and also many Annamese wares were exported to the countries of Southeast Asia and further afield. They are therefore of interest not only in their rude utility and as additional types for collectors to study, but also because their provenance can often indicate the extent of the Chinese maritime trade and even the date of the archaeological sites where they are found. Moreover, the uses to which they were put by the peoples of Southeast Asia can also serve ethnologists as pointers to the beliefs and customs of primitive societies.

Until the arrival of the Europeans early in the sixteenth century, the porcelain export trade was shared between Arab and Hindu merchants, and, to rather a lesser extent, Chinese merchants trading in the Southeast Asian region. All voyages started from ports in Kwangtung and then progressed either by way of the Straits of Molucca, sometimes touching ports in Borneo or the Moluccas, or else across the South China Sea, calling at the thriving Chinese community in the Kuching area, and on to southwest Malaya or Jakarta. From there goods were transhipped either to East Africa, notably Zanzibar, where they were exchanged for ivory or such exotic animals as giraffes, or else up through the Straits of Malacca to Tenassarim, near Mergui, which during the period we are considering was part of Siam. At Tenassarim they were exchanged for goods from Persia and re-exported to the Middle East and also across the Indian Ocean and up the Red Sea to Egypt. In the early days of the trade porcelain was also exported from north China by the overland route across central Asia to Persia, but as yet we do not have evidence to indicate its full extent or for how long this route was used.

The quantities of Chinese porcelain found throughout Southeast Asia, particularly at the various ports of call and entrepôts used by the traders, clearly indicate that not all the consignments intended for the Middle East reached their destination. The founding of the sultanate of Malacca about 1400 caused greatly increased activity in the area, and excavations there have revealed a quantity of blue and white porcelain of a very fine quality more like that found in the Middle East than in the Southeast Asian region. The quality and fragility of the porcelain found in the Philippines also suggest that those islands were not used for the indiscriminate dumping of inferior wares. Unlike other ports of call in the region, Manila was not a staging post but the ultimate destination of a particular trade route. Most of the wares exported there were used as containers for foodstuffs and so had to appeal to a particular market.

Chinese blue and white has always been greatly admired by the peoples of Southeast Asia, and has frequently even been treated with considerable awe. Even the fragments of broken vessels are carefully smoothed and shaped by the villagers of Malaya and used in many a kampong as counters in a variety of games, and the intact vessels themselves are often mounted in silver. Many of the Longhouse people of north Borneo hang large Chinese jars from the rafters of their houses and treasure them against all attempts to buy them. Until very recently, too, the Burmese regarded excavated porcelain with such awe that they at once buried it again or else presented it to a temple, and the natives of Tenassarim had such a belief in its potency that they ground it up and took it as a medicine. Many of the Dyaks of north Borneo still do so, though it appears that they have a preference for the medicinal properties of celadon wares.

Much of the porcelain that found its way to the peoples of Southeast Asia was, of course, used for the purpose for which it was originally intended. An account from the *Ming Annals* tells us that the people of Banjarmasin in southern Borneo formerly 'used plantains as plates, but since they trade with the Chinese they have gradually begun to use porcelain'.[3] The 'ring' of fine porcelain was also greatly admired, and among the Palawan people in the Philippines husked rice, betel nut preparations and other ritual foods were placed

in a bowl and held by a medium who tapped it several times to call the spirits of relatives and other deities to partake of the offering. A true porcelain dish was always preferred for this purpose, for then the deities would be able to hear more clearly. There is little doubt that porcelain vessels were used for similar purposes by other communities in the region, and even today those that do not appear to be highly regarded in other ways are prized for the 'ring' they give when tapped. In some parts of Indonesia, indeed, porcelain dishes were sometimes used as instruments in a gamelan orchestra, and in the seventeenth century we find a sultan of Tidor writing in despair to the governor-general of the Dutch East Indies: 'My father, I am like a bowl of fine porcelain on which both the Dutch and the people of Ternate strike at once.'[4]

Much of the porcelain that has come in recent years from Southeast Asia has been excavated from graveyards, in which it had been buried as 'grave-goods', so that the dead might have the use of the utensils they had known in life. In Calatagan in the Philippines food was also often placed in local earthenware dishes and buried with the dead, while Chinese dishes were placed over the pubic areas of the dead body and saucers beneath the hands. Small Sawankaloke jarlets from Siam were also placed behind the head. It is clear that the imported wares were keenly revered, for they were always wrapped with the dead body, whereas the local earthenware pieces were merely placed in the grave. Chinese porcelain also played an important part in burials amongst the Melanau people of Sarawak. When someone died there, the body was placed outside his house for at least a year, with a Chinese dish beneath the head and smaller ones under the hands and feet. At the end of the year the body was buried in a large Chinese jar, and smaller wares were used as grave-goods.

Another tribe in Sarawak, the Kelabits, who were notorious as headhunters, found a less innocent use for their porcelain. They considered that certain types of Chinese pot had the same properties as the human skull, and so hung them from the rafters of their houses with the openings stopped up in order to keep in the spirits, in much the same way as they hung up those more grisly trophies, the skulls of their enemies. Not content with this, they often considered Chinese jars the equal of the human body, and frequently exchanged them for slaves or sacrificial victims.

7 Blue and White and The West

Chinese porcelain, particularly blue and white, has long been prized in the West. As is well known, antique wares decorated with traditional motifs have for many years excited the greatest interest in collectors and scholars alike, but rather less attention has been paid to changing tastes for Chinese porcelain and to the wares made specifically for export to Europe and North America. This is regrettable, for Chinese porcelain has had a long history in the West and has made a considerable impact there.

Pottery and porcelain has, indeed, been exported to the West since T'ang times, and the provenance of a number of the massive jars or *kuans* produced at the end of the Yüan dynasty and in the early years of the Ming suggests that they were originally made for export to the Middle East. This trade continued into the fifteenth century, and then, in the middle and later years of the sixteenth century and also during the Transition period between the fall of the Ming and the rise of the Ch'ing, increasing quantities of blue and white porcelain were exported to Europe. The few examples of earlier porcelain to reach Europe, however, appear to have been presented by Near Eastern potentates. The Sultan of Egypt presented some blue and white to the Doge of Venice in the middle of the fifteenth century and some more to Lorenzo de Medici a few years later.[1]

The flow of porcelain increased later in the century and in the following one, when European explorers and merchants began to appear in the Orient, though at first it was still considered very much a rarity. An account of the porcelain in the collection of Florimond Robertet, royal treasurer to Charles VIII, Louis XII and Francis I of France, early in the sixteenth century mentions '. . . fine porcelain, the first that has reached Europe since Europeans first went there [the Orient]. It is white and beautifully decorated with small paintings'.[2] It is highly probable from this brief description that the writer was referring to blue and white, but unhappily no wares from this early collection are known to be extant. What is thought to be the first example of blue and white to reach England, however, does still exist in a private collection. Tradition has it that Philip of Austria, King of Castile, and his consort, Joanne, were forced by a storm to land at Weymouth in 1506 and were given shelter by Sir John Tren-

chard. When he left, the King presented Sir John with two Hsüan-tê bowls in gratitude for the hospitality offered him; one of these is known to have survived over the years, and was so highly prized that it was set in silver-gilt mounts later in the sixteenth century.[3]

There is no doubt that the arrival of the Portuguese in the Orient early in the sixteenth century eventually made Chinese porcelain available to a fairly wide group of people, though it was still considered very rare and was highly prized. Damien de Goes, a friend of Erasmus, went so far to say that a single piece of porcelain was worth the price of several slaves. Predictably, it was the Portuguese who first developed a taste for it, and both Vasco da Gama and the Viceroy d'Almeida presented pieces to King Manuel I, who was so pleased with them that he had them mounted in silver. It was also this same King Manuel who first commissioned porcelain to his order, and an example of this, a ewer bearing his emblem (an armillary sphere) and an apocryphal Hsüan-tê reign mark, is now in the José Cortes Collection in Lisbon.[4] It is very likely that the Portuguese sea captains and merchants in the East had porcelain made specially for them, too, and it appears that these also show an interesting combination of European and Chinese decorative motifs. Some of them bear Latin inscriptions that are frequently illegible, but a bowl in the British Museum (Plate 74) is clearly inscribed with the motto *Sapienti nihil novum* ('Nothing is new to the wise'). Apart from this inscription, the decoration is wholly Chinese, showing a seven-headed hydra within a central medallion and the Eight Buddhist Precious Objects evenly spaced around the exterior of the bowl. A pair of similar bowls bearing the Hsüan-tê *nien hao* and dated 1541 were made for Pero de Fero, governor of Malacca for some seven years from 1539, and so it is very possible that the one illustrated was also made about the same time for one of his staff.

Of rather greater interest and probably rather earlier date is the dish illustrated in Plate 75. It is decorated on the inside with a fine example of a dragon with a foliated tail, which is clearly wholly in the Chinese taste, and the underside shows five medallions, three of which take the form of a crown of thorns enclosing the sacred monogram of the Jesuits. The two remaining medallions, however, and the stylised clouds around the rim

74 Bowl made for the Portuguese market, early sixteenth century, decorated with a medallion containing a seven-headed hydra, a Latin inscription, *Sapienti nihil novum* ('Nothing is news to the wise') and the Eight Buddhist Precious Objects. (Diameter: 33cm)

75 Dish made for the Portuguese market, early sixteenth century, decorated in the central field of the interior with a foliated dragon surrounded by a narrow band of formal floral scrolls and on the rim with a cruciform diaper border; decorated on the underside with five medallions, three of them framing the sacred monogram of the Jesuits and the other two birds in flight above breaking waves, interspersed with cloud scrolls. (Diameter: 31cm)

are entirely Chinese in style. Of the three other dishes of this size and type recorded, one shows a similar foliated dragon within a central medallion incorporating Buddhist emblems on the inside, and five others enclosing the sacred monogram on the underside. The other two are decorated on the underside with the arms of Portugal and the armillary sphere of King Manuel I. It is very possible, therefore, that all four dishes were made before he died in 1521, and may well have been among those that he had commissioned. The religious tolerance of the Chinese is again demonstrated in the way they felt able to decorate the same piece of porcelain with Buddhist emblems and the Jesuit sacred monogram. That they were able to do so with these dishes also suggests that they were made before the accession of Chia-ching in 1522, for, as has already been noted, he was intolerant of all religions except Taoism.

There is no doubt that the Portuguese esteemed Chinese porcelain very highly throughout the century, and many may well have echoed the words of Archbishop Dom Bartolomeu. Attending the Council of Trent in 1562, he was so aghast at the huge quantity of gold and silver displayed on the Papal table that he so far forgot himself to exclaim:

> In Portugal we have earthenware vessels with many advantages over gold and silver. I would counsel all princes to buy this material, and to forego the use of silver. We call it porcelain. It comes from the Indies, but is made in China; a material so fine and translucent that its beauty is as great as glass or alabaster. Sometimes it has blue decoration, which appears to be a mixture of alabaster and sapphire. Of course it is fragile, but it is also cheap. Such vessels are esteemed for their beauty as well as their rarity, and that is why we use them in Portugal.[5]

This outburst made such an impression on the Pope that he requested that some of these vessels be sent to him. A large consignment duly arrived in Rome, and this so pleased him that he chose the best pieces for himself and distributed the remainder among his cardinals.

When, slightly after the Portuguese, Spanish explorers also arrived in the Orient, they were also able to take a share of the new-found treasure from China; but the journey from the Philippines, where consignments were assembled, across the Pacific to Mexico, and thence to Vera Cruz and home to Spain, was perilous in the extreme. In the spring of 1579 one of their galleons carrying porcelain across the Pacific was captured by Sir Francis Drake, who was later forced to make a landfall at a little bay, now known as Drake's Bay, just north of San Francisco. It was here, while repairs to the *Golden Hind* were in progress, that a case of blue and white porcelain was dropped overboard. Later washed ashore, this was to be the first Chinese porcelain to reach North American soil, and today fragments of Wan-li blue and white adorn the graves of the Miwok Indians who then inhabited that coast of California.

Other consignments were, of course, more fortunate and reached Spain in safety. Such was their impact there, and so delighted was the Emperor Charles V, that, not content with the few examples that he had received, he ordered a complete dinner service decorated with his arms and cipher. This service, which is the first known instance of a large European order, later passed to the electors of Saxony, but unfortunately cannot be traced today.

The Portuguese had been the first Europeans to arrive in the Orient, and in 1558 were granted the promontory of Macau in return for their assistance against pirates and smugglers. They were thus the supreme European power in the region for a spell, but this was not to last for long. The absorption of Portugal into the Spanish empire damaged their prestige, but even more serious was the conflict with the Dutch. Prevented from trading through Lisbon, the Dutch determined to trade direct with China for porcelain, which they coveted as being finer than crystal. For several years they harassed Portuguese shipping in the region, and then, in 1604, seized the carrack *Santa Caterina*, which was laden with porcelain destined for Lisbon. This porcelain, which the Dutch were to call *kraaksporselein* to commemorate its seizure, was then shipped to Amsterdam. The subsequent auction there caused considerable excitement and was long remembered by the burghers. Henri IV of France, who

bought a complete dinner service of the very finest quality, and James I of England were among the buyers, and the sale realised 5 million guilders. The popularity of porcelain in Holland subsequently increased by leaps and bounds, and it was imported on such a scale that within a few years we are told it was 'in nearly daily use with the common people'.[6]

Kraaksporselein was the first Chinese porcelain made on any appreciable scale specifically for export to Europe. Generally inferior to the better sixteenth-century wares, it also has a number of distinctive characteristics that set it apart from the blue and white porcelain made for the home market. Perhaps the most prominent of these is that many of the vessels appear to be exceptionally thinly potted and are so brittle that most of them tend to chip or crack very easily. Unlike most sixteenth-century wares, a number of the larger dishes do not have glazed bases, but whether they do or not, it is often possible to discern radial marks on them; these are known as 'chatter' marks, for it is supposed that they were caused by a slipping of the finishing tool when the potters were gossiping among themselves rather than concentrating on their work. Like the contemporary 'Swatow' wares, the foot-rings of these vessels often have grit adhering to them; they are also strongly made and are either vertical in relation to the base or else appear to be undercut. More significant is the shape of the edge of the dishes, for this is both wide and joined to the cavetto by a gentle curve, so that both areas can be decorated as a single unit (Plate 76c). It has been suggested that this wide and flattened edge was to hold the condiments necessary to a European meal but superfluous to a Chinese one.

The blue decoration of these wares varies, according to the conditions in the kiln when they were fired, from rich purplish shades to pale silvery tones and a dry-looking black. Their decorative motifs are totally different from the traditional ones found on wares intended for the home market; the border designs on dishes and the outside of bowls are frequently divided into several radial segments, usually from eight to twelve in number, depending on the size of the area, and are often decorated with alternating motifs (Plates 76b and c). A favourite motif for the central panel of saucer dishes is deer, symbolic of longevity (Plate 76a); though another very

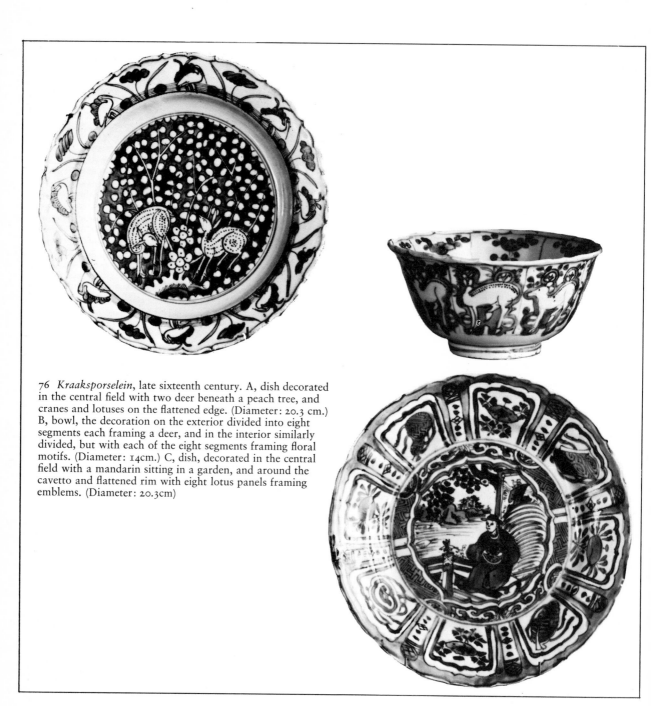

76 *Kraaksporselein*, late sixteenth century. A, dish decorated in the central field with two deer beneath a peach tree, and cranes and lotuses on the flattened edge. (Diameter: 20.3 cm.) B, bowl, the decoration on the exterior divided into eight segments each framing a deer, and in the interior similarly divided, but with each of the eight segments framing floral motifs. (Diameter: 14cm.) C, dish, decorated in the central field with a mandarin sitting in a garden, and around the cavetto and flattened rim with eight lotus panels framing emblems. (Diameter: 20.3cm)

popular motif, as on the dish illustrated in Plate 77, appears to be a prototype of the famous 'Willow Pattern' of the late eighteenth century, which was to be copied again and again on English Spode during the nineteenth century and after.

The subsequent activities of the Dutch East India Company in importing *kraaksporselein* into Europe were to have far-reaching effects. In 1635 it established itself on the island of Formosa and from there carried on a lucrative trade. The directors authorised their agents to sell their stocks when they considered the price was right, and all the indications are that they were able to find a ready market for their wares; but with the development of a more sophisticated taste and the growth of competition from the locally produced delftware, the agents became more exact-

77 *Kraaksporselein* dish, late sixteenth century, decorated in the central field with a lakeside scene, a man in a boat, two people crossing a bridge, a pagoda, birds in flight and a willow tree—probably the prototype of the later 'Willow Pattern'—and with cranes and lotuses around the flattened edge. (Diameter: 20.3cm)

78 Covered vase, seventeenth century, decorated in the Transition style and set with European seventeenth-century mounts to transform it into a tankard. (Height: 20.3cm)

ing in their demands, and it seems that their clients were beginning to be less content to accept just anything that happened to be available. A company memorandum from the middle of the seventeenth century reads as follows:

> Send bowls of varying sizes, but let them have straight sides, not curved, because straight-sided ones sell for twenty-five per cent more . . . If you can manage to send us medium-sized plates so that they can look like one service when laid side by side, we should be in a position to accept a large quantity.[7]

The demand for plates with straight sides rather than curved ones suggests that the company had been sending a number of Chinese dishes made for the home market in addition to conventional *kraaksporselein* shapes, and that in response to this their European clients were beginning to make what was to be a long series of specific demands.

The early European traders of the seventeenth century had at first been content to buy up anything they found saleable, and then often had it adapted for European use. Thus the kind of Transition vase illustrated in Colour Plate VII could be set with silver mounts and be transformed into a European tankard (Plate 78). Later on, however, when Chinese porcelain became better known in Europe, the importers persuaded

their agents in Canton to commission wares decorated more in the European taste, and they themselves became more demanding. In so far as they could, the Chinese were ready to comply, though sometimes the results of their efforts were rather amusing combinations of Chinese and European styles of decoration. The dish illustrated in Plate 79 has been potted as if for a European table, with a narrow cavetto and wide flattened edge for condiments, and is decorated with three unmistakable Chinese ladies with their hair dressed in the style fashionable in Europe in the second half of the seventeenth century.

In the early days of the European trade the only European vessels that were available for the Chinese to copy were the wooden tablewares that the East India merchants had taken to the Orient with them. With the growth in popularity of Chinese porcelain, however, later in the seventeenth century and afterwards, European earthenware and silver vessels were sent to the agents in Canton with instructions that they should be copied (Plate 80). This is scarcely surprising, for the popularity of Chinese porcelain was immense by the end of the century, for it was, indeed, virtually the only 'china' known in Europe. So highly was Chinese porcelain regarded that examples of blue and white were depicted in many of the still-life compositions of the period.[8] Moreover, as tea became increasingly fashionable in Europe, it was generally supposed that it could

79 Dish made for the European market, second half of the
seventeenth century, decorated in the central field with a
scene depicting three Chinese ladies with their hair dressed in
the European style and an attendant, and with eight medall-
lions framing further Chinese ladies and floral motifs inter-
spersed with swastika lozenges around the cavetto and
flattened edge. (Diameter: 34.4cm)

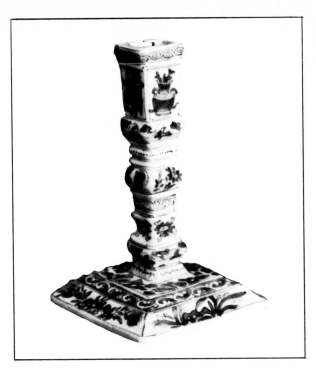

80 Candlestick, late seventeenth century, modelled on a contemporary English silver candlestick but decorated in the Chinese style with floral motifs and emblems. (Height: 13.5cm)

81 Soup plate, *circa* 1730, made for the European market, but decorated in the Chinese style with chrysanthemums and bamboo in the central field, a diaper design around the cavetto and formalised floral scrolls with the arms of the Gough family of Staffordshire applied in overglaze red and gold enamels on the flattened edge. (Diameter: 22.9cm)

82 Dish, second half of the seventeenth century, in 'Jesuit China', probably intended for export to the Japanese Christians and decorated with a scene depicting the baptism of Christ. (Diameter: 61cm)

83 English 'Nobody', one of the characters who was featured in the Jacobean drama *Somebody and Nobody*, late seventeenth century. (Height: 15.35cm)

84 Saucer dish, late seventeenth century, intended for the Dutch market and decorated in the central panel with a scene depicting an episode in the Rotterdam riots of 1690, and around the flattened edge with a diamond diaper alternating with fruit motifs. (Diameter: 11.45cm)

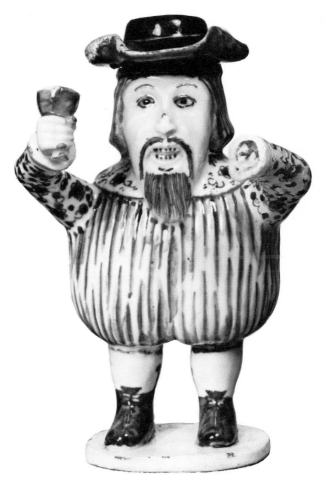

be truly appreciated only when drunk from Chinese porcelain cups.

A number of the aristocracy and landed gentry ordered complete dinner services to be made for them in China and adorned with their coats of arms. Until about 1730 these were very skilfully decorated with underglaze blue, but after that date they were also painted with polychrome enamels. The dish illustrated in Plate 81, which was made for the Gough family of Staffordshire in the first quarter of the eighteenth century, is finely decorated in blue and white with typically Chinese motifs, but the arms of the family have been added in overglaze red, blue and gold enamels. This may have been done in Canton, where the agents could exert a greater degree of control over the decoration, or perhaps even in London after it had been imported.

In decorating the wares intended for export the Chinese potters were also very ready to copy from European prints that had found their way to China. The earliest such prints to become popular in the Far East came from a collection illustrating the Gospels that had been published towards the end of the sixteenth century and distributed in China by Catholic priests. It is doubtful if these prints were ever copied on to porcelain for domestic use or for export to Europe, but it is clear that a number of saucer dishes (Plate 82) and other small wares were so decorated and later smuggled to the Japanese Christians. Some of this porcelain, which today is known as 'Jesuit China', came into the hands of the good Père d'Entrecolles, and he tells us that he treasured it 'more than the finest porcelain made during the past thousand years'. For a time it was sent to Japan in quite large quantities concealed in consignments of other commodities, but the trade came to an end when the Japanese discovered the subterfuge towards the end of the century. The trade was revived later in the eighteenth century, but then the motifs were painted in black and gold enamels instead of underglaze blue.

In addition to these earlier prints, a number of the best English, Dutch, French and Italian prints were sent to China towards the end of the seventeenth century, and these were copied on to porcelain intended for Europe in underglaze blue and polychrome enamels. The Jacobean figure of an English 'Nobody' illustrated in Plate 83 was almost certainly based on a scene depicted in such

a print (the play *Somebody and Nobody* had appeared in London in 1606), and we may well assume that there was a demand for such figures much in the same way as there was later for 'Toby' jugs. There were also a number of small plates, also made towards the end of the century, which are illustrated with a scene depicting the siege of Rotterdam, captured from the Spanish by the Dutch in 1572. These are probably based on an earlier print, and were predictably very popular in Holland. Contemporary with them is the dish illustrated in Plate 84, which was copied not from a print but from a medal that was struck in Rotterdam in 1690. The scene depicts an incident during the riots that took place there that year. One Cornelius Costerman had been unjustly executed, and the enraged crowds set fire to the house of the magistrate who had sentenced him.

The import of *kraaksporselein* into Holland at the beginning of the seventeenth century had, as we have seen, made an enormous impression there, and later stimulated the production of the local delftware. In the early days, however, the difficulties the Dutch met with in its production were such that it could be sold only at a price that was beyond the means of many people. In fact, European merchants trading in the East found it cheaper to have examples shipped out to them and copies made in China. The result of their enterprise is the existence today of a number of amusing little dishes depicting the Chinese potters' notion of life in Holland, and decorated wholly in the Delft style (Plate 85). The wheel, as it were, had turned full circle, for now we find the Chinese copying the styles of European potters that were themselves imitations of Chinese skill.

The merchants were not always so successful, often experiencing considerable confusion and frustration as the demands of their clients back in Europe became increasingly exacting. Far away from the kilns themselves and totally ignorant of the problems the potters had to face, they imagined that anything and everything they commissioned was possible, This was not always so, and when, in particular, they ordered the backs of chairs and table tops to be made in porcelain, the Chinese potters were unable to cope, these huge pieces coming out of the kiln hopelessly warped. They did just find it possible to make the huge vases, sometimes measuring as much as 3ft in height, that were also ordered, but the wastage

was tremendous. Père d'Entrecolles reported in his letters that he had been told that only eight such vases emerged from the kiln satisfactorily out of twenty-four attempted. It is clear that too much was being expected, and in making their most exacting demands, the merchants were defeating their own aims, for the prices of wares destined for the European market increased markedly. This was but to be expected, for the merchants were not willing to buy imperfect pieces, and, because these were so completely alien to the Chinese taste, they could not be disposed of locally. Porcelain thus rejected by the merchants became a charge on the factory, adding considerably to the production costs.

The tendency for European families to commission porcelain to their own specifications also caused a good deal of confusion. Like so many people even today, they naively imagined that suppliers on the other side of the world would understand their instructions as clearly as they would if they were standing beside them when they were drafted. This was very far from being the case, for they were often transmitted through a series of agents before they reached the potters, and sometimes, indeed, were copied word for word on to the porcelain. Some families therefore received their porcelain bearing such unintended inscriptions as 'in blue', and on one occasion at least misunderstandings of this kind resulted in a good deal of embarrassment. It seems that a Swedish family once wrote their instructions on a page torn casually from a diary and were subsequently taken aback when their porcelain arrived to find that it bore the inscription 'Mother is in an even worse temper today'.[9]

Despite these problems, it is clear that by the middle of the seventeenth century at least Chinese porcelain had become a commercial commodity of major importance, and that blue and white formed by far the major part of this. This is scarcely surprising, for decoration in underglaze blue was considered the ideal medium until well into the eighteenth century, and it was this realisation, as we have seen, that stimulated the production of delftware. Indeed, it is true to say that no other genre in porcelain decoration has had a greater influence on the ceramic art of Europe. It gained immense popularity throughout the seventeenth century, and was so highly prized that it was inevitable that it should attract the

85 Dish, early eighteenth century, decorated in the Delft style with a scene representing life in Holland. (Diameter: 25.4cm)

86 Covered cup and saucer, seventeenth century, one of a pattern allegedly made for Louis XIV of France and decorated partly in the Chinese style with figures, lotus panels and peach trees, and partly in the European with a medallion framing a scene depicting Queen Blanche advising the infant Louis IX of France, and the inscription *L' Empire de la vertu est établi jusq'au bout de l'univers* ('The king- dom of virtue stretches to the ends of the earth') just below the rim of the cup. (Cup height: 9.1cm; saucer diameter: 11.4cm)

keen appreciation of the crowned heads and nobility of Europe.

Royal visitors were often presented with gifts of porcelain, and in 1639 the Princess of Orange personally chose pieces to present to Marie de Medici of France. Louis XIII also favoured it, and used to drink his *bouillon* from a bowl of Chinese porcelain, as his son did after him, though the latter had his bowl set with a pair of European silver handles. Louis XIV also commissioned a set of cups and saucers to be made specially for him (Plate 86). The saucers of this set have as their central motif a scene depicting the young Louis IX being advised by his mother, Queen Blanche, and the lip of the cups bears the inscription *L'Empire de la vertu est établi jusq'au bout de l'univers* ('The Kingdom of virtue stretches to the ends of the earth'). His son, the Grand Dauphin, also had a collection of porcelain, which was the envy of James II of England, who was considered to be something of an authority on the subject. Perhaps, however, it is Augustus the Strong, Elector of Saxony and later founder of the porcelain factories at Dresden, who takes pride of place among

his fellow monarchs, for it was he who maintained that he would happily exchange a regiment of dragoons for forty-eight Chinese vases.

This enthusiasm for Chinese porcelain was not confined for long to the highest aristocracy, for as it became more plentiful and therefore less expensive, the craze for it spread throughout all levels of society. In fact, Daniel Defoe was able to report in the early years of the eighteenth century:

The queen [Queen Mary of Orange] brought in the custom, or humour as I may call it, of furnishing houses with Chinaware, which increased to a strange degree afterwards, piling their China upon the tops of cabinets, scutories and every chimney-piece to the tops of ceilings, and even setting up shelves for their China-ware, where they wanted such places, till it became a grievance in the expense of it and even injurious to the families and estates.[10]

Many a modern collector would share the enthusiasm of these early connoisseurs, and sym-

87 Saucer dish, middle of the eighteenth century, decorated in imitation of the Meissen style and showing the Meissen crossed swords on the base, with a pair of quail, a floral plant and bamboo; the lip has been coated with a brown wash, possibly with the intention of preventing it from chipping. (Diameter: 13.5cm)

pathise with them in the expense they were put to.

The avidity that seventeenth-century collectors had shown continued well into the century that followed, and by 1700 the British, French and Dutch East India Companies were importing porcelain in very large quantities. In that year the *Amphitre* unloaded the first of a series of large consignments of assorted wares to arrive in France, and in 1722 alone some 400,000 pieces of porcelain were imported into Britain. This steady stream of trade porcelain became a torrent later in the century, and in 1755 a single consignment brought to England on board the East India Company's *Prince George* included 26,000 blue and white cups and saucers, nearly that number of single plates, 402 complete dinner services and 200 tea sets. Despite this greatly increased popularity and demand, or perhaps because of it, the general quality of porcelain imported deteriorated and the decoration became increasingly European in character. European taste, moreover, was also changing, and a high proportion of the porcelain was decorated with polychrome enamels rather than in underglaze blue, though the latter was rather less expensive.

Little distinction was made between the blue and white wares of China and Japan, and an order from the French East India Company in the middle of the century actually states a preference for Japanese wares. There is evidence, too, that Chinese porcelain was no longer regarded with the same awe that it had been in the previous

88 Saucer dish, nineteenth century, decorated in the style of
English transfer ware with a scene resembling the Spode
'Willow Pattern', and with a 'Double Happiness' border
around the rim. (Diameter: 20.3cm)

century, and a good deal was imported 'in the blank' so that it could be decorated in Europe. This was legitimate enough, for locally made porcelain was still scarce, but what was very much less excusable was the distressing tendency for workmen in London and elsewhere to 'improve' on the Chinese porcelain by adding to the under-glaze blue designs crudely applied overglaze enamels. Porcelain treated in this way is known by the expressive term 'clobbered china', in which the more delicate Chinese decoration is often wholly obscured by garish enamels that do not tone with it at all.

Just as the seventeenth-century Chinese potters, as we have already noted, showed skill in copying delftware, so their eighteenth-century successors expanded their activities to include copies of other European wares. This often meant painting

89 Blue and white made for the American market, late eighteenth or early nineteenth century. A, plate decorated around the flattened edge with the 'Fitzhugh' border and with part of President Washington's arms in the central field. (Diameter: 23cm.) B, ice bucket decorated with the 'Willow Pattern' and a 'Nanking' border at the rim. (Height: 25.9cm.) C, tray decorated with the 'Willow Pattern' and a 'Canton' border. (Length: 18.3cm)

wholly in the European style (Plate 87), though the quality of the paste reveals the wares as unmistakably Chinese. In the following century this tendency to copy European wares took an interesting twist, for the dish in Plate 88 is a copy of English transfer-printed ware that was itself a copy of the late eighteenth-century Chinese design that has come to be known as the 'Willow Pattern'. We have already considered the prototype of this in the *kraaksporselein* dish illustrated in Plate 77, and there are examples of the eighteenth-century variation in Plates 89B and C. The English potter Josiah Spode was so attracted by this design that he had it copied on to the porcelain produced in his factory at the end of the eighteenth century. This was to achieve such popularity throughout the nineteenth and twentieth centuries in England that it has been copied again and again, and has become today the most widely known of motifs in blue and white.

Ironically enough, the very popularity that Chinese porcelain had achieved in the seventeenth and first half of the eighteenth centuries led to a decline in interest in the latter part of the eighteenth and in the nineteenth century and a drastic curtailment in imports. The success of such factories as those at Sèvres, Dresden and Chelsea persuaded Europeans that their native potters could produce porcelain comparable to the imports from China. The success of a domestic industry, moreover, always leads to a demand for tariffs to protect it, and at the end of the eighteenth century highly protective duties were imposed on the import of Chinese porcelain. Even so, some people in England thought this inadequate, and in 1803 the Staffordshire potter Enoch Wood, of Burslem, complained about the proposed reduction in the duty from £58 8s 6d per cent to 50 per cent.

The view that European wares could stand comparison with those imported from China was to a very large extent justified, for the Chinese, unlike earlier, were no longer alone in the field, and, as has been noted, many of the wares produced during the nineteenth century were noticeably below the quality of the earlier ones. As the century advanced and the West turned increasingly towards the Orient, it saw on the one hand an emergent and vital Japan, and on the other the Chinese empire torn by internal strife and in the process of disintegration. It was not surprising, therefore, that interest turned from the one to the

other, and the succession of Japanese exhibitions in Europe in the middle of the century reinforced the view that it was Japan that should be looked to for oriental art. This point of view was less strongly held at the turn of the century, when there was considerable interest shown in K'ang-hsi blue and white, but it was not until the Chinese Exhibition of 1935 that there was a true renaissance in the appreciation for Chinese art. Since that time, though the West no longer looks to China for its everyday household wares, there has been a keener appreciation of Chinese porcelain and greater scholarship in the field than ever before.

In North America the demand for Chinese household wares lasted rather longer into the nineteenth century than in Europe, owing to the almost complete absence of any comparable local sources of supply. The eighteenth-century settlers in the American colonies were as keen to obtain fine porcelain as the people of Europe, and, as the century progressed, probably developed an even greater taste for blue and white than the Europeans. The types that the East India Company shipped to them were similar to those imported into Britain, but were more often in the purely Chinese taste for the simple reason that the settlers were less able to place specific orders. They therefore took what was sent to them and cherished it, handing it down from one generation to the next till today, when Chinese porcelain may still be found adorning many New England homes.

Perhaps the last colonial consignment to be sent to the American settlers was the one advertised in the *New York Gazette and Weekly Mercury* on 4 July 1777, exactly one year after the Declaration of Independence:

China Ware in the Hannah from London. A large and very general assortment among which are six complete blue and white table sets; bowls of all sizes, breakfast bowls, cups and saucers and saucers of different sizes and patterns . . .[11]

The reference to saucers that do not appear to be related to cups in this consignment seems to confirm that at this comparatively late date the porcelain exported to America was still in the Chinese style, for the advertiser was probably referring to 'saucer dishes' made for the Chinese table.

As soon as the War of Independence was over, the Americans determined to rid themselves of the overriding control of the East India Company and obtain tea and porcelain for themselves. On 2 February 1784, therefore, the *Empress of China* sailed for Canton with one Samuel Shaw, soon to become American Consul in Canton and a successful businessman, as supercargo. So successful were the American traders, and their ships so fast, that they rapidly overhauled the East India Company in the volume of trade, and from 1795 were making a greater profit.

Along with their consignments of tea, the American clippers brought back to the United States porcelain that can be considered more characteristic of North American wares than any of those imported during the colonial days. Many of these are decorated with linear black drawings coloured with polychrome enamels, showing President Washington and other patriotic subjects. Certain wares decorated in underglaze blue also became popular, and were treasured over the years. The best known are the 'Canton ginger jars', which, as their name suggests, were made in and around Canton for the traders there and are a travesty of the finer 'prunus blossom' jars of the kind illustrated in Plate 51, made during the K'ang-hsi period. Much more important, however, are dishes decorated with the so-called 'Fitzhugh' border and named after the person for whom they were first made (Plate 89A). These borders are characterised by four split pomegranates with the inside of the fruit showing, and butterflies with their wings spread wide. In the centre of these dishes either bouquets of flowers or a variety of emblems are displayed; the central motif in the example shown is part of President Washington's arms—an angel blowing a trumpet and an eagle with spread wings.

Equally popular were the 'Nanking' or 'Nankeen' wares, which were imported in such large quantities that nearly all late eighteenth- and nineteenth-century blue and white shipped to America is frequently and incorrectly referred to as 'Nanking' or 'Old Nanking'. As can be seen in Plate 89B, the rims of the finer Nanking wares are frequently embellished with burnished gold. Very similar to these wares and a later development of them are the so-called 'Canton' wares, which are

decorated with a lattice or network border in dark or light blue with wavy or scalloped lines above. As shown in Plate 89c, the central motif of many of these wares is frequently a variation of the familiar 'Willow Pattern'.

Like the Europeans of the seventeenth and earlier eighteenth centuries, those Americans who placed specific orders for various types of porcelain often become increasingly exacting in their requirements. We thus find one Benjamin Shreve writing very specific instructions in 1815 about the porcelain he had ordered. 'The blue and white dining sets should be of uniform shade', he stipulated, 'and the same pattern. They are often put up without any attention to these matters.'[12] He may well have been voicing the views of the more sophisticated part of the American clientele, but there can be no doubting the immense popularity that Chinese porcelain enjoyed during the forty or so years following the Declaration of Independence. Robert Walsh almost certainly spoke for the mass of American society when he was able to record some five years after Shreve:

> . . . the porcelain of China displaced the English ware hitherto in use and became exclusively employed by the higher and middle ranks, even the poorest families could boast at least a limited proportion of China ware, and although it should require the united exertions of the family to effect the object, few young girls, at the present time, enter into the marriage state without contributing their respective China ware tea setts to the general concern.[13]

Walsh was referring to the situation as he knew it. The demand for and popularity of Chinese porcelain was to continue for a few years yet, but there were storm clouds ahead for the importers. Writing a few years after Walsh, one Matthew Ralston, an importer, echoed the growing disillusionment that was beginning to be felt much more widely with the whole business of importing porcelain from the other side of the world when he told his agent in Canton that 'the quality has been much complained of lately'. It is clear that the Americans had long passed the time when they were content to accept any porcelain that was sent to them, and now, entirely understandably, they were demanding plates that suited the Western table rather than the Chinese. It is not very surprising either that they became very dissatisfied when an appreciable proportion of the consignments they had ordered from Canton arrived broken as a result of careless packing. They may well have concluded that the exporters were letting them down, and providing them with merchandise that could not be easily marketed.

The hazards of breakage in the clipper ships must have been very considerable and inevitably added appreciably to the costs of importing. Had there still been no alternative sources of supply, these disadvantages would have had to be overcome, but by the 1830s a number of American kilns were producing robust and very acceptable pottery, which served many households. 'The same articles which we formerly imported from China, and for which nothing but dollars would pay', noted Philip Hone, a well known observer of New York's commercial scene, in 1845, 'are now manufactured here at one third the cost and sent out to pay for teas.'[14]

It was the old familiar argument—why import when we can produce as effectively ourselves? Just as in Europe in the previous century, there had been a ready demand for imported wares when there was no local competition, but now that there was, the taste for imported porcelain declined markedly and the local industry demanded protective tariffs. For a generation or two a confident and self-assertive America was no longer interested in Chinese porcelain. When that interest revived, just as it did in Europe, it was not an interest in the import of everyday household wares, but in the finer antique porcelain that the Chinese had originally intended for themselves.

Appendices

Appendix A
The Manufacture of Blue and White

Pottery has been produced in China since neolithic times, but it was not until the T'ang dynasty (AD 618–906) that a little plain-glazed high-fired porcelain was produced. During the Sung dynasty (960–1279) there was a counter-trend that delayed the arrival of the 'porcelain age', for to the taste of that time the characteristics of porcelain—a marble-like whiteness and a clear and brilliant finish—held only a limited appeal. Throughout the dynasty, however, a bluish-white porcelain known as *ch'ing-pai* was produced at a number of kilns in southern and western China, most notably at the rapidly developing manufacturing centre of Ching-tê Chên in Kiangsi province. During the Mongol Yüan dynasty that followed the Sung the only porcelain made for the court, *shu-fu* or 'privy council' ware, was also made there, as were variations of *ch'ing-pai* decorated with brown iron spots and copper red and cobalt blue floral patterns under the glaze. The underglaze blue decoration proved to be the most successful and popular, and, when a transparent and colourless glaze replaced the *ch'ing-pai* and the paste was freed from all impurities to appear milky white, it evolved as the fine blue and white we are familiar with. The earliest examples were thus produced at Ching-tê Chên and, while later wares were also made at a number of provincial kilns, notably in Fukien province, the finest have always been attributed to this centre, which Père d'Entrecolles was later to call the 'porcelain capital'.

Ching-tê Chên is ideally placed to be a great manufacturing centre, standing in a plain, as it does, surrounded by the mountains of Kiangsi and watered by two rivers that converge to form an excellent port nearby. The city has no wall, and this has both allowed it to spread as the factories increased in number and facilitated the transport of raw materials to the kilns. It was governed by a single mandarin and was well policed. Each street was barricaded at night against marauders, and had a number of leaders, each responsible for the security of ten houses.

The wealth of the city was derived solely from the manufacture of porcelain, and work was always comparatively easy to find there; even the blind, crippled and children could be employed in grinding the cobalt that was used for decoration. Père d'Entrecolles, who lived there at the beginning of the eighteenth century, wrote that the total population was one million and that there were 18,000 families of potters living in the city. 'Everyday', he

goes on to say, 'ten thousand loads of rice and a thousand pigs are eaten, not to mention quantities of horse and dog meat.'[1] He also states that 3,000 kilns were kept burning throughout the year, and that at night the red glow above the city gave the impression that it was on fire. This might seem something of an exaggeration, but Lord Macartney, who led a mission from George III at the end of the eighteenth century, described the city in almost identical terms.

These descriptions of Ching-tê Chên date only from the eighteenth century, but there is good reason to believe that life had not changed very much since early Ming times. The city was clearly a major industrial centre, both well ordered and well supplied with the raw materials the potters needed. The most important of these were the two clays used in the manufacture of porcelain, kaolin and petuntse, which come from the Kiangsi mountains. Kaolin is a decomposed clay that fuses at a temperature of about 1,740°C, which is too high for practical purposes, and petuntse is less decomposed and fuses at a rather lower temperature. Both are essential to the preparation of porcelain paste; they are mixed together in equal proportions to make the finest porcelain, and in the proportion of three of petuntse to one of kaolin for the coarser wares. The Chinese called kaolin the 'bones' of porcelain and petuntse the 'flesh'. Père d'Entrecolles tells a story of how some Europeans once stole some petuntse and tried to make porcelain from it, but were laughed at by the Chinese for their pains in trying to make 'a body without bones'.

Once the clays had been found, they were ground, formed into soft white bricks and taken in that form to the kilns. There they were mixed together with water and certain mineral salts, which served as a flux in the fusion when the wares were placed in the kiln. The mixture was then stirred with a rod and trodden underfoot by men and boys. Père d'Entrecolles described this work as 'very arduous, for those Christians who have been employed at it come to church with great difficulty, and cannot get leave without substituting another in their place, for when their labour is suspended, all the rest are stopped'.[2] Quartz and crystalline sand were heated and pulverised, and then added, and the mixture was put on one side for several years.

When it had been left long enough to mature, the potter took the prepared clay, or, as it should now be called, porcelain paste, and beat and kneaded it so as to remove air bubbles that might expand in the heat of the kiln (Plate 90). He then formed it on his wheel, modelling it into the shape of the vessel he wished to make. When he had done this, he moulded

90 Preparing the clay and working at the potter's wheel.

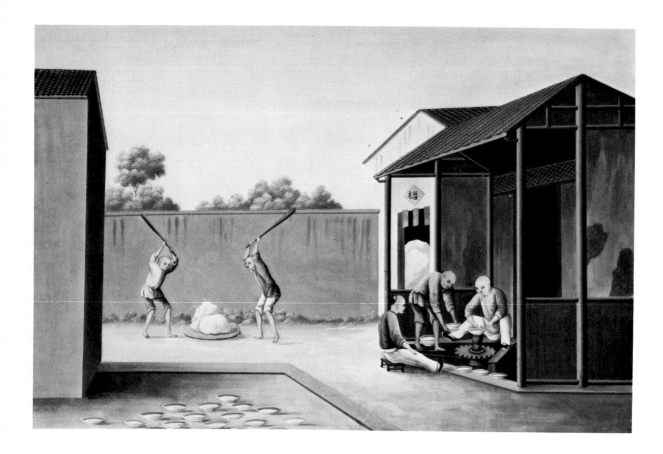

it into perfect shape, and sometimes trimmed it with a chisel in order to give the sides the correct thinness. If he was making a large jar or vase, he usually had to pot it in two or sometimes even three sections, which were then luted together with slip (clay diluted with water and mixed together to the consistency of cream), and the join smoothed over with more slip to conceal it. The objects were then left out to dry for anything up to a year before porters sorted them into various categories of vessel and craftsmen attached handles and spouts to them with slip as an adhesive. In some cases the vessels were brushed over with slip or, from the latter part of the K'ang-hsi period, with *hua-shih* or 'soft paste', to conceal any blemishes in the body and to prevent the absorption of the cobalt with which they were to be decorated.

The wares were now ready to be decorated with cobalt blue. This always presented peculiar difficulties, and has been compared to writing with ink on blotting paper with a full pen. If the artist hesitated with his brush, the result was a smudge, and if he moved it too quickly, there was no result at all. Great skill was therefore needed on the part of the decorator, and it is not surprising that blemishes in the decoration are often discernible in even the finest wares. Moreover, the difficulties encountered in grinding imported cobalts often left particles of poorly ground pigment in the mixture. When these were applied to the vessel with a too heavily loaded brush, they frequently caused the somewhat blotchy effect described as 'heaped and piled'. Particles of cobalt from the bristles of a brush would also sometimes adhere to the vessel and subsequently burst through the glaze to cause minute rust spots. The potters later found it possible so to grind their local cobalt so that it could be applied very much more evenly, and from the latter half of the fifteenth century were able to etch the outline of the motif first and later fill it in with a paler wash.

Little is known about the sources from which the Chinese obtained their cobalt, but there is strong evidence to suggest that during the Yüan dynasty and early part of the Ming period it was imported from the Middle East. This is known as *hui hui ch'ing* or 'Mohammedan Blue' and has always been

greatly admired. A similar variety of cobalt, known as *su-ma-li* or *su-ni-po*, also reached China between the years 1426 and 1448 as tribute from Sumatra and possibly Zanzibar. But by the beginning of the Ch'êng-hua reign it seems that the supplies of imported cobalt had completely run out, so that the Chinese were obliged to rely on native sources. Unlike the imported varieties, the native cobalt contained manganese, which caused it to turn a rather greyish blue, but it was very much easier to handle and grind. A better source was discovered in Kiangsi province early in the sixteenth century, and it was this new variety of cobalt that enabled the potters to decorate their wares once again in the rich dark blue that today we consider typical of the blue and white wares that were made during the Chia-ching reign. This supply, in turn, appears to have been exhausted by the end of the century, but the lack of it caused no lasting problem, for by the early years of the K'ang-hsi reign the potters were able to purify the rather inferior cobalt that was now obtained from other sources to such an extent that they could paint in carefully shaded washes of blue that have delighted generations of connoisseurs ever since.

After the main decoration had been painted, the reign mark or *nien hao* was added in cobalt blue, usually to the base of the piece in question, though occasionally during the Hsüan-tê period to the shoulder of jars and vases or else just below the rim of dishes. It is possible that in the fifteenth and sixteenth centuries, at least, many of the potters who painted this mark were illiterate, and so copied the earlier reign marks, particularly those of the Hsüan-tê and Ch'êng-hua periods, as part of the general decorative motif, without realising what they implied.

The wares were now ready to be glazed. The glaze itself was composed of petuntse mixed with water, fern ash and lime. The fact that it contained petuntse, which, as we have already noted, was also used in making the paste, enabled it to adhere closely to the body and gave it both depth and brilliance. Before firing, it was opaque and so concealed the decoration beneath, but it became transparent in the kiln. The glaze was either blown on to the body through a bamboo pipe or else the vessel was dipped into a pot of glaze and swilled round. It was then held up to allow any excess glaze to run off; in many provincial pieces we can see the marks made by the potter's fingers as he gripped the vessel, for it is clear that the glaze tended to congeal around his fingers and could not seep beneath them.

After being glazed, the wares were taken to the kilns to be fired. These kilns were built of brick, and many of them were between 12 and 20ft high and as much as 50ft long. Such was the heat generated after the fires had been lit that the kilns often tended to disintegrate after several firings and had to be rebuilt. Before being placed in the kiln, the wares were put in strong cylindrical vessels, called saggars, which were made of fire-clay to protect them from falling ash in the kiln. The firing would last at least thirty-six hours and often longer. The maximum recorded was nineteen days, during which the fires were kept at a low heat for seven days, and then increased for a further two to maximum heat before being allowed to cool during the final ten days. Even then the saggars were frequently still red hot, so that they could not be opened for at least another day.

Not until the kilns were opened did the potters have any idea of how successful the firing had been. 'It is a rare thing', wrote Père d'Entrecolles, 'for a firing to be completely successful. Often it is a total loss, and when the kiln is opened the potter is confronted with porcelain and fire-clay melted into a solid mass of rock.'[3] Not only might some accident in the kiln cause the porcelain to fuse with the fire-clay of the saggars, but for a long time the behaviour of the cobalt blue was totally unpredictable. In order to produce a good blue, it is necessary to remove all the oxygen in the kiln, so that the cobalt oxide can be converted into a blue cobalt silicate. Wood smoke, which contains tiny particles of carbon monoxide, is a strong agent in reducing the oxygen, but if the kiln is opened before it has cooled down sufficiently, and the process of conversion is still incomplete, cool air rushes in from the outside and the cobalt silicate is reconverted to cobalt oxide, which burns black in the heat of the kiln. Many of the fourteenth-century and later provincial wares show decoration that is grey or even blackish in tone, and this is almost certainly due to the kiln having been opened prematurely. It was not until the Ch'êng-hua period, when two coats of glaze were frequently applied over the decoration, that this hazard could be avoided, and even then it was still experienced in many of the provincial wares made later in the century. During the sixteenth and seventeenth centuries the finer examples of blue and white were always fired in a strong reducing atmosphere, ie one in which there was an abundance of wood smoke, so that there were seldom any instances of reconversion. This danger was also avoided during the eighteenth and nineteenth centuries, for it appears to have been a rule that the kilns were never opened until they had completely cooled down.

The Chinese discovered the methods of firing porcelain by trial and error, and the hazards in the

kiln throughout the fourteenth and fifteenth centuries were very considerable. In fact, no one knew for certain how even the finest wares intended for the court would turn out until the kilns were opened. This almost certainly accounts for the number of finely potted and decorated wares of the Ming dynasty available today with some blemish, however slight, which consigns them to the 'commercial' category rather than allowing them to be considered of imperial quality.

1 Beurdeley, Michel. *Porcelain de la Compagnie des Indes*, trans as *Chinese Trade Porcelain* by D. Imber (Vermont and Tokyo, 1962), 14
2 Lloyd Hyde, J. A. *Oriental Lowestoft: Chinese Export Porcelain* (Newport, 1955), 46
3 Beurdeley, op cit, 14

Appendix B
Decorative Motifs and Marks

Decorative motifs

The decorative motifs found on Chinese porcelain may vary very considerably, and can often be of significant value in dating wares. Some motifs, it is true, were applied solely for their aesthetic appeal, but others, in addition to this, also have a symbolic meaning that can sometimes tell us a good deal about the use to which the vessel in question was put and can also act as a pointer to the period when it was made. The list of motifs in this appendix does not profess to be exhaustive, but it does include those most commonly found in the blue and white genre.

Fauna

1 *Bats*. They are a symbol of longevity, prosperity and happiness. Five bats symbolise the five blessings of age, health, wealth, virtue and a natural death.
2 *Butterflies*. They are credited with a life span of seventy to eighty years and so have become symbolic of longevity. They are also sometimes supposed to represent the spirits of ancestors (see Plate 60).
3 *Ch'ilins*. These are mythological beasts that are sometimes likened to unicorns, though they also have certain leonine characteristics. They have been seen as a symbol of grandeur, felicity and wise administration since about 2000 BC. They are said to tread so lightly as to leave no footprints and so carefully as to crush no living thing (see Plate 67A).
4 *Cocks*. These birds are symbolic of courage and a warlike disposition, and also represent the warmth and life of the universe.
5 *Cranes*. These are symbolic of longevity and are thought to be a mode of transport for the Eight Immortals (see Plates 76A and 77).
6 *Deer* (Plate 76A). As they are believed to live to a very great age, they symbolise longevity and are also thought to be the only animals capable of finding the sacred fungus of longevity, *ling-chih* (see p 128).
7 *Dragons*. A five-clawed dragon has long been thought to represent the emperor and four- and three-clawed ones to be symbolic of a descending social status. It is, however, misleading to accept this rule without any qualification, for, from the sixteenth century onwards, porcelain decorated with five-clawed dragons is known to have been made for courtiers, and at the same time some of the porcelain that is clearly of imperial quality is decorated with four- and three-clawed dragons.

The dragon in Chinese mythology is also the lord of the skies and the benevolent bringer of rain. In addition, therefore, to symbolising authority, strength and goodness, as of the emperor, it is also symbolic of fecundity and fertility.

The appearance of the dragon has changed very considerably over the years. In the fourteenth century it appeared to have peculiar antler-like horns, and in the first half of the succeeding century became a very fearsome animal, complete with lion-like mane. In the years that followed it became increasingly innocuous, and in the Hung-chih period in particular was often portrayed as a singularly ridiculous beast. Two other forms of dragon also appeared during the fifteenth century: the first of these is the fish-tailed sea dragon that can be seen on the bowl illustrated in Plate 18, and the other is a dragon with a peculiar foliated tail of the type that can be seen on the dish in Plate 75. Neither of these two types of dragon, however, appears to have been popular as a form of decoration since the middle of the sixteenth century.
8 *Ducks*. Mandarin ducks and geese are symbolic of marital happiness and faithfulness, for they are known to mate for life. A pair of ducks is therefore the marriage symbol and emblematic of felicity. Ducks often formed part of the decorative motif of fourteenth- and early fifteenth-century wares, but are much less often seen on later porcelain, unless there is clearly a deliberate attempt to copy the decoration of the earlier period (see Plate 4).
9 *Fish*. Commonly used in decorative motifs, they are the emblem of fecundity and wealth or abundance. The pronunciation of the word for fish in Mandarin, *yu*, is similar to that for abundance and surplus. Paired fish are a symbol of marital bliss and harmony (see Plate 19).

Fig 5
A Crapemyrtle and blackberry lily
B Chrysanthemum spray
C Chrysanthemum scroll
D Grapes
E *Ling-chih* fungus

F Lotus spray
G Lotus scroll
H Lotus petals

10 *Horses*. They are symbolic of speed and perseverance.

11 *Peacocks*. They symbolise a happy marriage and signify dignity and beauty. Peacocks are seldom found as part of a decorative motif after the end of the sixteenth century (see Plate 67).

12 *Pheasants*. Crested love-pheasants are symbolic of matrimonial pairing. Like peacocks, they are seldom seen on wares made after the end of the sixteenth century (see Plate 6).

13 *Phoenixes*. Like the *ch'ilin* and the dragon, phoenixes have long been used for decorative and symbolic purposes. They are emblematic of the empress and also, because they are supposed to preside over the south, they symbolise the warmth of the sun, the summer harvest and, less directly, fertility. Phoenixes can be found as part of the decoration of wares of all periods (see Plate 7).

14 *Tortoises*. They are symbolic of longevity, strength and endurance.

Flora

15 *Blackberry Lily and Crapemyrtle*. These two flowers are frequently found together as border patterns on early dishes. The former survived into the fifteenth century, but crapemyrtle is seldom seen after the end of the fourteenth. Blackberry lily, with its characteristic six-petalled star-shaped blossom, is frequently found as the decoration on one of the sides of square jarlets of the type illustrated in Plate 2A, and the wedge-shaped leaves of crapemyrtle are probably those found in the scrolling floral patterns of the earliest blue and white wares (see Fig 5).

16 *Chrysanthemum*. This flower represents the tenth month of the lunar calendar, autumn and joviality, and a life of ease and retirement from public office. It does not appear to have been used as a major element in blue and white decoration after the early part of the fifteenth century (see Fig 5).

17 *Grapes* (Fig 5). They are frequently found in the decoration of the big dishes of the fourteenth and fifteenth centuries (see Plate 10B), and are often associated with melons, plantain leaves and morning glory (see below).

18 *Ling-chih*. This sacred fungus (Fig 5) is symbolic of longevity. It occurs in decoration with such other emblems of longevity as peach and pine trees and cranes (see p 126).

19 *Lotus*. The lotus not only occurs as part of Chinese decoration of every period from the Han dynasty onwards, but is also a motif found all over the Far East. In the fourteenth and fifteenth centuries, in particular, it is frequently found in a scroll pattern, and is normally depicted in association with curious spiky leaves. It may also be found alone or growing in a pond with other water plants, duck or fishes. It is emblematic of the seventh month and summer and conveys the notion of happiness in maturity, creative power and genius. In nature the lotus grows in muddy water but emerges clean from it, and so in art it is seen as symbolising purity in adversity. In Mandarin the word for lotus is *lien*, and it is used as a pun to mean permanent adherence; the lotus therefore also symbolises marital happiness (see Fig 5).

20 *Melon*. Though this fruit is quite often found as part of the blue and white decoration of fourteenth- and early fifteenth-century dishes (see Plate 10A), it is seldom seen after the close of the fifteenth century (see Fig 6).

21 *Morning Glory*. This is fairly often found in the crowded compositions that fill the centres of the large dishes of the fourteenth and early fifteenth centuries, but seldom in the blue and white decoration of later periods (see Fig 6).

22 *Peach*. The fruit and tree are symbolic of longevity, the latter usually being twisted into the form of the *shou* character, which stands for longevity. The blossom is a charm against evil and represents the second month (see Plate 37).

23 *Pear*. The blossom represents the eighth month and is symbolic of wise and benevolent administration.

24 *Peony*. The peony motif was a major factor in blue and white decoration in the early years of the fifteenth century, but is seldom found on wares dating from about 1460. In the late fourteenth century it was also occasionally depicted reserved in white on a blue ground. It represents the third month in the lunar calendar, is the emblem of spring and is symbolic of love and affection, feminine beauty, wealth, honour and happiness (see Fig 6).

25 *Plantain Leaves*. A species of plantain bearing no fruit is commonly found in the Yangtse Valley, and in consequence it is familiar to the people of Kiangsi province. Most often depicted in the form of stiff plantain leaves, it features as part of blue and white decoration from the fourteenth to twentieth centuries (see Fig 6).

26 *Prunus Blossom*. This is the flower of the first month and winter. It is most often depicted reserved in white against a background of dark blue on the 'prunus blossom' or 'hawthorn' jars of the K'anghsi period (see Plate 51).

27 *The Three Friends*. The 'Three Friends of Winter'—prunus, pine and bamboo—are all emblematic of winter and longevity, and also symbolic of the qualities of a gentleman. The prunus is associated with good looks and sturdy independence in that it flowers at a time when nothing else

Fig 6
A Melon
B Morning glory
C Peony spray
D Peony scroll
E Stiff plantain leaves
F Plantain leaves as growing on a banana plant
G Waterweeds—eel grass

Fig 7
A1–A8, The Eight Buddhist Emblems:

A1 Chakra A5 Lotus
A2 Conch shell A6 Vase
A3 Umbrella A7 Paired fish
A4 Canopy A8 Endless knot or entrails

B1–B8, The Eight Taoist Immortals:

B1 Chung-li Ch'üan B5 Han Hsiang-tzŭ
B2 Ho Hsien-ku B6 Li T'ieh-kuai
B3 Lan Ts'ai-ho B7 Lü Tung-pin
B4 Ts'ao Kuo-chiu B8 Chang Kuo-lao

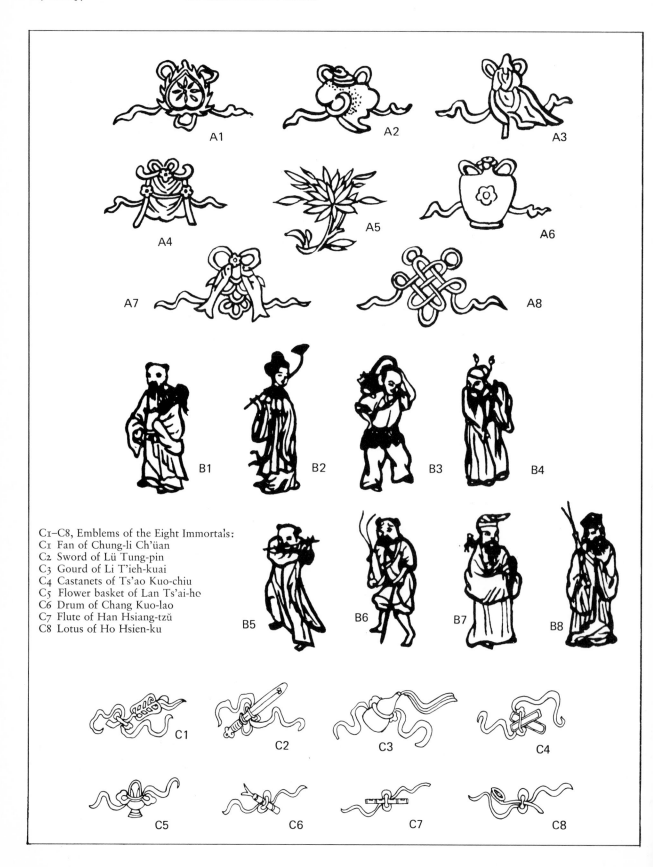

C1–C8, Emblems of the Eight Immortals:
C1 Fan of Chung-li Ch'üan
C2 Sword of Lü Tung-pin
C3 Gourd of Li T'ieh-kuai
C4 Castanets of Ts'ao Kuo-chiu
C5 Flower basket of Lan Ts'ai-ho
C6 Drum of Chang Kuo-lao
C7 Flute of Han Hsiang-tzŭ
C8 Lotus of Ho Hsien-ku

Fig 8
A1–A8, The Eight Precious Things:

A1 Jewel or mirror A5 Jade gong
A2 Cash A6 Pair of books
A3 Solid lozenge A7 Horn cups
A4 Open lozenge A8 Artemisia leaf

B The Eight Trigrams surrounding the *Yin-yang*
C Flaming pearls
D Swastika lozenge

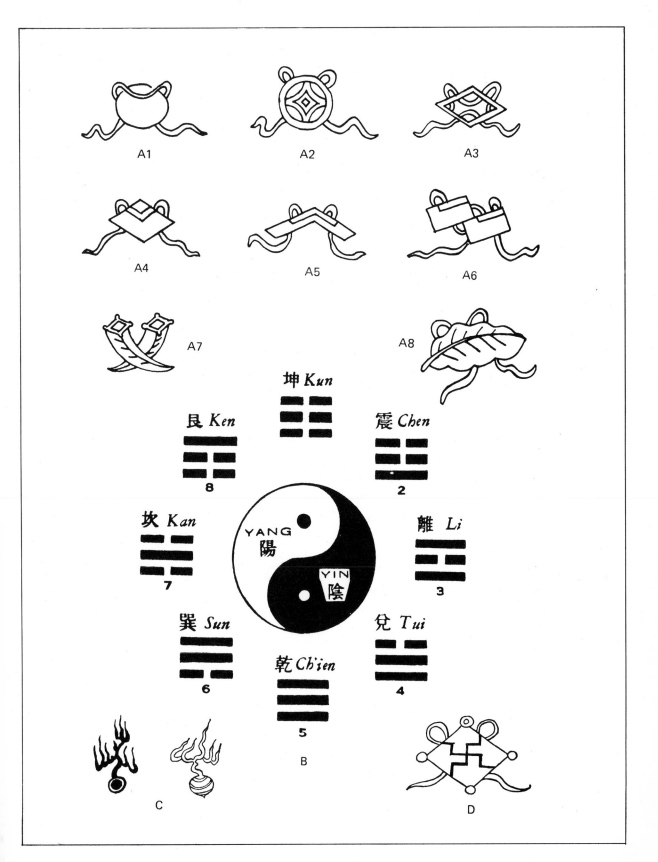

appears to grow; the pine is symbolic of constancy of friendship in times of adversity, and also of endurance, sturdy old age and longevity; and the bamboo is symbolic of longevity, of the integrity of a gentleman and courage in adversity, for even in strong winds it bends but never snaps. The 'Three Friends' are also symbolic of the three religions of China—Taoism, Buddhism and Confucianism—respectively (see Plates 23 and 27).

The pine and the bamboo can also occur as part of the decoration on a vessel independently, and need not always be associated, therefore, with the 'Three Friends'.

28 *Waterweeds*. They are the symbol of the Spirit of the Waters. The most commonly depicted example is eel grass (see Fig 6).

29 *Willow Trees*. They were supposed to ward off the influence of evil, and so were popular trees to grow around houses. The gait of women in bound feet was likened to the swaying of willows in the wind and was greatly admired (see Plate 77).

Religious symbols

30 *Dog of Fu*. This is a Buddhist guardian lion, which occurs in ceramic decoration from the fifteenth century onwards. It is a creature resembling a pekinese dog with a large bushy tail, and is often depicted playing with a brocaded ball to which ribbons are attached.

31 *Eight Buddhist Emblems* (*pa chi-hsiang*). These emblems (Fig 7), which are also sometimes referred to as the Happy Omens, are often found on Ming and later ceramics. They comprise the following:

[1] The Wheel or *chakra* (*fa lun*), symbol of Buddha's person and of infinite changing. It is also sometimes called the Wheel of Life, the Wheel of Truth or the Holy Wheel (occasionally the Wheel is replaced by the Bell or *chung*, the sound of which disperses evil spirits).
[2] The Conch Shell (*lo*), the emblem both of the voice of Buddha and of a prosperous voyage. In addition it is the insignia of royalty and an appeal to wisdom.
[3] The Umbrella (*san*), which symbolises spiritual authority and charity.
[4] The Canopy (*kai*), which symbolises royalty, particularly the princely rank of Buddha, dignity, high rank and spiritual authority.
[5] The Lotus (*ho hua*), which symbolises faithfulness.
[6] The Vase (*p'ing*), which symbolises perpetual harmony, supreme intelligence, and triumph over birth and death. It is also considered as a ceremonial jar for relics.
[7] The Paired Fish (*shuang yü*), which symbolise marriage, conjugal felicity, fertility and tenacity, and are considered to be a charm against evil.
[8] The Endless Knot (*chang*), which symbolises longevity, Buddha's entrails, infinity and eternity, and also promotes abundance.

During the Ch'ing dynasty these emblems were sometimes mixed with the Eight Taoist Emblems (see p 133), and the arrangement does not appear to have mattered very much, provided only eight emblems were depicted.

32 *Eight Immortals*. They were persons who for various reasons achieved immortality. Three were historical characters and the rest were legendary. The tradition is not believed to date from before the latter part of the Sung dynasty. The Immortals are as follows:

[1] Chung-li Ch'üan, Chief of the Immortals, who has the elixir of life and the power of transmutation.
[2] Ho Hsien-ku, the female sage, who assists in house management. She is said to have lived in the seventh century AD.
[3] Lan Ts'ai-ho, the patron saint of florists.
[4] Ts'ao Kuo-chiu, the patron saint of the theatre.
[5] Han Hsiang-tzŭ, the patron saint of musicians, who also has the power to make flowers grow and blossom immediately.
[6] Li T'ieh-kuai, a magician, sometimes known as 'Iron-crutch Li', for he is always depicted walking with the aid of a large crutch.
[7] Lü Tung-pin, the patron saint of barbers, who is worshipped by the sick and rids the world of evils. He lived in the latter part of the eighth century AD.
[8] Chang Kuo-lao, who is said to have lived in the seventh century AD.

The Eight Immortals are frequently associated in decoration with Shou Lao, the Star God of Longevity (see Fig 7).

33 *Eight Precious Things* (*pa pao*). These, which are also sometimes referred to as the 'Eight Treasures', often occur as part of the general decoration on porcelain and sometimes individually as marks on the base of wares. They are the following:

[1] The mirror (*ching*), sometimes referred to as the jewel, which promotes conjugal happiness and counteracts evil influences.
[2] The cash (*ch'ien*), which is emblematic of wealth.
[3] The solid lozenge (*fang sheng*), which was used in ancient times to ornament a headdress as a symbol of victory.
[4] The open lozenge (*fang sheng*), which, like the solid lozenge, was also an ornament on a headdress as a symbol of victory.

⁵ The jade gong (*tê ch'ing*), which is a ministerial emblem and a symbol of the exercise of discrimination and felicity.
⁶ The pair of books (*shu*), which are a symbol of learning and also ward off evil spirits.
⁷ The horn cups (*hsi chüeh*), which represent happiness and are the symbol of plenty.
⁸ The artemisia leaf (*ai-yeh*), which has healing properties and is a symbol of felicity. It was also used as a mark on the base of porcelain during the K'ang-hsi period (see Fig 14).

All the Eight Precious Things are illustrated in Fig 8.
34 *Eight Taoist Emblems* (*pa an-hsien*). These are the attributes of the Eight Immortals (see Fig 7). They sometimes appear on later ceramics and are as follows:

¹ The Fan of Chung-li Chüan, which is said to be capable of resuscitating the dead.
² The Sword of Lü Tung-pin, which was used for dispelling evil spirits.
³ The Gourd of Li T'ieh-kuai, which is said to contain all kinds of magical cures and drugs.
⁴ The Castanets of Ts'ao Kuo-chiu, symbol of revival.
⁵ The Flower basket of Lan Ts'ai-ho.
⁶ The Drum of a bamboo tube and rods of Chang Kuo-lao.
⁷ The Flute of Han Hsiang-tzŭ.
⁸ The Lotus of Ho Hsien-ku.

35 *Eight Trigrams* (*pa kua*). These are eight groups of lines arranged in three ranks and representing the eight main points of the compass, as follows:

¹ The North, symbolising the earth, capaciousness and submission.
² The Northeast, symbolising thunder and moving and exciting power.
³ The East, symbolising fire, sun, lightning, brightness and elegance.
⁴ The Southeast, symbolising still water, pleasure and complacent satisfaction.
⁵ The South, symbolising heaven, power and untiring strength.
⁶ The Southwest, symbolising wind, wood, penetration and flexibility.
⁷ The West, symbolising moving water, moon, rain, difficulty and peril.
⁸ The Northwest, symbolising mountains, hills and resting.

The Eight Trigrams are traditionally said to have been invented by the legendary hero Fu Hsi, and formed the basis of an ancient system of philosophy and divination. They appear to have become a decorative motif in ceramics about the middle of the fourteenth century (see Fig 8).
36 *Flaming Pearl* (*chu*). This symbolises the heart of Buddha, pure intentions, genius in obscurity and feminine beauty and purity. It is often found in decoration in conjunction with dragons that appear to be contending for it (see Fig 8).
37 *Swastika* (*wan*). The swastika represents the heart of Buddha, resignation of the spirit, all happiness, the mind and infinity (see Fig 8).
38 *Yin-yang*. This is a circle divided into two equal parts by an S-curving line, and represents the mystic dual principle behind the interaction of opposites in nature (see Fig 8). The light portion, *yang*, stands for the male principle, and takes in light, heaven, the sun, vigour, penetration and odd numbers; and the dark portion, *yin*, representing the female principle, takes in dark, the earth, the moon, quiet absorption and even numbers. In decoration the *yin-yang* is often associated with the Eight Trigrams.

Miscellaneous symbols

39 *Classic Scrolls*. These are formal linear scrolling patterns of uncertain origin that were normally used as border patterns. The finest and most freely drawn are found on fourteenth- and early fifteenth-century wares, but later examples show some signs of degeneration (see Fig 9).
40 *Cloud Collar*. This is an important decorative motif that is variously referred to as a '*ju-i* pattern', 'ogival pattern', 'lambrequin' or 'lappet', and is very commonly found in porcelain decoration from the fourteenth century onwards. In its strict form it consists of four lobed panels set at right-angles to each other and each terminating in a point, but the number of lobes to a panel may vary. The interior is often filled with some other decorative motif, which is, however, in keeping with the general decoration of the vessel in question (see Fig 9).
41 *Cloud Scroll*. This motif, which can show very considerable variation, is frequently found in ceramic decoration from the fourteenth century onwards. Clouds denote beneficial rain and fertility (see Fig 9).
42 *Diamond Diaper*. This form of decoration is frequently used as a border to large dishes and as a filler. Consisting of repeating geometric patterns, it is found on the wares of the fourteenth century onwards, but begins to show considerable degeneration after the early sixteenth century (see Fig 9).

Fig 9
A Classic scrolls
B Cloud collar or lappet
C Cloud scrolls
D Diamond diaper border
E *Ju-i* head
F Key fret or 'thunder pattern' border

43 *Flames*. These are symbolic of the spirit of fire, heat and the *yang* principle.

44 *Ju-i Head*. This heart-shaped motif resembles the head of the curved *ju-i* sceptre, a ceremonial object carried by certain Buddhist deities and the emblem of monastic authority (see Fig 9). Occurring most commonly as a repeating motif, *ju-i* heads are very similar, on a smaller scale, to cloud collars or lappets (see above).

45 *Key Fret*. This is a repeating design most commonly used as a band around jars and vases or else as a border pattern on dishes. Sometimes referred to as the 'thunder pattern', it was first used on bronzes, but later became a very popular motif in ceramic, lacquer and cloisonné decoration (see Fig 9).

46 *Lotus Panel*. This panel is one of the commonest of ceramic decorative motifs and dates from Sung times. Lotus panels frequently form a band of decoration around the foot of jars and vases, and may be either upright or pendant. The design derives ultimately from the Buddhist lotus throne. It may be seen in a number of different stylisations, but all are derived from the shape of a petal with the tip turned back a little. The panels may also be used to frame a variety of decorative devices that are normally in keeping with the general decoration of the vessel in question. They are also mistakenly referred to as 'gadroons' or 'false gadroons', but these are terms that should be discarded (see Fig 10).

47 *Mountains*. They are considered to be places of worship, rest and retreat from the world.

48 *Pagoda*. This is a receptacle for relics, and was believed to secure good geomantic influences (see Plate 77).

49 *Petal Diaper*. This is a very common design found on ceramics and other art forms. It consists of a band of elliptical forms set at right-angles to each other (see Fig 10).

50 *Rocks*. These symbolise permanence and solidarity.

51 *Shuang-hsi*. This mark, which may form part of the general decoration of a vessel or else be found on the base as a mark of commendation, indicates 'two-fold joy' or wedded bliss. It consists of two *hsi* characters placed side by side, often with the lowest horizontal bar running across to unite both characters. Vessels bearing the *shuang-hsi* mark were often presented as wedding presents (see Fig 10).

52 *Shou*. This can appear in a number of conventionalisations of the character *shou*, meaning longevity. Like the *shuang-hsi* mark, the *shou* can either form part of the decoration or else be found on the base of a vessel as a mark of commendation.

It is very commonly found on blue and white wares from the sixteenth century onwards (see Fig 10).

53 *Trefoils*. These are a form of lappet suspended beneath the main decoration of bottles, jars and vases. They are seldom found as part of the decoration of Ch'ing wares (see Fig 10).

54 *Waves*. Water is depicted in various forms in decorative motifs throughout the history of blue and white porcelain, and waves, which were considered to be the abode of dragons, are very commonly found in decoration throughout the Ming dynasty. The three main types of waves are the following:

[1] Serpentine waves, which often form the border decoration of large dishes and are found around the rims of other wares. In general it is true to say that the serpentine waves of most of the fourteenth century break to the left, while those of the end of the century and the early fifteenth century break to the right, but exceptions to this rule can be found.
[2] Concentric waves, which are used as a solid ground pattern and look like concentric discs arranged to overlap so that the top one-third of each is visible.
[3] Scalloped waves, which, like concentric waves, are used as a ground pattern and space filler; but they are rarer and are not normally found in decoration after the end of the fourteenth century (see Fig 10).

Marks and inscriptions

Marks and inscriptions of various kinds are frequently found on Chinese porcelain. Those that occur as part of the decoration are normally of a poetical nature (see Plates 45, 46 and 53) and are related to the decorative motif; but they tell us nothing about the possible date of the vessel or where it was made. On the other hand, those marks and inscriptions that tell us something of the history of the porcelain are normally painted in underglaze blue on the base. They are usually written in ordinary script or *k'ai shu*, though during the Ch'ing dynasty the reign mark of an emperor was frequently inscribed in *chuan shu* or seal characters, and was often enclosed in a rectangular frame as though it was a seal mark. Chinese characters in *k'ai shu* are normally written in vertical columns and are read from top to bottom, with the sequence of the columns running from right to left. If the characters are written horizontally, they are read from right to left.

Marks on porcelain may conveniently be grouped under one of the following four headings: reign marks, cyclical marks, hall marks and marks of commendation. We shall now consider each of these in order of their importance.

Fig 10
A Lotus panels framing auspicious objects
B Petal diaper border
C *Shuang-hsi* mark
D *Shou* character
E Trefoils

F1 Serpentine waves
F2 Concentric waves
F3 Scalloped waves

A

B

C D E

F1

F2

F3

Fig 11

REIGN MARKS

Yung-lo 1403-24	Yung-lo 1403-24	Hsüan-tê 1426-35	Ch'êng-hua 1465-87	Hung-chih 1488-1505
Chêng-tê 1506-21	Chia-ching 1522-66	Lung-ch'ing 1567-72	Wan-li 1573-1619	T'ien-ch'i 1621-27
Ch'ung-chên 1628-43	Shun-chih 1644-61	K'ang-hsi 1662-1722	Yung-chêng 1723-35	
Ch'ien-lung 1736-95	Chia-ch'ing 1796-1820	Tao-kuang 1821-50	Hsien-fêng 1851-61	
T'ung-chih 1862-73	Kuang-hsü 1874-1908	Hsüan-t'ung 1909-12		

Fig 13 Hall Marks:

A *Ch'u shun mei yu t'ang chih* ('Made for the Ch'u Shun—Abundant Prosperity—Hall of Beautiful Jade')
B *Yang ho t'ang chih* ('Made at the Hall for the Cultivation of Harmony')
C *Hsieh-chu ts'ao* ('Made at the Hsieh Bamboos')
D *Ta shu t'ang chih* ('Made at the Big Tree Hall')
E *Ts'ai jun t'ang chih* ('Made at the Hall of Brilliant Colours')

Reign marks (see Fig 11)

The normal method of indicating when a piece of porcelain was manufactured was to include the name of the reigning emperor of the time when it was made in the mark. As it has been pointed out in Chapter 2, however, it would be very unwise to assume that the presence of a particular reign mark on the base of a vessel shows without any doubt that it was produced during that reign. These reign marks, or *nien hao*, are normally arranged in two vertical columns thus,

Tê	*Ta*
Nien	*Ming*
Chih	*Hsüan*

which can be translated as 'Made in (*chih*) the Hsüan-tê period (*nien*) of the Great (*ta*) Ming Dynasty'. Occasionally the first two characters, *Ta ming*, are omitted. Rather more rarely the name of the emperor is left out, so that the resulting inscription reads rather vaguely '*Ta ming nien chih*'. The character *chih* is occasionally replaced by *ts'ao*,

but as both mean 'made in', the meaning of the inscription as a whole remains unaltered.

Occasionally the year of manufacture is indicated in the *nien hao* by adding the year of the reign in which the piece was made (see Plate 44). In order to distinguish the year, one must be able to read the Chinese numerals from 1 to 10:

1 = 一	*i*		6 = 六	*liu*
2 = 二	*êrh*		7 = 七	*ch'i*
3 = 三	*san*		8 = 八	*pa*
4 = 四	*ssŭ*		9 = 九	*chiu*
5 = 五	*wu*		10 = 十	*shih*

As has previously been mentioned in Chapter 4, a number of 'shop marks' were used during the K'ang-hsi period in the place of the *nien hao*. Four of the most common of these—the hare and crescent moon, the lotus, the artemisia leaf and the *ting* mark—are illustrated in Fig 14.

Cyclical marks (see Fig 12)

The system of dating according to the cyclical calendar is supposed to have started in the year

Fig 12

CYCLICAL MARKS

甲 chia	乙 i	丙 ping	丁 ting	戊 mou	己 chi	庚 keng	辛 hsin	壬 yên	癸 kuei
子 tzu [1]	丑 ch'ou [2]	寅 yin [3]	卯 mio [4]	辰 ch'ên [5]	巳 ssŭ [6]	午 wu [7]	未 wei [8]	申 shên [9]	酉 yu [10]
戌 hsu [11]	亥 hai [12]	子 [13]	丑 [14]	寅 [15]	卯 [16]	辰 [17]	巳 [18]	午 [19]	未 [20]
申 [21]	酉 [22]	戌 [23]	亥 [24]	子 [25]	丑 [26]	寅 [27]	卯 [28]	辰 [29]	巳 [30]
午 [31]	未 [32]	申 [33]	酉 [34]	戌 [35]	亥 [36]	子 [37]	丑 [38]	寅 [39]	卯 [40]
辰 [41]	巳 [42]	午 [43]	未 [44]	申 [45]	酉 [46]	戌 [47]	亥 [48]	子 [49]	丑 [50]
寅 [51]	卯 [52]	辰 [53]	巳 [54]	午 [55]	未 [56]	申 [57]	酉 [58]	戌 [59]	亥 [60]

F *Hsieh-chu chu-jen ts'ao* ('Made by the Lord of the Hsieh Bamboos')
G *Ch'i yu t'ang chih* ('Made at the Rare Jade Hall')
H *Yuan wen wu kuo chih chai* ('Pavilion where I wish to hear of my faults')
I *Wan shih chu* ('The Myriad Rocks Retreat')
J *I yu t'ang chih* ('Made at the Ductile Jade Hall')
K *Lu yi t'ang* ('The Hall of Waving Bamboos')

L *Shu-fu* ('Privy Council'—mark of the Yüan dynasty, 1279–1368)
M *I yu t'ang shih* ('Made at the Hall of Profit and Prosperity')
N *Chu chih chu* ('The Red Rocks Retreat')
O *Ta ya chai* (Hall mark and motto of the Empress Dowager)

Fig 14

A1–A4, K'ang-hsi marks:

A1 Hare within double circle A3 Artemisia leaf
A2 Lotus A4 Ting (archaic bronze
 cauldron) mark

B1–B13, Commendation marks:
B1 *Ta Chi* ('Great good luck')
B2 *Wan shou wu chiang* ('A myriad ages never ending')
B3 *Fu kuei ch'ang ch'un* ('Riches honour and enduring
 spring')
B4 *Wen chang shan tou* ('Scholarship high as the mountain
 and the Great Bear')

B5 *Te hua ch'ang ch'un* ('Virtue, culture and enduring
 spring') in the inner rectangle and *Wan-li nien ts'ao*
 ('Made in the Wan-li period') in the outer circle
B6 *Chih* ('By Imperial Order')
B7 *Fu lu shou* ('Happiness, rank and longevity')
B8 *Ch'ing* ('Congratulations')
B9 *Yung ch'ing ch'ang ch'un* ('Eternal prosperity and
 enduring spring')
B10 *Ch'ang ming ju kuei* ('Long life, riches and honour')
B11 *Chi hsiang ju i* ('Good fortune and fulfilment of wishes')
B12 *Tan kuei* ('Red cassia')
B13 *Fu kuei chia ch'i* ('Fine vessel for the rich and
 honourable')

2637 BC. For the period that we are concerned with, however, the first cycle of importance began in AD 1324, and was then renewed every subsequent sixty years, in 1384, 1444, 1504, 1564 and so on. Each of the sixty years within the cycle has an individual name in two characters formed by combining one of the Ten Stems with one of the Twelve Branches. These Ten Stems are shown on the first horizontal line of the chart in Fig 12, and the Twelve Branches occupy the second line and the first two spaces of the third. One of the Stems will be found in conjunction with one of the Branches in every cyclical date mark. If the eye is carried straight down the column in the chart from the Stem that has been identified in the mark until it recognises the Branch character that is also in the mark, the year of manufacture in a particular cycle can be read off at once from the numeral in the same square as the Branch character in question.

As an illustration of this, let us consider the year *kuei-ch'ou* in the mark on the bowl illustrated in Plate 39. *Kuei* is the Tenth Stem and so is found at the end of the top line in the chart. If we then look down the *kuei* column until we recognise the Branch character *ch'ou*, we will see that the fiftieth year of the cycle is indicated. As the bowl in question is clearly decorated in typical sixteenth-century style, the date referred to must be the fiftieth year of the cycle that began in 1504, ie 1553.

The dating of a piece of porcelain bearing a cyclical date mark normally requires, as has been the case in this instance, consideration of the decorative style of the vessel in question as well as the cyclical date mark itself. Occasionally, however, the cyclical date mark is combined with the reign mark of a particular emperor, and then the task of dating a piece is clearly very much more straightforward.

Hall marks (see Fig 13)

Hall marks are so called because they normally include the words *t'ang* (hall), *chai* (study) or *t'ing* (pavilion). These marks are open to a variety of interpretations, for they may indicate the name of the workshop where the vessel was made; the family hall name of the person for whom it was intended, eg *ta ya chai*, the Empress Dowager (Fig 13/O); the building for which the piece was destined, eg *shu-fu*, 'Privy Council' (Fig 13/L); or the shop for which it was ordered. There is rarely any indication of the correct choice of these meanings in the hall marks themselves, but happily the collector does not need to decide on this.

Marks of commendation (see Fig 14)

It is not unusual to find a few characters on the base of a vessel (where one would normally expect to find the *nien hao*) that indicate the use for which the piece of porcelain was intended, a message of good wishes for the owner or some moral aphorism. Fairly long dedicatory inscriptions are often incorporated into the general decoration of a vessel, but such brief inscriptions on their own as 壇 *t'an* ('altar') are frequently found on the inside of Hsüan-tê altar cups, and 茶 *ch'a* ('tea') or 酒 *chiu* ('wine') on cups of the Chia-ching period. Similarly, some wares are marked as having been made by authority with the simple *chuan shu* inscription *chih* ('By Imperial Order', see Fig 14/B6) or have their destination indicated by such inscriptions as 用公府帥 *shuai fu kung yung* ('For public use/in the general's hall').

Good wishes are expressed by such phrases as *Fu kuei ch'ang ch'un* ('Riches, honour and enduring spring', Fig 14/B3) or else by symbolic terms like *tan kuei* (red cassia), which implies a wish for success in state examinations. The phrase 'to pluck the cassia in the moon' implies obtaining a high place in the examinations. The use of marks of commendation was particularly common during the Chia-ching and Wan-li periods, and some are occasionally found inscribed in conjunction with the Wan-li reign mark (Fig 14/B5). Perhaps the most popular commendation mark on late Ming wares is *Fu kuei chia ch'i* ('Fine vessel for the rich and honourable', Fig 14/B13), but many others were also used.

Good wishes may also be expressed by such symbols as the stork, crane or peach for longevity and the bat for happiness. These symbols are more common on Ch'ing than Ming wares, but the stork is sometimes also found on late sixteenth-century vessels. The best known of these symbols is the hare and crescent moon, which is frequently found on K'ang-hsi porcelain, but the hare depicted alone is also known as a mark on late sixteenth-century wares. In Taoist lore the hare is one of the denizens of the moon, and assists the moon toad to pound the elixir of life.

Appendix C
Collecting Blue White

To study Chinese porcelain without collecting it at the same time can easily become a frustrating and even barren pastime. Collecting it, on the other hand, without at least some degree of study can result in the collector making some appalling mistakes and cause him a good deal of unnecessary expense. We have so far considered the history of

blue and white from its origins in the fourteenth to the beginning of the present century, and that should have helped familiarise any new collector with its development, and taught him what to look out for. It will not, however, necessarily make him the complete collector, for the art of collecting can be learned only through a good many years of experience. There is a great deal of pleasure, however, in the process of learning.

In this appendix we shall consider some of the practical factors that the collector should bear in mind when he is building up his own collection. Foremost among these is, of course, the ability to recognise the characteristics of the porcelain of different reigns and to attribute different pieces to their correct periods. This will call for careful examination of the material of the body, the glaze, the method of potting and the shape and finish of the piece, the nature of the cobalt blue used in the decoration and that decoration itself. Each of these fields of study deserves a good deal of time and attention, and so the collector should beware of jumping to the conclusion that a particular piece of porcelain can be attributed to a certain period just because one or two of its characteristics seem to suggest this.

It often happens, for instance, that the provincial blue and white of the sixteenth century shows those rust marks around particularly heavy concentrations of cobalt that we normally associate with the early fifteenth century. Moreover, as has already been mentioned, many Yung-chêng and Ch'ien-lung blue and white wares were made in faithful imitation of those of the fifteenth century, and though for the most part they were not originally intended to, these can also deceive the unwary. Not only this, but it is also true that in the 1920s and 1930s a good many excellent copies of fifteenth-century wares were made with the deliberate intention of deceiving. Such pieces, and even some of the very good fakes that have been made very much more recently in Taiwan and in parts of Southeast Asia, present pitfalls for those who are rather too ready to jump to conclusions. The collector should therefore remember that it is in general true to say that the earlier pieces of porcelain—those made before the end of the sixteenth century—show a good deal of individual craftsmanship in their method of manufacture, whereas the later ones, having been finished off with specific forming tools, give a very much more uniform appearance. The latter, therefore, while probably technically superior, are less interesting than the earlier wares, which betray the imperfections and touch of the individual potter.

The collector should also bear in mind that very

few examples of antique porcelain do not show some signs of wear, even if it is sometimes merely indications of scratching in the glaze. Any piece of porcelain alleged to date from the seventeenth century or earlier that does not show some slight signs of wear should be treated with the greatest reserve. The collector should at the same time remember that fakers are adept at counterfeiting antique wear, and so, for example, if all the scratches in the glaze are evenly applied and appear to be running in the same direction, the collector may well be correct in assuming that they were deliberately done with sandpaper.

Nearly all Ming wares not of the finest imperial quality also show such slight blemishes in the body as cracks, chips and minute holes in the glaze where it was not evenly applied. These blemishes nearly always reveal accretions of dirt that can usefully be examined under a powerful lens (magnification by ten or twenty times), which the collector should keep in his pocket. He should remember that a crack in the body that is altogether devoid of dirt or discolouring almost certainly means that it is not very old itself, and may well suggest that the vessel in question is not either.

He may also use his lens to examine the bubbles that are normally found in the glaze. Study of the size and distribution of these bubbles is a complicated business calling for considerable skill and knowledge, and so we shall not consider it in detail here; but if the collector discovers a complete absence of bubbles in the glaze, or indications of burst bubbles in a piece that has been buried or lain under the water for many years, he may well conclude that the glaze has been very thinly or evenly applied indeed, and therefore the vessel in question must be comparatively modern. He would also be well advised to make a point of examining the glaze on such flat surfaces as the base of a vessel; if it gives the impression of being crinkled when held up to the light, he may be certain that the piece was made fairly recently and may, indeed, be only a few years old.

Many wares of the Ming and Yüan dynasties have been extensively restored. However well these repairs may have been glazed over, they are usually fairly easy to detect if the collector feels round the rim of the piece in question with a coin or ring and listens for variations in the sound made. He should also examine the piece under a strong light—a 'black' or ultra-violet light is particularly useful for this purpose—and should look for changes in the colour of the body. It often happens that a faint yellow discolouring of the transparent glaze indicates a repair and reglazing using paraffin as one of the

constituents. Joins and repairs may also be revealed if the dish is held up so that the beams from a 'black' light fall directly on it.

In conclusion, here are a few simple pieces of advice that the collector would do well to remember.

1 See and handle as many pieces of porcelain as possible. There are in Europe and North America a number of museums and collections that contain wares of immense importance and value. You can study these for as long as you like, and learn to recognise the characteristics of porcelain of different periods that you have previously been able only to read about. Valuable though this may be, it is unfortunate that in museums nearly all the porcelain is in show-cases, so that you cannot handle the pieces for yourself. This disadvantage, however, is not found in the large number of antique dealers' galleries and fine art auction houses that sometimes hold porcelain of very great importance. Here you will be able to handle it for yourself and get to know the feel of the pieces. The importance of this cannot be over-estimated, for the more antique wares you are able to handle, the more familiar you will become with their 'feel'; then you will be better able to decide whether the porcelain you have found for yourself is 'right' or not.

2 Make sure in your shopping expeditions that you regularly go to a reputable dealer. It often pays to spend a little more in a shop that you have confidence in than be fooled by some unscrupulous person who sells you a 'bargain'. Beware, too, of the man who tells you that you have 'good eyes', for the chances are that he is trying to push some piece of trumpery that you will later regret buying. There can scarcely be any private collector—or museum either, for that matter—who has not been taken in at one time or another. With a reputable man, however, you are greatly reducing the chances of buying something that you will later regret, and you will be able to learn a great deal from him. When you are surer of yourself and certain of the authenticity of a piece, you can afford to shop with great confidence at establishments you would probably have avoided earlier on.

3 Make sure that you know the market price of the porcelain that you want to buy. There are two simple ways of doing this. The first is simply to shop, or at least to browse, extensively, and be ready to walk out of a shop without the piece that first caught your notice. You will certainly see a good deal of porcelain in this way, but the danger is that you may not find many pieces that compare at all closely with those you are interested in. More reliable, therefore, are the lists of sale prices that most of the more important fine art auction houses issue after a sale. These lists, or the highlights of an auction, are also frequently referred to in detail in fine art magazines. The great value of auction sale prices is that they give a very fair indication of what the public was prepared to pay for a particular piece of porcelain at any given time. Their weakness is that many important houses are interested in the more striking and fairly expensive pieces that are beyond the reach of many a modest collector. The solution, however, to this seeming quandary is simple: the collector should use both methods, exploring and browsing in shops and also studying auction sale reports. He will thus be well acquainted with both ends of the market.

4 Do not be an 'antique snob'. There are those who delude themselves that just because a piece of porcelain is Ming or Sung it must for that reason be beautiful. Nothing in fact could be further from the truth, for some examples of Ming porcelain are very ugly. By the same token, though nineteenth-century porcelain is in general inferior to the earlier wares, some exceptionally pleasing pieces were produced during that period. The collector who closes his eyes to the merits of comparatively recent wares is therefore missing a great deal. The intrinsic value of a piece of porcelain depends on four criteria—beauty, age, rarity and academic interest and importance. If a collector possesses a piece of porcelain satisfying all these criteria, he may count himself fortunate indeed.

Notes

1 Origins: the Fourteenth Century, pp 17–25

1 It has long been a Chinese belief that blue and white wares were produced substantially before the end of the thirteenth century, but until recently no hard evidence was produced to support this view. Very recent archaeological discoveries, however, seem to suggest that some rough blue and white pottery was produced under the influence of the invading Mongols in northern China well before their conquest of the country was complete (see Feng Hsien-ming, 'Some Problems concerning the Development of Chinese Ceramics', *Wen Wu*, No 7 (1973)

2 Brankston, A. D. *Early Ming Wares of Ching-techen* (Peking, 1938; reprinted Hong Kong, 1970), 8

2 The Classical Period: the Fifteenth Century, pp 26–47

1 Brankston, A. D. *Early Ming Wares of Ching-techen* (Peking, 1938; reprinted Hong Kong, 1970), 3

2 Gray, Basil. 'The Influence of Near Eastern Metal-work on Chinese Ceramics', *Transactions of the Oriental Ceramic Society*, Vol 18 (1940–41), 51

3 Brankston, op cit, 19

4 Pope, J. A. *The History of the History of Ming Porcelain* (1972), Plate 7B

5 Joseph, A. M. *Ming Porcelains: Their Origins and Development* (1971)

6 Pope, J. A. *Chinese Porcelains from the Ardebil Shrine* (Washington, DC, 1956), 107

7 Medley, Margaret. *Porcelains Decorated in Underglaze Blue and Copper Red in the Percival David Foundation of Chinese Art* (1963), 17–18

3 Late Ming Wares: the Sixteenth Century, pp 48–60

1 Jenyns, R. Soame. *Ming Pottery and Porcelain* (1953), 99

2 Medley, Margaret. *Porcelains Decorated in Underglaze Blue and Copper Red in the Percival David Foundation of Chinese Art* (1963), 64

The inscription reads as follows: 'The words of [God] Almighty . . . And that the places of worship belong to God, so call on none along with God. And that when the servant of God arose calling on Him they [the Jinn] were near to being too great an oppression for him. Say: I worship my Lord alone and associate none with Him'

3 Ibid, 7

4 Jenyns, R. Soame. *Later Chinese Porcelain* (2nd edition, 1971), 59, n3

4 New Developments: the Seventeenth Century, pp 61–75

1 Medley, Margaret. *Porcelains Decorated in Underglaze Blue and Copper Red in the Percival David Foundation of Chinese Art* (1963), 57

2 Jenyns, R. Soame. 'The Chinese Ko-sometsuke and Shonzui Wares', *Transactions of the Oriental Ceramic Society*, Vol 34 (1962–3), 16

3 Ibid, 16

4 Ibid, 23

5 Hobson, R. L. *Chinese Pottery and Porcelain* (1915), 128

6 Jenyns, R. Soame. *Later Chinese Porcelain* (2nd edition, 1971), 25

7 Medley, op cit, 72

8 Ibid

5 Later Blue and White: the Eighteenth and Nineteenth Centuries, pp 76–88

1 Pope, J. A. *The History of the History of Ming Porcelain* (1972), 1–2

2 National Palace Museum, Taiwan. *Chinese Cultural Art Treasures* (9th edition, Taipei, 1974), Plate 6

3 *Arts of Asia*, Vol 4, No 6 (Hong Kong, 1974), 47

6 Provincial Ming Wares and Exports to Southeast Asia, pp 89–103

1 Sullivan, Michael. 'Notes on Chinese Export Wares in Southeast Asia', *Transactions of the Oriental Ceramic Society*, Vol 33 (1960–62), 61

2 Locsin, L. and C. *Oriental Ceramics Discovered in the Philippines* (Vermont and Tokyo, 1967), 13

3 Sullivan, op cit, 66

4 Beurdeley, Michel. *Porcelain de la Compagnie des Indes*, trans as *Chinese Trade Porcelain* by D. Imber (Vermont and Tokyo, 1962), 36

7 Blue and White and the West, pp 104–121

1 Ayers, John. 'Early Ming Taste in Porcelain', *Victoria and Albert Museum Bulletin*, Vol 2, No 1 (1966), 25

2 Beurdeley, Michel. *Porcelain de la Compagnie des Indes*, trans as *Chinese Trade Porcelain* by D. Imber (Vermont and Tokyo, 1962), 103

3 Hackenbroch, Yvonne. 'Chinese Porcelain in European Silver Mounts', *Connoisseur* (June 1955), 24

4 Beurdeley, op cit, Figure 50

5 Ibid, 114

6 Volker, T. *Porcelain and the Dutch East India Company* (Leiden, 1954), 23

7 Beurdeley, op cit, 92

8 Spriggs, A. I. 'Oriental Porcelain in Western Paintings', *Transactions of the Oriental Ceramic Society*, Vol 36 (1964–6), 73–87

9 Beurdeley, op cit, 119

10 Mudge, J. M. *Chinese Export Porcelain for the American Export Trade* (Delaware, 1962), 64

11 Ibid, 67

12 Ibid, 75

13 Ibid, 124

14 Ibid

Bibliography

Addis, Sir John. 'Chinese Porcelain Found in the Philippines', *Transactions of the Oriental Ceramic Society*, Vol 37 (1967–9)

Aga-Oğlu, K. 'Five Examples of Annamese Pottery', *Bulletin of the University of Michigan Museum of Art*, Vol 5 (Ann Arbor, 1954)

——. 'Ming Export Blue and White Jars in the University of Michigan Collection', *Art Quarterly*, No 11 (Detroit, 1948)

——. 'The Relationship between Ying-ch'ing, Shu-fu and Early Blue and White', *Far Eastern Ceramic Bulletin*, No 8 (Ann Arbor, 1949)

Arts of Asia, Vol 4, No 6 (Hong Kong, 1974)

Ayers, John. 'Early Ming Taste in Porcelain', *Victoria and Albert Museum Bulletin*, Vol 2, No 1 (1966)

——. *The Seligman Collection of Oriental Art*, Vol II (1964)

Beurdeley, Michel. *Porcelain de la Compagnie des Indes*, trans as *Chinese Trade Porcelain* by D. Imber (Vermont and Tokyo, 1962)

Brankston, A. D. *Early Ming Wares of Chingtechen* (Peking, 1938; Hong Kong, 1970)

Christie, Manson & Woods Ltd. *The Frederick Mayer Collection of Chinese Art* (Catalogue, 24–25 June 1974)

Frank, A. *Chinese Blue and White* (1969)

Fry, R., Binyon, L., Siren, O., Rackham, B., Kendrick, A. F. and Winkworth, W. W. *Chinese Art* (1925; Taipei, 1969)

Garner, Sir Harry. 'Blue and White of the Middle Ming Period', *Transactions of the Oriental Ceramic Society*, Vol 17 (1951–3)

——. *Oriental Blue and White* (3rd edition, 1970)

Gray, B. 'A Chinese Blue and White Bowl with Western Emblems', *British Museum Quarterly*, Vol 22, No 3 (1960)

——. 'Chinese Porcelain of the Fourteenth Century: 1, Blue and White', *British Museum Quarterly*, Vol 23 (1961)

——. 'The Influence of Near Eastern Metalwork on Chinese Ceramics', *Transactions of the Oriental Ceramic Society*, Vol 18 (1940–41)

Hawley, W. W. *Chinese Folk Designs* (New York, 1949)

Hobson, R. L. *Chinese Pottery and Porcelain* (1915)

——. *The Wares of the Ming Dynasty* (1923; reprinted Vermont and Tokyo, 1973)

Honey, W. B. *Guide to the Later Chinese Porcelain in the Victoria and Albert Museum* (1927)

——. *The Ceramic Art of China and Other Countries of the Far East* (1945)

Jenyns, R. Soame. *Later Chinese Porcelain* (2nd edition, 1971)

——. *Ming Pottery and Porcelain* (1953)

——. 'The Chinese Ko-sometsuke and Shonzui Wares', *Transactions of the Oriental Ceramic Society*, Vol 34 (1962–3)

Joseph, A. M. *Ming Porcelains: Their Origins and Development* (1971)

——. *Chinese and Annamese Ceramics* (1973)

Lammers, Cheng. *Annamese Ceramics in the Museum Pusat Jakarta* (Jakarta, 1974)

Lane, A. 'Ming Ceramics', *Transactions of the Oriental Ceramic Society*, Vol 30 (1955–7)

——. 'The Gagnières-Fonthill Vase: a Chinese Porcelain of about 1300', *Burlington Magazine*, Vol CIII (1961)

Lee, J. G. 'Ming Blue and White', *Philadelphia Museum Bulletin*, No 223 (Philadelphia, 1949)

Lloyd Hyde, J. A. *Oriental Lowestoft: Chinese Export Porcelain* (Newport, 1955)

Locsin, L. and C. *Oriental Ceramics Discovered in the Philippines* (Vermont and Tokyo, 1967)

Medley, M. *A Handbook of Chinese Art* (1964)

——. *Porcelains Decorated in Underglaze Blue and Copper Red in the Percival David Foundation of Chinese Art* (1963)

——. 'Regrouping 15th Century Blue and White', *Transactions of the Oriental Ceramic Society*, Vol 34 (1962–3)

——. *Yüan Porcelain and Stoneware* (1974)

Mudge, J. M. *Chinese Export Porcelain for the American Export Trade* (Delaware, 1962)

National Palace Museum, Taiwan. *Chinese Cultural Art Treasures* (9th edition, Taipei, 1974)

——. *Masterworks of Chinese Porcelain* (Taipei, 1969)

——. *Masterworks of Chinese Porcelain: Supplement* (Taipei, 1973)

Oriental Ceramic Society. *The Ceramic Art of China* (Catalogue of the Society's 1971 exhibition, 1972)

Oriental Ceramic Society of Hong Kong. *Chinese Blue and White Porcelain* (Catalogue of the Society's exhibition, 1975)

Pope, J. A. *Chinese Porcelains from the Ardebil Shrine* (Washington, DC, 1956)

——. *Fourteenth Century Blue and White in the Topkapu Sarayi Musesi, Istanbul* (Washington, DC, 1952)

——. *The History of the History of Ming Porcelain* (1972)

Sayer, G. R. (translator). *Ching-te Chen T'ao Lu* (An Account of Ching-te Chen Pottery) (1951)

Sorsby, W. *Southeast Asian and Early Chinese Export Ceramics* (1974)

Sotheby & Co. Catalogues of Important Chinese Ceramics, 13 November 1973, 1–2 April 1974, 8–9 July 1974, 2 December 1974

Sotheby Parke-Bernet Inc. *Fine Chinese Works of Art* (Catalogue, 23–24 May 1974)

Sotheby Parke-Bernet (Hong Kong) Ltd. Catalogues of Important Chinese Ceramics, 31 October– 2 November 1974

Southeast Asian Ceramic Society. *Ceramic Art of South-East Asia* (Catalogue of the Society's exhibition, 1971)

Spriggs, A. I. 'Oriental Porcelain in Western Paintings', *Transactions of the Oriental Ceramic Society*, Vol 36 (1964–6)

Sullivan, M. 'Notes on Chinese Export Wares in Southeast Asia', *Transactions of the Oriental Ceramic Society*, Vol 33 (1960–62)

Tregear, M. *Guide to Chinese Ceramics in the Department of Eastern Art* (Ashmolean Museum, Oxford, 1966)

Volker, T. *Porcelain and the Dutch East India Company* (Leiden, 1954)

Acknowledgements

I would first of all like to acknowledge the great debt
of gratitude I owe to all those individuals and
institutions who have kindly allowed me to publish
photographs of the porcelain in their possession.
I would also like to thank Professor Brian Lofts of
the University of Hong Kong and Mr Peter Mathews
for the trouble they have taken in reading my
manuscript, for their very helpful suggestions and
for the encouragement they have given me. I am also
very grateful to Mr Savio Au for his skill in producing
the line drawings in this book; to the Department of
Geography and Geology, University of Hong Kong,
for the map of China and Southeast Asia that
appears in Fig 4; to Dr Raymond Hsu of the
University of Hong Kong for his most valuable
advice on the pronunciation of Chinese sounds; and
to Mr Chan Yuk Kwan for his skill and meticulous-
ness in photographing a number of the wares
illustrated in this book. In conclusion, I also wish to
record the thanks I owe to Mr Joshua Yau for his
care and patience in typing what at times was
undoubtedly a difficult manuscript.

Index

Figures in italics refer to illustrations but readers should also study the text on the page number(s) quoted as the subject is frequently discussed on the same page.
Reference to 'porcelain' in this index means 'Chinese porcelain'.
The letter-by-letter system of alphabetization has been adopted.